SHADOW CATCHERS CAMERA-LESS PHOTOGRAPHY

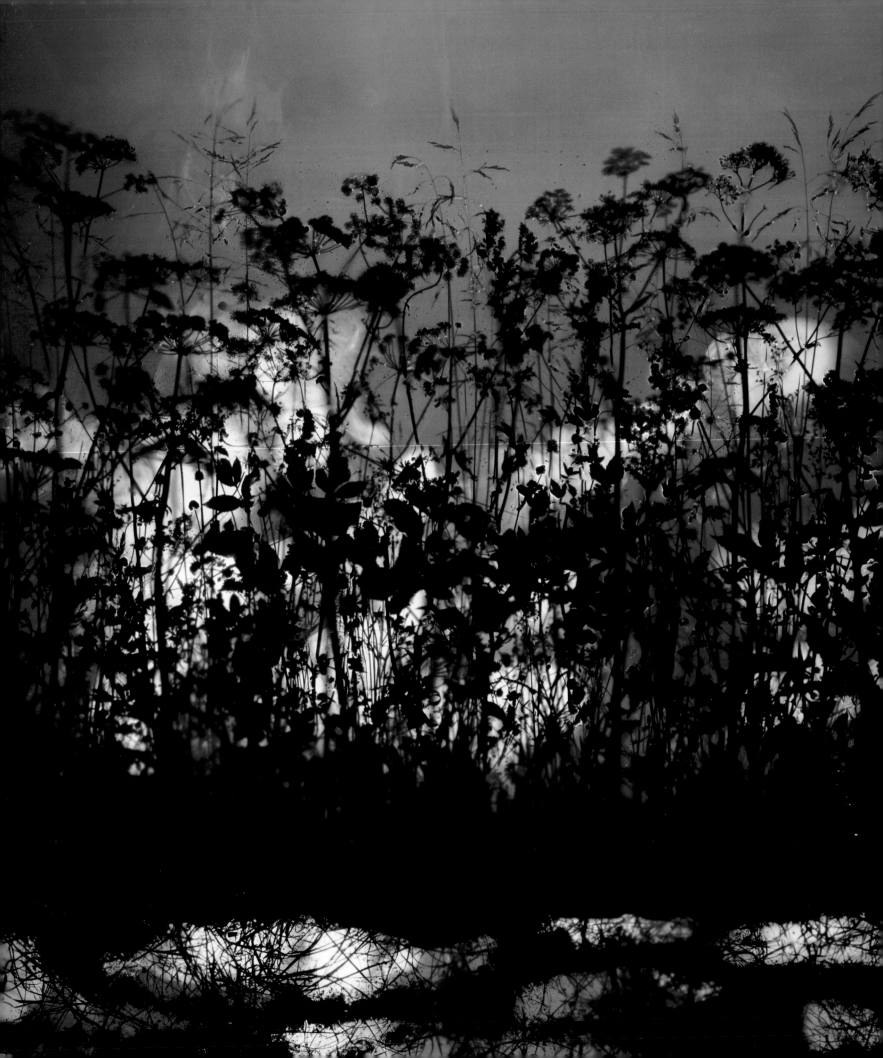

Martin Barnes

SHADOW CATCHERS CAMERA-LESS PHOTOGRAPHY

V&A MERRELL
LONDON · NEW YORK

For Imke, Hannah, Leyla, and my mother and father

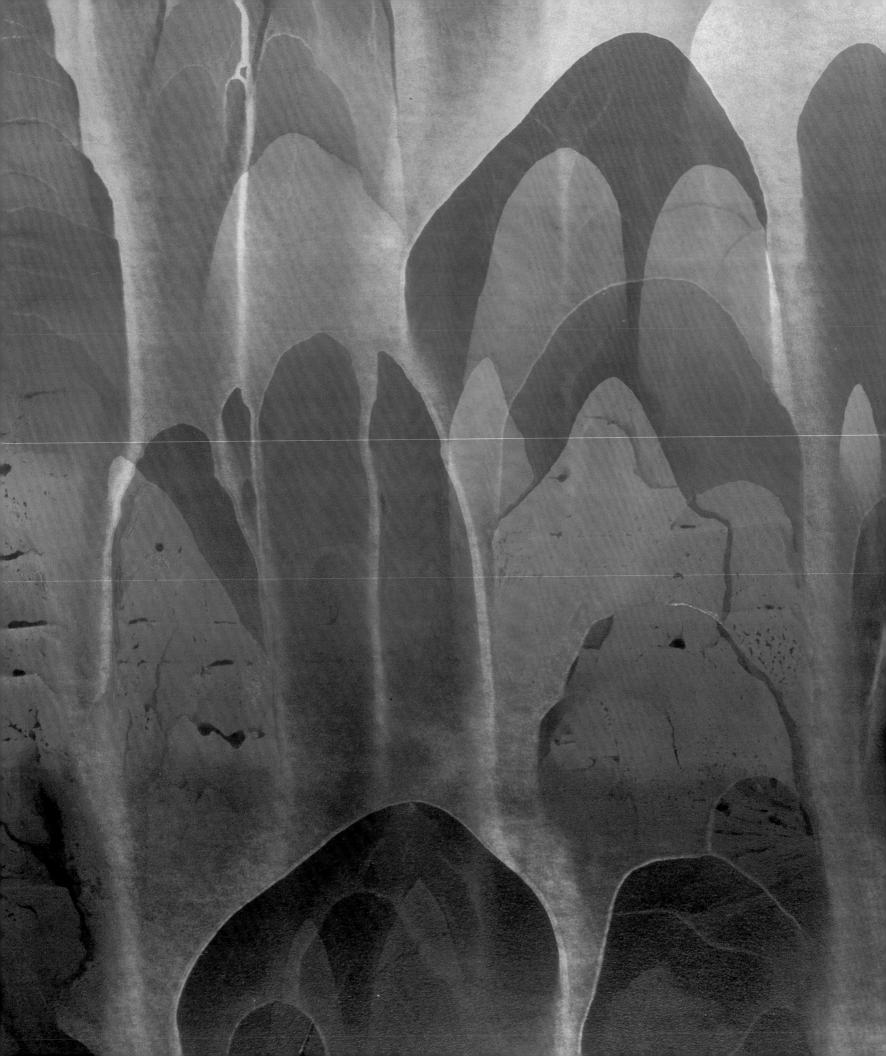

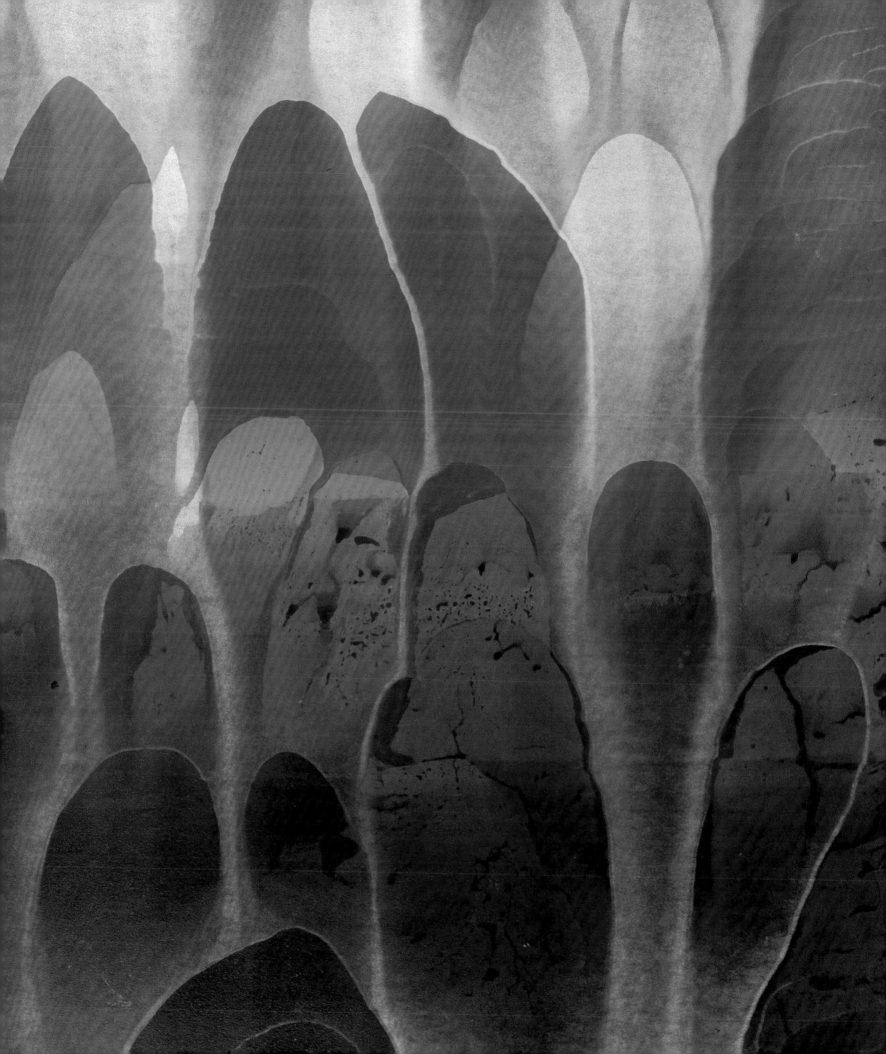

INTRODUCTION

Shadow Catchers presents the work of five international contemporary artists: Floris Neusüss, Pierre Cordier, Susan Derges, Garry Fabian Miller and Adam Fuss. Each of them has, for the last twenty years or more, consistently challenged the assumption that a camera is necessary to make a photograph. By casting shadows, blocking and filtering light on photographic paper, or chemically manipulating its surface, they capture the presence or trace of objects, figures or glowing light.

The essence of photography lies in its seemingly magical ability to fix shadows on to light-sensitive surfaces. Removing the camera enforces a direct, powerful and almost alchemical transformation at the point where light and chemistry interact, leaving the memory of enigmatic forms. Camera-less techniques were explored at the dawn of photography in the 1830s, were popular again during the 1920s, and have been rediscovered by contemporary image-makers in the midst of the digital age.

This book, and its related exhibition, is the first to gather together this particular group of major European practitioners of camera-less photography. Many others have been making significant artworks in this way during recent years, but the choice of Neusüss, Cordier, Derges, Fabian Miller and Fuss is based on their highly distinctive bodies of work, their longstanding experimentation and development of techniques, and their ability to transcend the potential danger of the decorative effects inherent in much camera-less imagery with a deep understanding of its creative possibilities. Considered collectively, their work constitutes a neglected, alternative and experimental version of the hitherto predominantly American, Modernist and documentary photographic canon.

The five selected artists have dedicated decades to pushing back the boundaries of camera-less photography, and for each of them it is his or her core activity. All can be considered pioneers of the medium, as well as important independent artists. Although their backgrounds differ, their works share similar methods of production, certain visual characteristics, and wider intellectual and conceptual concerns. Broadly speaking, they highlight two contrasting yet overlapping approaches: a Continental European 'Concrete' school of photography; and a Romantic, metaphysical tradition.

Neusüss's and Cordier's earliest camera-less pictures date back to the 1950s. Both artists emerged from post-Second World War art-photography movements, Neusüss combining influences from the Bauhaus, Surrealism and performance art, and Cordier hailing from the experimental practice of the Generative Fotografie group. Through their training and subsequent teaching in Germany and Belgium respectively, Neusüss and Cordier bridge the gap between the European avant garde of the 1920s and 1930s and the present.

British artists Derges, Fabian Miller and Fuss began using experimental photography in the 1980s, and have since gained international reputations. In particular, they updated the photogram – one of the earliest types of camera-less photograph – using vibrant colour alongside black and white. Connecting them is an interest in the relationship between nature and science, and the belief that revelation is contained in both. The history and physicality of English landscape also play a large part in their image-making: Derges and Fabian Miller live and work on the fringes of Dartmoor in the south-west of England, while Fuss lives and works in New York but draws upon his formative youth in rural England. Their works can be placed in a tradition of English art ranging from the mysticism of William Blake to the Modernist abstraction of Ben Nicholson.

In the age of increasingly mass-produced snapshots – and photographs that exist only in cyberspace or on screen – the images of these five selected artists provide a welcome and surprising alternative of often large-scale, unique works that reward intellectual, spiritual or philosophical enquiry. Artists' fascination with camera-less photography perhaps stems from the apparently unmediated emergence of form out of formlessness. One definition of art is the satisfaction of realizing abstract thought as communicable concrete reality. Camera-less photography can be viewed as an embodiment of this definition, the images created through the process itself harnessing the ephemeral. Camera-less photographs show what has never really existed, but have the

appearance of fragments, signs, memories or dreams. The results leave room to appeal to the imagination, transforming the world of objects into the world of visions.

For those who equate photography with the camera, the immediate question posed by a book about camera-less photographs is a technical one: how is it done? With all the technical possibilities available today, why would an artist choose to abandon technology for such seemingly rudimentary or old-fashioned methods? Then, a more interesting question arises: why is it done? This book is only tangentially concerned with the 'how' of camera-less photography, insofar as it gives an insight into the 'why'. Choosing to return to the basic elements of photography is not merely a technical experiment, a nostalgic or anachronistic statement, or an interesting diversion from other, more conventional ways of working. For the featured artists, the application of camera-less techniques is their principal occupation, allowing them to create images that they could not achieve by any other means.

The title of both the book and the related exhibition, *Shadow Catchers*, is not intended to be exclusive. In fact, many of the works shown here are as much about catching, filtering or blocking *light* as about depicting shadow. The title has been chosen rather broadly to evoke the idea of fixing traces, accepting elements of mystery and dealing with forces beyond normal vision. It concerns the dynamics of time and space, revealing the unseen, entering the labyrinth of the subconscious and making links with the meditative, symbolic and metaphysical realm. Camera-less photography can have a contradictory personality. What can be asserted about it from one perspective may with equal validity be countered by its opposite. For example, while its openness can suggest numerous symbolic interpretations, it may simultaneously and simply be captured by the sometimes glib – but also profound – definition 'It is what it is'. That is why it is sometimes comforting to fall back on explanations of process without probing deeper. However, the following pages begin by presenting a brief account of the history of camera-less photography in order to place the selected artists in a wider context. This is followed by an

examination of some of the key works by these artists made over the span of their careers. My focus is less on theoretical contexts than on looking closely at the artworks themselves, offering various ways of understanding a most rewarding form of art practice and individual bodies of work.

TRACES A SHORT HISTORY OF CAMERA-LESS PHOTOGRAPHY

The very first photographic images were formed without cameras. Indeed, it is astonishing to think that the elements that make up photography were available and noted hundreds of years before they coalesced in the early nineteenth century. To recount but a few instances:[1] as far back as the second half of the eighth century, the Arab alchemist Jabir ibn Hayyan (*c.* 721 – *c.* 815) recorded that silver nitrate – the essence of the light-sensitive emulsion of photographs – darkened in the light; in 1556 the German scholar Georg Fabricius (1516–1571) published his discovery that by adding a solution of salt and silver nitrate to certain ores, the metal would turn from white in the prepared state to black when exposed to sunlight; and in 1725 Johann Heinrich Schulze (1687–1744), a professor of anatomy at the University of Altdorf in Germany, mixed powdered chalk into a solution of nitric acid in an attempt to make a phosphorescent material, and was amazed to discover that the mixture turned dark violet in sunlight. He eventually proved that silver compounds were visibly changed by the action of light rather than heat or exposure to air, as had been previously suggested, and even made stencil prints on the sensitive contents of his bottles. Crucially, however, he apparently never applied the solutions to paper or made any attempt to fix these natural images. In 1802 Thomas Wedgwood (1771–1805) and Humphry Davy (1778–1829) published their famous paper 'An Account of a Method of Copying Paintings upon Glass, and of Making Profiles by the Agency of Light upon Nitrate of Silver'.[2] Wedgwood made paintings on glass and placed these in contact with pieces of paper and leather made sensitive to light with chemical treatments. He then left them exposed to sunlight. Where the painted areas blocked the light, they left their trace on the sensitized material. But the results can only be imagined. Wedgwood lacked the knowledge of how to fix the images, and they vanished like apparitions almost as soon as they appeared.

From 1834 William Henry Fox Talbot (1800–1877) had made similar camera-less images by placing botanical specimens and other objects, such as pieces of lace, on sensitized paper (fig. 1). At first, he solved the problem of fixing the images by using common salt, but later revised the process with advice from his friend the astronomer Sir John Herschel (1792–1871), who suggested using sodium hyposulphate solution – a method that is still in use today. Talbot's remarkable 'fairy pictures', as he called them, could now be confidently frozen in time. He also discovered the 'latent image': an image created by exposure to light that is present in the paper but invisible, and brought out later by chemical development. The idea of images existing beyond the visible spectrum, unseen by the naked eye, was powerfully suggestive of supernatural forces. Writing in 1839, Talbot neatly described his process: 'It is a little bit of magic realised.'[3]

Talbot gave his technique various names, including 'sciagraph' (the depiction of shadows) and 'photogenic drawing'. Today, the term 'photogram' encompasses all such images made by the contact of an object or objects on photographic paper. Strictly speaking, although they may appear do so, these images do not depict shadows because a shadow is not cast on the paper; rather, the form is produced by the blockage of light. It was a small but crucial step for Talbot to expose light-sensitive paper fixed to the inside of a rudimentary camera (the *camera obscura*, a wooden box with a lens), thus making the first photographic negative. Talbot's first camera-made negative images are generally smaller than his photograms (sometimes not much larger than a postage stamp) and difficult to read. To reverse the tones, Talbot's photograms – and negatives made in a camera – were 'contact printed'; that is, placed face to face with a second sheet of light-sensitive paper and left in the sun to form a one-to-one-sized positive impression. Thus, the size of the print depended on the size of the negative. And bigger negatives required correspondingly larger cameras to accommodate them. The process of enlarging negatives by projecting them through an enlarger lens did not become practicable until towards the end of the nineteenth century. Since camera-made images are produced through a lens, the resulting vision of the world appears closer to how the eye sees. It was this realistic quality that won the day over the photogram. So it seems remarkable now that Talbot continued to experiment with photograms even after he had discovered how to make images

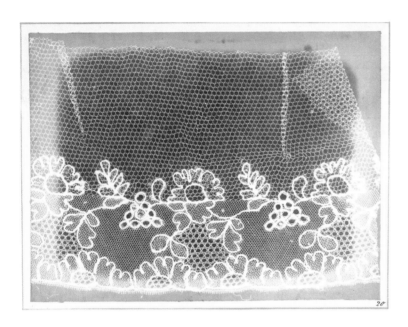

in a camera. Perhaps the photogram's direct contact with the objects depicted had the greater ring of truth. Yet, for all its authenticity of touch, the photogram is compromised as a medium of description by its ambiguity towards the rendition of perspective. Many objects in photograms appear to hover in space, unhinging the more comfortable sense of orientation created by images made through a lens.

After Talbot, relatively few people used the photogram seriously. However, one of its popular applications was for botanical illustration, for it showed the specifics of plant specimens in outline at true scale, and was much less time-consuming than drawing.[4] Anna Atkins (1799–1871) was one of the greatest exponents of this particular use of the technology. Atkins used 'cyanotype' paper, which required only water for development, and produced seemingly floating blue-and-white images of great appeal (fig. 2). After a brief flowering in the 1840s and early 1850s, the photogram lay dormant for some fifty years. Camera-made portraiture and, latterly, documentary, record and news photography proliferated. Ultimately, commercial concerns came to dominate. In the increasingly industrial Victorian age, camera-less photography offered little by way of practical application or financial gain. As one commentator has pointed out, 'photograms are like photography's bad twin, the dark side of the nineteenth-century faith in description that is implicit in the medium'.[5]

By the early years of the twentieth century, growing scientific debates about the dimensions of space and time had filtered through into the consciousness of artists. This was coupled with increased study into the nature of the mind and human perception, and the rise of psychoanalysis. Old certainties became fractured. Around this time photography began to develop a kind of self-consciousness about its own short history. It was possible to look back at its beginnings and evaluate the under-exploited rudiments of the medium for inspiration. In 1894 the playwright August Strindberg (1849–1912) experimented by leaving sheets of photographic paper in a tray of developer exposed to the night sky. The resultant images consisted of what appeared to be points of light created by the stars. Strindberg called them 'celestographs'.

The true cause of the specks of light was far less poetic: the tiny spots had been created by dust and debris collecting on the paper. Despite the prosaic explanation of the results, Strindberg's experiments arose from an important shift in perception: a mistrust in camera lenses, which he felt gave a distorted translation of reality. The 'celestographs' aligned with what Strindberg described as 'natural art', outlined in his essay 'The Role of Chance in Artistic Creation' (1894). The function of controlled (or partly calculated) chance and the idea of capturing forces outside of normal perception are notions that echo down the decades in relation to camera-less photography.

Strindberg's experiments evoked nature and the subconscious. And with the discovery of X-rays in 1895 by Wilhelm Konrad von Röntgen (1845–1923), whereby images could be recorded directly on to sensitized plates without the use of a camera, the hitherto unseen interior of the human body was revealed. Furthermore, around this time certain types of spirit photography aligned with occult investigation began to utilize camera-less techniques, purporting to show auras and paranormal activity invisible to the naked eye.[6] It seemed as if, relieved from the factual description of outward appearances, camera-less photographs were better suited to being witnesses of revelation.

The German artist Christian Schad (1894–1982) began making camera-less images in 1918. He is generally cited as the first person in the twentieth century to rediscover the photogram as a deliberate means of artistic expression. That said, his embrace of the medium was largely to do with its automatic qualities, freeing him from what he and fellow modern artists saw as the heavy-handed authorial control of the past. Schad was part of the Dada movement, which fed on the detritus of post-First World War Europe, attuned to the fractured society and its resulting absurdity as a creative force for renewal. Although Schad turned largely to painting after 1920, he picked up the photogram again in 1960. However, from the early 1920s, numerous other modern artists rediscovered the special appeal of the camera-less image. Like Schad, they subtly modulated its application to their own philosophies and art-movement affiliations. Foremost among them

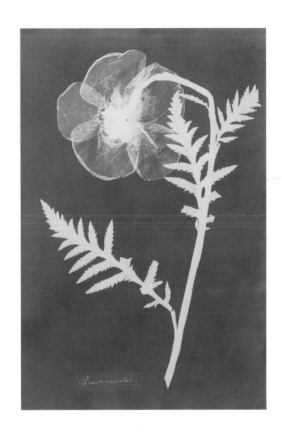

FIG. 2
Anna Atkins
Papaver Orientale, from *Cyanotypes of British and Foreign Flowering Plants and Ferns* (1854)
Cyanotype
35 × 24.2 cm (13³/₄ × 9¹/₂ in.)
VICTORIA AND ALBERT MUSEUM, LONDON

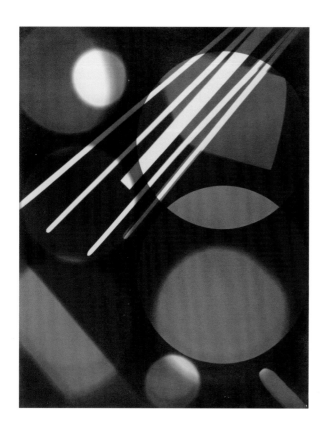

FIG. 3
Curtis Moffat
Abstract Composition, 1925
Gelatin-silver print
36.5 × 29 cm (14³⁄₈ × 11³⁄₈ in.)
VICTORIA AND ALBERT MUSEUM, LONDON

were Man Ray (1890–1976) and László Moholy-Nagy (1895–1946), both of whom first used the process in 1922. Moholy-Nagy wrote:

> The photogram, or camera-less record of forms produced by light, which embodies the unique nature of the photographic process, is the real key to photography. It allows us to capture the patterned interplay of light on a sheet of sensitized paper without recourse to any apparatus. The photogram opens up perspectives of a hitherto wholly unknown morphosis governed by optical laws peculiar to itself. It is the most completely dematerialized medium which the new vision commands.7

In Paris, Man Ray's adoption of the photogram (which he dubbed the 'Rayograph', after his own name) was linked to his interest in Surrealism. It was a way to turn photography inside out, a means of giving familiar objects an uncanny twist, thereby creating a sensual realization of dreams and the subconscious. For him, it was a kind of automatic writing, with light, in the darkroom. Man Ray also successfully applied the medium to a commercial role, producing *Électricité* (1931), a portfolio of photogravures based on photograms for the Paris electricity company. His apprentices and studio assistants learned the process too, among them the American Curtis Moffat (1887–1949). Moffat collaborated on photograms with Man Ray in the early 1920s before moving to London, where he exhibited his own abstract works in the medium in 1925 (fig. 3). Moholy-Nagy's 'Contructivist' photograms were often radically abstract in appearance, capturing characteristically dynamic white forms in black space. They played an important role in the formation of the philosophy behind his teaching at the Bauhaus schools in Weimar, Germany, what he called the 'New Vision' – art as part of society that rejoiced in revealing novel experiences of space and time through the action of light. The photogram flourished in Europe during the interwar years, extending from France and Germany and capturing the imaginations of artists, in particular such members of the Czech avant garde as Jaromír Funke (1896–1945) and Jaroslav Rossler (1902–1990).

With Moholy-Nagy's move to teach at the New Bauhaus in Chicago in 1937, appreciation and use of camera-less photography were carried over to the United States. His students and associates there – among them György Kepes (1906–2001), Arthur Siegel (1913–1978) and Henry Holmes Smith (1909–1986) – embarked on an expansion and refinement of Bauhaus methodology. Kepes's book *Language of Vision* (1944) was the group's most thorough outline of its philosophy and underlying utopian scheme: a reorganization of visual habits to bring about a revolution in mankind's perception of space, time and the order of society. Whether such grand ideas had much practical influence is debatable; yet, at the very least, the group's example showed how the photogram and related techniques – with their apparent negation of linear perspective – could free photography from a role of literal description. In the group's production of images using very little equipment, they also anticipated aspects of process art (the making of which forms part or all of its subject) and Minimalism.

The trajectory of the photogram and its Bauhaus affiliations in Europe was interrupted by the Second World War. However, those who had participated in its practice emerged in the post-war years as influential teachers of a new generation. One of the most prominent of these was Heinz Hajek-Halke (1898–1983), one of Floris Neusüss's teachers, who had created his first photomontages, photograms and abstract light studies by 1925. In 1951 he resumed his interest in photographic abstractions and darkroom techniques, joining the experimental photography group Fotoform, founded by Otto Steinert (1915–1978) in 1949. The outlet for Fotoform's works was a series of exhibitions titled *Subjektive Fotografie*, which took place between 1951 and 1958 at the Staatlichen Schule für Kunst und Handwerk in Saarbrücken, Germany. Like the New Bauhaus in Chicago, Fotoform emphasized personal vision and experimental practice over documentary realism. The group's first exhibition included a section reassessing the works of Moholy-Nagy and Man Ray. Hajek-Halke's books *Experimentelle Fotografie* (1955) and *Lichtgrafik* (1964) expounded his and Fotoform's ideas on photography, ideas that had taken root in

Europe before the war but had not had a chance to flourish fully or to spread more widely.

With many important political and humanitarian events taking place during and immediately after the war, photography fulfilled an increasingly documentary role. The value of the medium as a tool for reporting newsworthy events, or for commenting more broadly on the human condition, seemed paramount. On the one hand, documentary photography took the form of the humanist tradition – embodied by the Magnum group of photographers – with Henri Cartier-Bresson (1908–2004) as its figurehead. On the other, it was later expressed in the style of street photography, made popular in America by such figures as Lee Friedlander (born 1934) and Garry Winogrand (1928–1984). However, the revival in the 1950s and 1960s of interest in more experimental practice, as facilitated by camera-less techniques, offered emerging artists, including Neusüss and Pierre Cordier, a viable alternative.

The term 'Concrete photography' has been used increasingly to encompass particular forms of experimental and camera-less photography. It was first used in 1967, for an exhibition in Bern, Switzerland, of the work of four young Swiss photographers.[8] Included under the Concrete heading is Generative Fotografie, a group partly inspired by the new computer art of the 1960s. Formed in Bielefeld, Germany, in 1968, its members include Gottfried Jäger (born 1937), who coined the term, and Cordier. Jäger exhibited his own pinhole photographs with the work of three other artists – Cordier, Kilian Breier (born 1931) and Hein Gravenhorst (born 1937) – at the Museum of Art Bielefeld in January 1968.[9] Concrete and 'generative' photography constitute an aesthetic of production rather than of interpretation. They represent a kind of photography that is driven by its own unique materials and apparatus, that makes itself the theme and subject, that deals with presentation rather than representation.[10]

On the whole, the post-war uses of camera-less photography were largely unacknowledged at the time, being misunderstood as overtly formalistic; lying powerless next to political art; or being subsumed under the blanket of conceptual fine-art practice. As the

author of a recent book tracing ideas of abstraction in photography has noted, 'Their subtle messages were not recognized, a kind of message in a bottle: for their results are now achieving new attention in a different time and place in historical contexts.'[11]

Compared to Neusüss and Cordier, Susan Derges, Garry Fabian Miller and Adam Fuss, who began their careers in the late 1970s and early 1980s, are part of a later generation. With the exception of Derges's study at London fine-art schools (which, in any case, was not geared towards photography), these British photographers were not exposed to formal camera-less training, of the type seen at the Bauhaus on the Continent and in America. Instead, they found the medium through a mixture of experiment, accident, investigation and personal interaction, facilitated by the Victoria and Albert Museum's former curator of photographs, and now fine artist, Christopher Bucklow.[12] Between 1985 and 1988 Bucklow introduced the artists to one another after meeting them himself. A shared interest in subjects ranging from land art, nature and British Romanticism (especially William Blake) to spirituality, psychology and revelation fuelled their subsequent discussions. They also exhibited together on numerous occasions, in Britain and abroad, creating what has come to be seen as an informal school of contemporary British camera-less photography.[13]

Various reasons have been suggested for the revival in recent years of interest in camera-less photography. Chief among them is the rapid rise of digital media and their impact on traditional forms of photography. There is a nostalgia for the alchemical appeal of vanishing, alternative chemistry-based processes; at the same time, these processes are being liberated yet further from their mimetic and descriptive functions to be reborn in radically modern ways. They offer an exciting, back-to-basics language that seems refreshing and surprising, yet they are also able to draw on a distinguished heritage stretching back to the first photographs. The uniqueness and craft of the images mean that they sit comfortably in an art market that is sometimes uneasy with multiples and editions. Changes in critical discourse have led to a reassessment of the canon of photographic history. This includes a reappraisal of the field of scientific photography, which has been newly appreciated for aesthetic as well as social and technical merits. On the one hand, camera-less photographs can withstand interpretations based on critical and linguistic theory. On the other, they can be resolutely tied to process and practice, with meaning and theory generated by the process itself. Some commentators have suggested that forms of abstraction in photography have mirrored the increasingly abstract structures of market capital; that camera-less photographs echo the dematerialization and fracture of contemporary society.[14] With fewer certainties in our culture today than perhaps ever before, such photographs appeal to a shift towards the contingent nature of the present. It is possible, too, that they highlight a more accountable, personal, psychological or spiritual consciousness as the imperative requirement of our times.

NOTES

Parts of this chapter appeared previously in my essay 'The Mirror of Alchemy', in *Alchemy: Twelve Contemporary Artists Exploring the Essence of Photography*, exhib. cat., ed. Anna Douglas and Katy Barron, Harewood, London, Kendal and Nottingham, 2006–07. There are many other artists who could have been mentioned in this preamble, and of course many more contemporary practitioners who have not been included. Please consult the 'Bibliography' of this book for other histories of camera-less photography.

1 For accounts of the genesis of photography and the numerous pre-photographic experiments, see Geoffrey Batchen, *Burning with Desire*, Boston (MIT Press) 1999; and Peter Galassi, *Before Photography: Painting and the Invention of Photography*, New York (Museum of Modern Art) 1981.

2 Thomas Wedgwood and Humphry Davy, 'An Account of a Method of Copying Paintings upon Glass, and of Making Profiles by the Agency of Light upon Nitrate of Silver', *Journal of the Royal Institution*, 1, 1802, p. 170.

3 William Henry Fox Talbot, letter to William Jerdan, 30 January 1839, available online at foxtalbot.arts.gla.ac.uk, accessed April 2010.

4 For an excellent account of the use of photograms in botanical illustration, see Carol Armstrong and Catherine De Zegher, eds., *Ocean Flowers: Impressions from Nature*, Princeton, NJ (Princeton University Press) 2004.

5 Charles Hagen, 'Photograms Today: The Essence of Process', in *Experimental Vision: The Evolution of the Photogram Since 1919*, exhib. cat. by Floris M. Neusüss *et al.*, Denver Art Museum, January–March 1994, p. 55.

6 See *The Perfect Medium: Photography and the Occult*, exhib. cat. by Clément Chéroux *et al.*, Paris, Maison Européenne de la Photographie, November 2004 – February 2005; New York, The Metropolitan Museum of Art, September–December 2005.

7 László Moholy-Nagy, 'A New Instrument of Vision' [1932], quoted in *Moholy-Nagy: An Anthology*, ed. Richard Kostelanetz, New York (Da Capo Press) 1970, p. 50.

8 Roger Humbert (born 1929), René Mächler (1936–2008), Jean-Frédéric Schnyder (born 1945) and Rolf Schroeter (born 1932).

9 The items from this exhibition and other works of Concrete photography have been on rotating display at the Museum im Kulturspeicher Würzburg since 2002.

10 For a detailed account of Concrete photography, see Gottfried Jäger *et al.*, *Concrete Photography/Konkrete Fotografie*, Bielefeld (Kerberger Verlag) 2005, and online at gottfried-jaeger-archiv.de, accessed April 2010.

11 Lyle Rexer, *The Edge of Vision: The Rise of Abstraction in Photography*, New York (Aperture Foundation) 2009, p. 276.

12 Bucklow (who went under the surname of 'Titterington' while curator) has made his own photographs without the use of a conventional camera, utilizing a kind of multiple pinhole camera during the 1990s to make his well-known *Host* and *Guest* series. Today he is mostly concerned with painting. His writing on the art of Derges, Fuss and Fabian Miller was crucial in linking their concerns and promoting their achievements. I am indebted to Bucklow in this present volume – and also to Mark Haworth-Booth, former senior curator of photographs at the Victoria and Albert Museum – for the collections of these artists' works that they made for the museum, and for their insights into the artists' practice.

13 See, for example, *Camera-less Photography: Susan Derges, Garry Fabian Miller*, exhib. cat., ed. Junichi Seki, Yokohama Museum of Art, October 1994; *Under the Sun: Photographs by Christopher Bucklow, Susan Derges, Garry Fabian Miller, and Adam Fuss*, exhib. cat., ed. Jeffrey Fraenkel, San Francisco, Fraenkel Gallery, December 1996 – January 1997; and *Elective Affinities: Susan Derges and Garry Fabian Miller*, exhib. cat. by Mark Haworth-Booth, London, Michael Hue-Williams Fine Art, April–May 1996.

14 See George Baker, 'Photography and Abstraction', in *Words Without Pictures*, ed. Alex Klein, Los Angeles (Los Angeles County Museum of Art) 2009, pp. 358–79; and Matthew Witkovsky, 'Another History: On Photography and Abstraction', *Artforum*, March 2010, pp. 213–21.

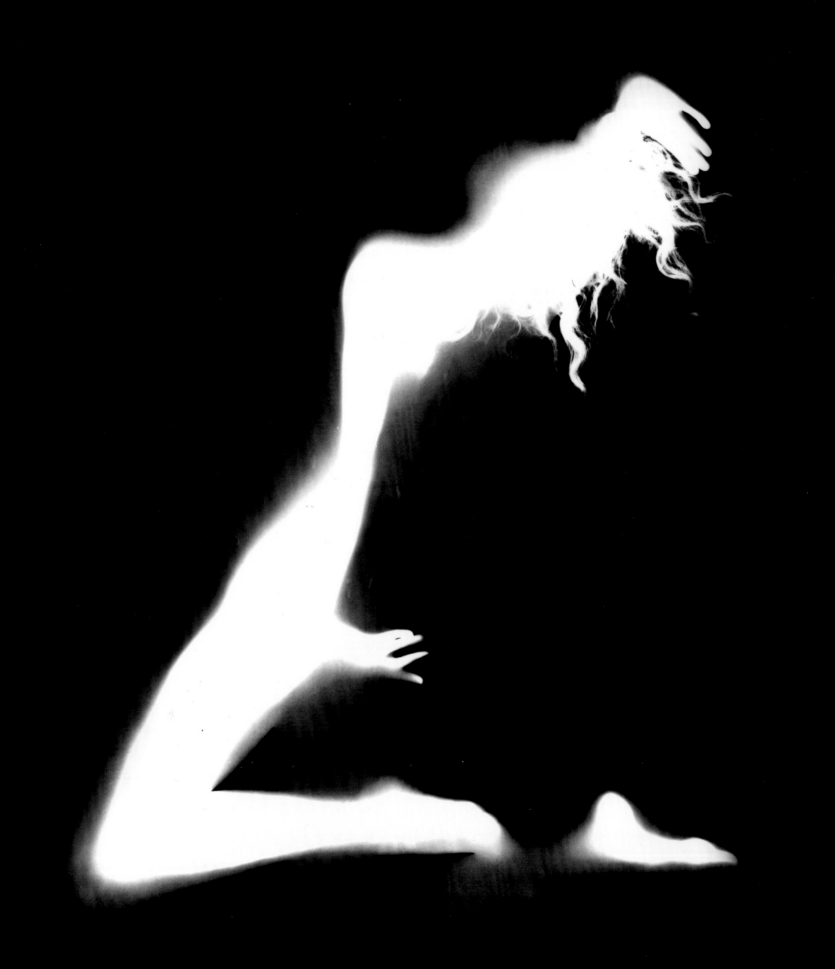

METAMORPHOSES Floris Neusüss

Floris Neusüss has dedicated his whole career to extending the practice, study and teaching of the photogram, consistently exploring its numerous technical and visual possibilities. Alongside his practice as an artist, he is known as an influential and authoritative writer on and teacher of the history of camera-less photography, only recently retiring from his position of professor in experimental photography at the University of Kassel, Germany, a post he had held since 1971. However, it is primarily his work as an artist that concerns us here.

Neusüss began his career studying mural painting before turning to photography. His first photograms were made in 1954 in the photography working group of Röntgen Grammar School in his home town of Lennep, Germany. It is fitting to note that the school is named after Wilhelm Konrad von Röntgen, a fellow native of the town and the discoverer of X-rays. Visual echoes of the X-ray can be seen in much of Neusüss's work. However, Neusüss's art carries none of the X-ray's medical associations; instead, it explores the forms of the body and external objects in a poetic dialogue between presence and absence.

From 1955 until 1963, Neusüss engaged in an intense period of study at numerous German art academies, absorbing the teachings at the Werkkunstschule Wuppertal, the Bayerische Staatslehranstalt für Photographie in Munich and the Hochschule für bildende Künst in Berlin. In was in Berlin that he studied under Heinz Hajek-Halke, who promoted an experimental approach to photography and embraced the creative possibilities of light and chemical manipulations. Influenced, too, by the Constructivist camera-less photography of László Moholy-Nagy and by Man Ray's Surrealist approach to the medium, Neusüss set about making his own mark with the photogram. In 1960 he produced his first *Körperfotogramms* (or whole-body photograms, also known as 'nudograms'), which are perhaps his best-known works.[1] These pieces brought renewed ambition to the photogram in terms of both scale and visual treatment.

Using the simple technique of laying a model directly on the photographic paper, Neusüss explored a remarkable variety of expressive figure poses. He worked intensively on his *Körperfotogramm* series throughout the 1960s and into the 1970s, initially using standard silver bromide paper to show white figures on a black background. Soon after, he also used auto-reversal paper to make black figures on white, which appear closer to normal experiences of the human shadow. The varying proximity of parts of the body to the paper created sharper or softer outlines. For example, in *Untitled (Körperfotogramm, Kassel)* (1967; pages 34–35), where the model's hands were in contact with the paper, the outline is clear; where parts of the body, such as the head, were further away, it is blurred. With their apparent weightlessness and ambiguity in relation to placement in space, Neusüss's *Körperfotogramms* extended the repertoire of the nude study in a way that had rarely been seen in either photography or painting.

The impact of Neusüss's *Körperfotogramms* is enhanced when they are encountered in an exhibition, where the full scale of the life-size bodies may be experienced at first hand. An important installation at the Photokina trade fair of 1963 in Cologne gathered some of Neusüss's single-figure photograms in a frieze-like procession. The display harked back to arrangements of Greek temple sculpture, yet combined this Classical reference with an erotic art-nouveau flavour. The contrasting postures, using alternating black and white backgrounds, create a lively dialogue between the figures (pages 30–31). Although made with the model holding still, some of the pieces suggest rapid motion that has been frozen in time: one figure appears to skip, casting a spray of petals from each hand; another, wearing a bride's headdress, releases a bird from her grasp. Such details imply an underlying symbolic narrative of fertility and flight. While satisfying in themselves as technical exercises or anthropometric studies, Neusüss's whole-body photograms provoke a deeper reading.

The sensual bodies in Neusüss's *Körperfotogramms* appear to leap or float, as though caught in space, implying dreams of flight or nightmares of falling. Clearly outlined silhouettes play against the vague indications of an interior. The works possess a quality of yearning, and give the impression of a person trapped behind glass; our response is to try to communicate. In their suspended state, devoid of the specifics that make an individualized portrait,

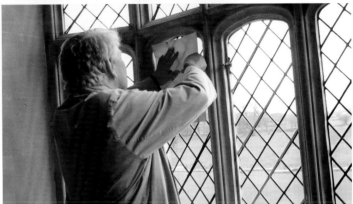

At Lacock Abbey in Wiltshire, England,
Neusüss prepares to make a photogram
of the window that formed the subject
of William Henry Fox Talbot's first
photographic negative, made in 1835.

the bodies are presented as ciphers of the female. Yet the
photograms have a vital bodily presence and tactile origins. The
fact of their subjects' nudity carries an alluring attraction. We know
that, at one time, a person touched the paper and that their shadow
was left behind in two dimensions as an incomplete and enigmatic
trace. As we search for connections between the individual, the
body and its indexical remnant, the images ask us to complete
them in three dimensions using flights of fancy. As Neusüss
has observed, 'In the photogram ... man is not depicted, but the
picture of him comes into being by an act of imagination.'[2] The
fragmentary essence of these works, perpetually emerging, holds
the attention of the viewer. While mourning the transitory nature
of the body, they simultaneously act as a celebration of something
coming into being. Neither ideal nor natural, the figures are better
described as metaphorical, suggesting the light emanations of an
astral rather than a corporeal body and, ultimately, a dialogue about
life and death.

The powerful metaphysical implications of Neusüss's
works suggest they might be better understood not primarily as
photographic traces (although, in a physical sense, that is of course
what they are) but rather as the realization of visions. The presence
of the figures is haunting precisely because, like visions, they are
elusive. The adult figure in *Untitled (Körperfotogramm, Berlin)*
(1962; page 26) adopts a foetal position, while the hovering body
in *Untitled (Körperfotogramm, München)* (1965; page 27) also seems
embryonic, her truncated limbs folded into her body in a cruciform
shape. Are they conceived as superhuman visitors, angelic others,
normally existing in the imagination or deep in the psyche? In
the teachings of Carl Jung (1875–1961), the founder of analytical
psychology, the shadow can be regarded as the most important
archetype. It stands for the collection of repressed qualities
that we have pushed into our subconscious. As with our literal
shadow, we sometimes do not recognize or want to recognize our
archetypal shadow; yet it is inseparable from us. One might view
Neusüss's *Körperfotogramms* as symbols for the subconscious, the
manifestation of a desire for a lost half that would make us whole.
Two more of Jung's concepts, 'animus' and 'anima', can also be

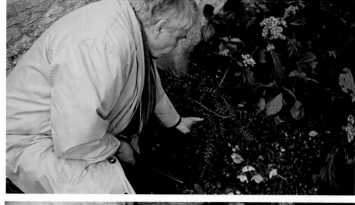

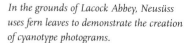

*In the grounds of Lacock Abbey, Neusüss
uses fern leaves to demonstrate the creation
of cyanotype photograms.*

usefully applied to thinking about Neusüss's works. These are the names that Jung gave to undeveloped parts of the male and female psyche. In men, the unexpressed anima is the inner feminine quality often personified as a mysterious, distant and beautiful character in one's dreams. As an archetype, she permeates both popular and high culture, appearing in art, fashion, poetry, religion and mythology. Anima acts for some people as a muse, a doorway that facilitates communication between conscious and unconscious areas of creativity.3

However they are interpreted, there is no doubt that Neusüss's early pieces acted as a muse and catalyst for much of his later work. Over the decades, he has broadened the concept of the photogram, addressing fundamental issues raised by the inherent qualities of the technique. His systematic endeavour to explore fully the conceptual, formal, practical and aesthetic possibilities of the photogram has included consideration of stillness and motion; the perception of three dimensions in physical objects and the depth implied in the picture; the dialogue between such binary opposites as black and white, positive and negative, object and reflection; the number of figures in the picture; and the differences between a single emblematic motif and an implied narrative sequence in a single image. Neusüss also employs such technical variations as changing the position of a figure or object during exposure, multiple exposure and superimposition.

Departing from the conventional photogram, Neusüss experimented by wiping a brush, sponge or rag dipped in developer or fixer across the surface of the paper to produce controlled, painterly gestures. This technique can be seen in *Untitled (Körperbild, Kassel)* (1966; page 33), where, after exposure, Neusüss painted around the outline of the model using photo-chemicals, thus selectively developing and fixing areas of the image. Certain areas of the paper were deliberately not fixed, allowing the work to change colour over the years.4 If the *Körperfotogramms* already discussed suggest spirits of the air, the fluidity of the making and appearance of *Untitled (Körperbild, Kassel)* implies a character more akin to a water nymph. In other works, all the chemicals are applied to the exposed photogram at the same time, generating in

their interaction colours that overlay the previously exposed image. This embrace of what might be described as 'chemical automatism' recalls the Surrealist technique of allowing chance to dictate the final creative outcome of an artwork. The volatile nature of Neusüss's experimental works – their shifting forms partially revealed, their disintegration and discolouration over the years – anticipated the artist's 'body dissolutions' made in Arles, France, in 1977.5 These 'actions', or performance pieces, required the participants to sacrifice their body photograms to the elements, by immersing them in the sea, burying them at the beach, setting them alight or flying them to tatters as a kite. Through this work, Neusüss fully realized the implications of dematerialization contained in the photogram.

Neusüss's art often acknowledges that the making of each unique photogram is a kind of performance in itself. Foregrounding the theatricality and temporality of the process in the 'body dissolutions' represents one aspect of this approach, while the installation piece *Bin Gleich Zurück* (Be right back, 1984 and 1997; page 49) represents another. Here, a chair stands on a sheet of photographic paper, which retains the shadow of a person now absent from the seat. The playful title becomes increasingly poignant as each year passes. This work anchors the shadow that has been detached from the person; it does not float, as in the *Körperfotogramms*, but is grounded. The more earthly approach of *Bin Gleich Zurück* was adopted for a series of portraits of artists in profile and full figure, recalling the cut-paper silhouettes popular in the eighteenth century, especially among such figures of German high culture as poet and philosopher Johann Wolfgang von Goethe and artist Philipp Otto Runge.

Over the years, Neusüss's work has expressed an increasing self-consciousness in relation to a wider cultural history, commenting on dialogues between nature and culture, science and art, and especially on its own position in the lineage of photographic history. Among a series of pieces paying tribute to nineteenth-century pioneers of photography is *Hommage à William Henry Fox Talbot: Sein 'Latticed Window' in Lacock Abbey als Fotogramm, Lacock Abbey* (Homage to William Henry Fox Talbot: his 'Latticed Window' in Lacock Abbey, as a photogram, Lacock

Abbey, 1978; page 37). In a change to his usual practice, Neusüss created this work on location and partly outdoors, rather than in a darkroom. The window at Lacock Abbey holds a special place in the history of photography because it is the subject of Talbot's first photographic negative, created in 1835. The negative, made using a mousetrap-sized camera, has a diffuse quality of light that defines the glazing bars as if seen through sleepy eyes. Where light was present, a dark deposit of silver occurred on the paper; where it was absent, the paper remained unchanged. Light and dark are therefore inverted, and the glazing bars and panes of glass are traced in a rectilinear pattern. Talbot no doubt selected the latticed window on the basis that it was a practical subject for his experiment; yet it has come to represent the genesis of photographic seeing. Prophetically, it anticipated the notion that camera-made photographs can be seen as windows on the world. The window itself – halfway between interior and exterior – is as beguiling as any view beyond. It was an appropriate motif to herald a new medium that would prompt deeper questions concerning visual and philosophical perceptions of the world.

Knowing of the resonance of Lacock Abbey, and the philosophical implications of the window image, Neusüss covered the interior of the window with photographic paper at night. He then exposed the paper by shining a light from outside. The resulting photogram recreates the subject of Talbot's negative, but in life size. Foliage trails over the window, suggesting the passage of time between Talbot's negative and Neusüss's homage. The work is based on the idea of continuing the trajectory of Talbot's photogram techniques by applying them to the subjects that – because of limitations in technology or personal inclination – Talbot was unable to capture himself. Neusüss's image was made on auto-reversal paper as a 'direct positive'. As a commission for the exhibition related to this book, Neusüss returned to Lacock Abbey, thirty-two years after his first visit, to create a new photogram in response to the iconic window (page 39).

Neusüss's work extends in different directions to include similarly non-figurative pieces, exploring the language of simple form, as well as technical challenges, in several other series. These

include *Faltbilder* (Folded pictures, from 1964), in which the photographic paper is folded, exposed to light, and unfolded to reveal the patterns and symmetries created; *Tellerbilder* (Plate pictures, from 1968), circular forms created with dinner plates, on both black-and-white and colour photographic papers; and *ULOs* (Unidentified lying objects, from 1989), which plays on the mysterious visual transformation that humble domestic objects undergo when they become the subject of a photogram. By removing objects from their usual context, Neusüss encourages the viewer to contemplate the essence of form with a feeling of surreal detachment or a sense of disengagement from time and the physical world. Alongside the Constructivist strictness, there is potential for a transcendent effect. As one commentator has pointed out, citing the philosopher Novalis, Neusüss gives '"the common a high meaning, the ordinary a mysterious appearance, the familiar the dignity of the unfamiliar, the finite the appearance of the infinite"'.[6]

Sometimes, the mysterious and abstract qualities of Neusüss's work are the result of natural forces, as in the *Gewitterbild* (Lightning picture) images, part of the *Nachtstücke* (Night pieces) series (1984; pages 44–45). The first *Gewitterbilder* were made by placing photographic paper in a garden at night during a thunderstorm, and letting lightning expose the paper. Later works were made without lightning; instead, an electronic flash was fired at the paper, often from several different angles. The orientation of the paper in the undergrowth was haphazard, so the final composition could be decided after the event. This openness to the orientation of an image, in terms of both making and reception, is also evident in the seminal *Equivalents* series of the 1920s and 1930s by Alfred Stieglitz (1864–1946) – camera-made cloud studies without a horizon. On the reverse of some of them, Stieglitz wrote, 'all ways are up', words that could equally apply to Neusüss's *Gewitterbild*. Neusüss's works made using the outdoors at night as an extended darkroom fully accept chance in their making. They also anticipate the deep exploration and development of this working method undertaken by Susan Derges from the 1990s.

Since 2000 Neusüss has been making photograms of the sculpture in various museum collections, contrasting nature with artifice, and returning to the motif of the human figure. Gaining access after hours, he has captured the shadows of Greek, Roman, Renaissance and Neoclassical sculptures, bringing them eerily to life. These pieces show new sides to well-known artworks. In *Hebe 1796 (Skulptur von Antonio Canova 1757–1822) Alte Nationalgalerie Berlin* (2004; page 47), for example, overlapping double exposures – both positive and negative – create multiple, almost cubist views of Canova's work. As with his early *Körperfotogramms*, Neusüss's sculpture photograms deal with the links between a three-dimensional form and its two-dimensional representation. They speak of artists' enduring fascination with animate bodily forms and how they can be transformed into idealized inanimate imaginings.

Neusüss's works deal in opposites: black and white, shadow and light, negative and positive, object and reflection, movement and stillness, real and ideal, presence and absence. Such mutually dependent counterpoints have, until the digital age, formed much of our understanding of the technical and philosophical ramifications of photography, which derives form and meaning through binary dialogues. Similarly, Neusüss has created meaning in his work through an understanding and use of opposites that is apt for the photogram and his own variations of the process. In addition, the heart of the appeal of his work lies in its acknowledgement of the potential for transformation that exists between opposite poles. As Neusüss has said, 'In the photogram the viewer distinguishes the fragmentary fixed object as a quotation of reality. But this perception is kept from sticking to the portrayal because the picture includes a decisive message, a certain action, a dealing with reality, not letting it appear as given but potentially variable.'[7] The photogram acts as an attempt to recognize and capture this potential variability. It is a melancholic substitute for something absent, a desire to fix what is, or will be, lost.

With Neusüss's early works featuring the female cipher as muse, and given the artist's career-long interest in the theme of metamorphosis, it is no accident that the subject of one of his

series of works is Ovid's myth of Orpheus and Eurydice (*Orpheus, Kassel*, 1983; pages 40–43). Orpheus descends into the underworld to rescue his love, Eurydice, after her death. Using the power of his music, Orpheus persuades Pluto, the ruler of the underworld, to allow Eurydice to follow him back to Earth. The only condition is that he must not look back at her until they reach the upper world. But at the last moment, Orpheus cannot resist glancing back, and Eurydice vanishes forever into the shadows.

NOTES

1 See *Floris Neusüss – Körperbilder: Fotogramme der sechziger Jahre*, exhib. cat. by T.O. Immisch *et al.*, Staatliche Galerie Moritzburg Halle, October–December 2001. It is likely that the first people to create whole-body photograms were Robert Rauschenberg and Susan Weil around 1950. Neusüss was not aware of this work at the time he made his own full-body photograms. Nor was he aware of Yves Klein's contemporaneous *Anthropométries*, made by coating nude models with paint and pulling them across the surface of a canvas. For a deeper examination of the whole-body photogram, see Tim Otto Roth, 'Imprint, Impression, Expression: Peter Gerwin Hoffmann's Traces in the Historical Context of the Whole Body Photogramme', in *Peter Gerwin Hoffmann*, ed. Heimo Ranzenbacher *et al.*, Cologne (Walther König) 2006, pp. 252–58.

2 Floris Neusüss, quoted in *Floris Neusüss – Körperbilder*, p. 8.

3 I am grateful to artist Christopher Bucklow for drawing my attention to this observation, which he has written about and can be seen in relation to his own work. See chrisbucklow.com.

4 The dark lilac-brown areas of the image are the parts that were not developed or fixed. While the colour of these areas has darkened over the years, it is likely that it will not continue to change, at least to a visually perceptible degree.

5 See Floris Neusüss, *Körperauflösungen*, Kassel (Edition Fotoforum) 1978.

6 T.O. Immisch, in *Floris Neusüss – Körperbilder*, p. 9.

7 Floris Neusüss, quoted in *Nachtstücke. Photogramme 1957 bis 1997*, exhib. cat. by Klaus Honnef, Bonn, Bad Arolsen and Hamburg, 1997, p. 22.

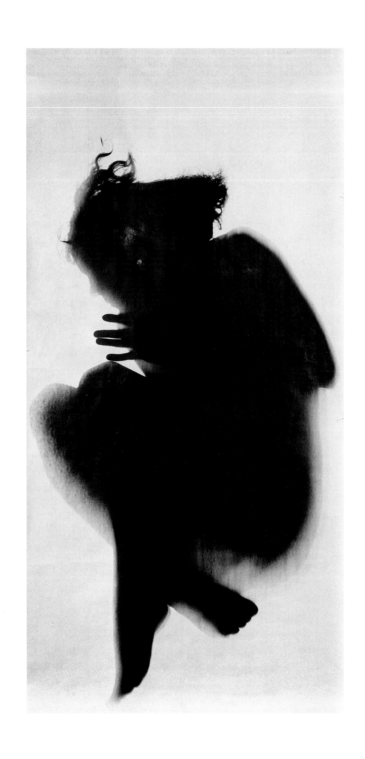

Untitled (Körperfotogramm, Berlin), 1962
Gelatin-silver print
130 × 58 cm (51¹/₈ × 22⁷/₈ in.)
CHRISTIAN DIENER COLLECTION, BERLIN

OPPOSITE
Untitled (Körperfotogramm, München), 1965
Gelatin-silver print
200 × 100 cm (78³/₄ × 39³/₈ in.)
CHRISTIAN DIENER COLLECTION, BERLIN

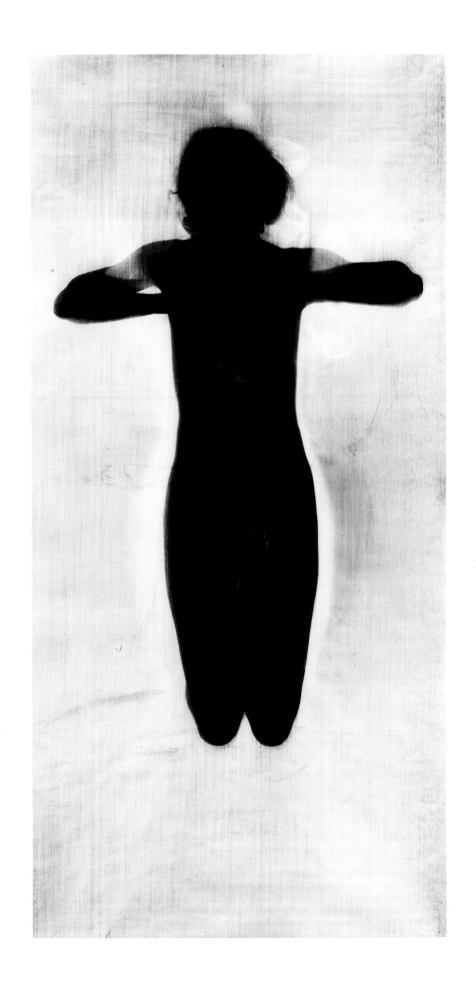

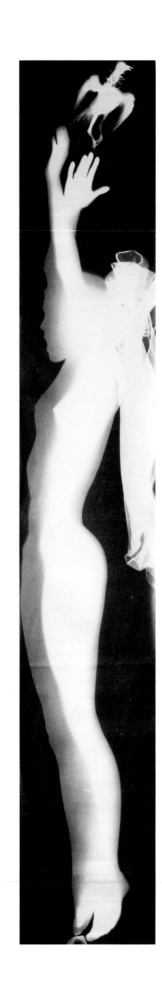

Untitled (Körperfotogramm, Berlin), 1962
Gelatin-silver print
260 × 40 cm (102³⁄₈ × 15³⁄₄ in.)
CHRISTIAN DIENER COLLECTION, BERLIN

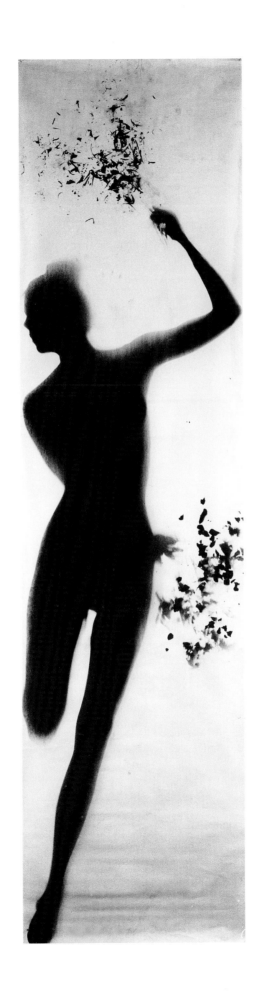

Untitled (Körperfotogramm, Berlin), 1962
Gelatin-silver print
250 × 65 cm (98³/₈ × 25⁵/₈ in.)
CHRISTIAN DIENER COLLECTION, BERLIN

PAGES 30–31
Preparation of photograms for installation
at Photokina, Cologne, 1963
COLLECTION OF THE ARTIST

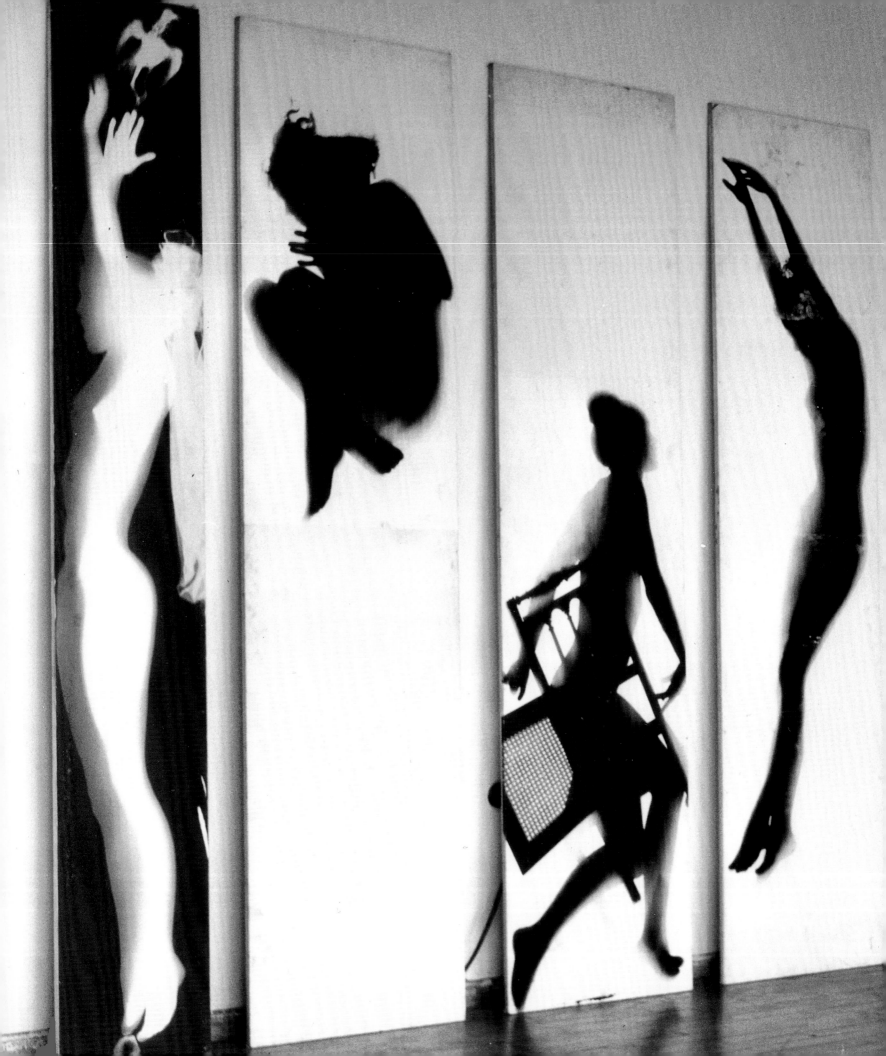

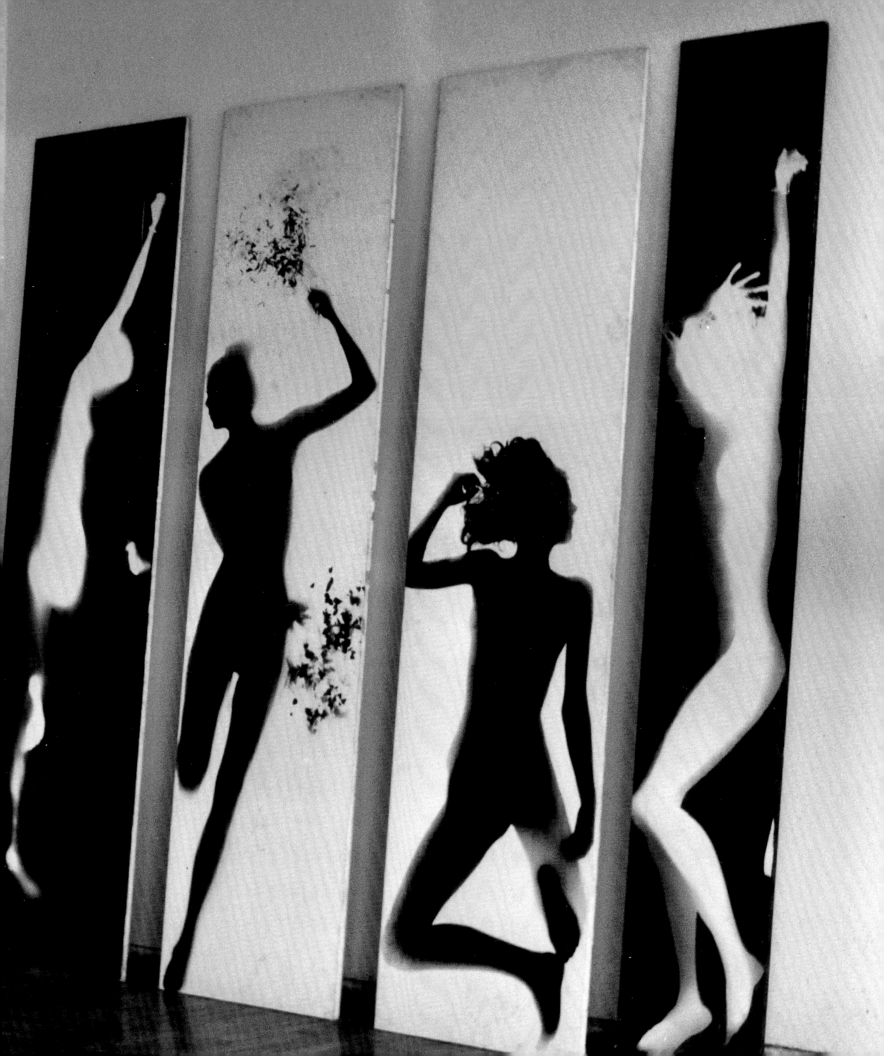

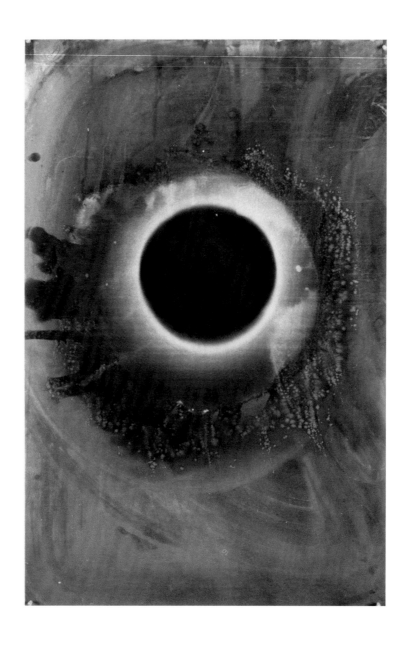

Sonnenfinsternis, Kassel (Solar eclipse, Kassell), 1968
Gelatin-silver print with painted developer and fixer
102 × 66.5 cm (40$\frac{1}{8}$ × 26$\frac{1}{8}$ in.)
COLLECTION OF THE ARTIST

OPPOSITE
Untitled (Körperbild, Kassel), 1966
Gelatin-silver print with painted developer and fixer
232 × 102 cm (91$\frac{3}{8}$ × 40$\frac{1}{8}$ in.)
COLLECTION OF THE ARTIST

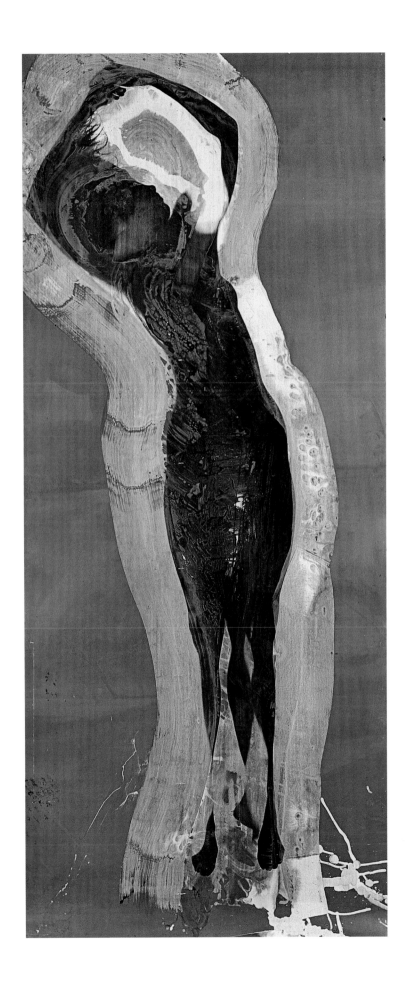

Untitled (Körperfotogramm, Kassel), 1967
Gelatin-silver print
104.3 × 130.5 cm (41 × 51 ³⁄₈ in.)
STAATLICHE MUSEEN, KASSEL

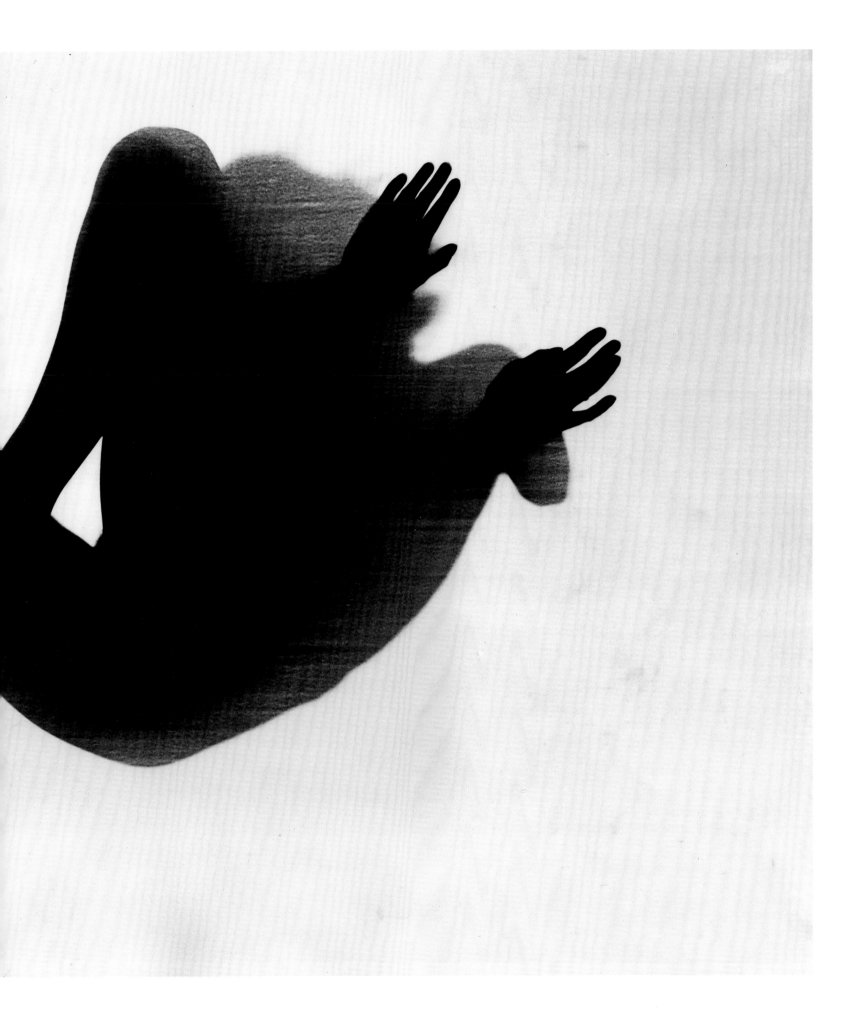

Hommage à William Henry Fox Talbot: Sein
'Latticed Window' in Lacock Abbey als Fotogramm,
Lacock Abbey (Homage to William Henry Fox Talbot:
his 'Latticed Window' in Lacock Abbey, as a
photogram, Lacock Abbey), made in collaboration
with Renate Heyne, 1978
Gelatin-silver print
270 × 212 cm (106$\frac{1}{4}$ × 83$\frac{1}{2}$ in.)

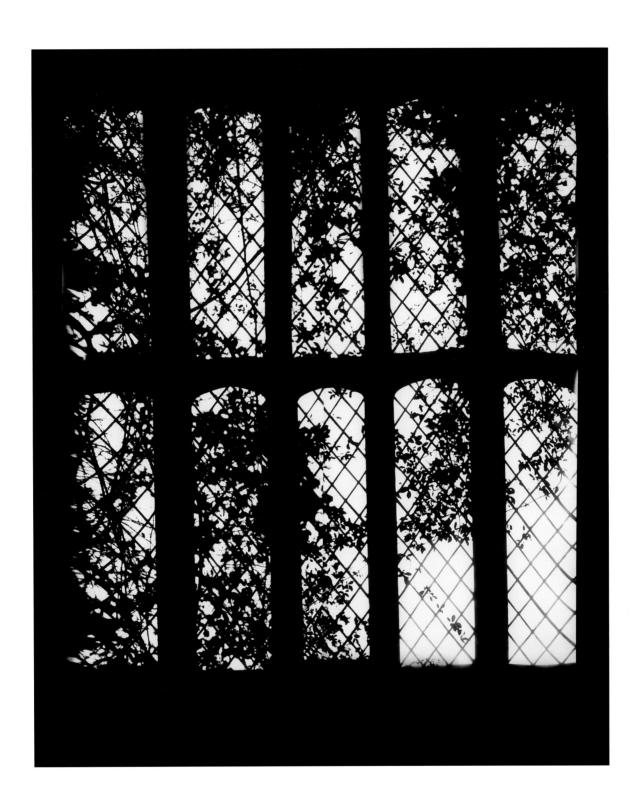

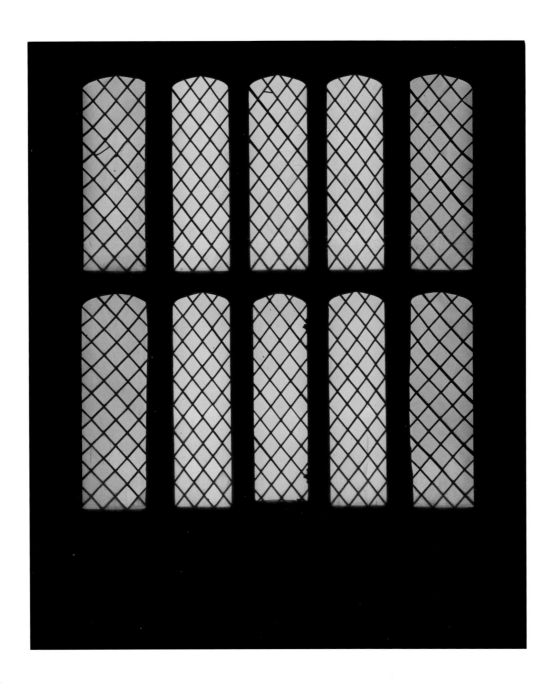

ABOVE (DETAIL SHOWN OPPOSITE)
*Hommage à William Henry Fox Talbot: Sein 'Latticed
Window' in Lacock Abbey als Fotogramm, Lacock Abbey,*
made in collaboration with Renate Heyne, 2010
Dye destruction prints
320 × 237 cm (126 × 93^{1}/$_{4}$ in.) overall
COLLECTION OF THE ARTIST

Orpheus, Kassel, 1983
Gelatin-silver print
229 × 212 cm (90^1/$_8$ × 83^1/$_2$ in.)

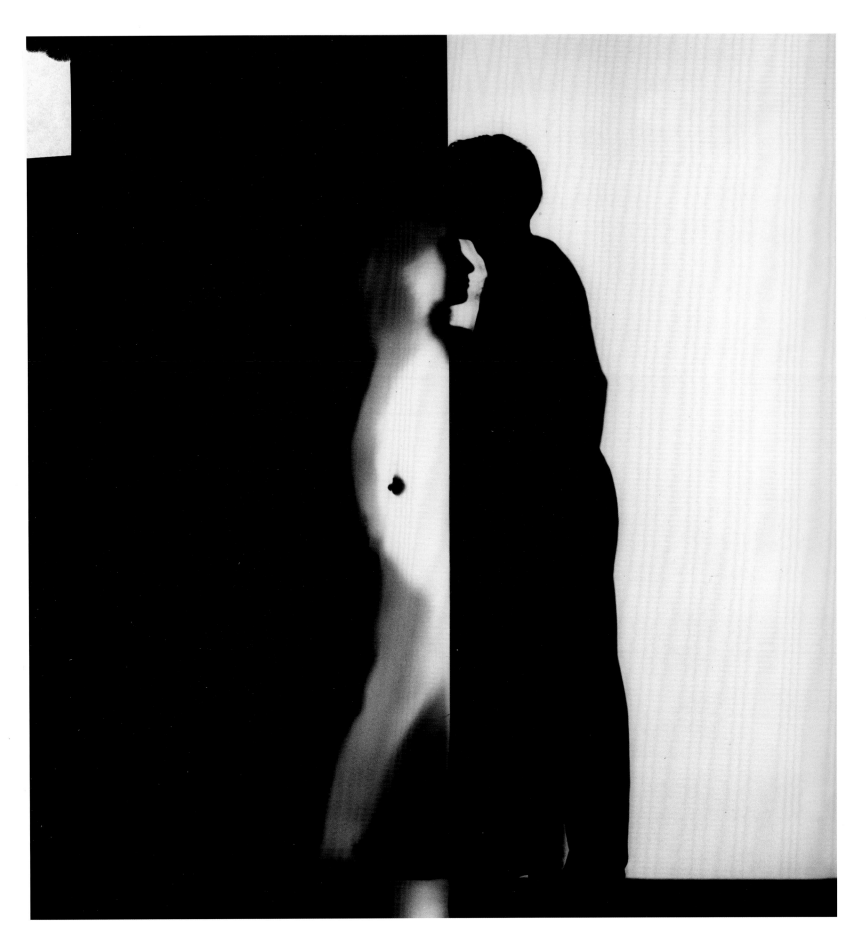

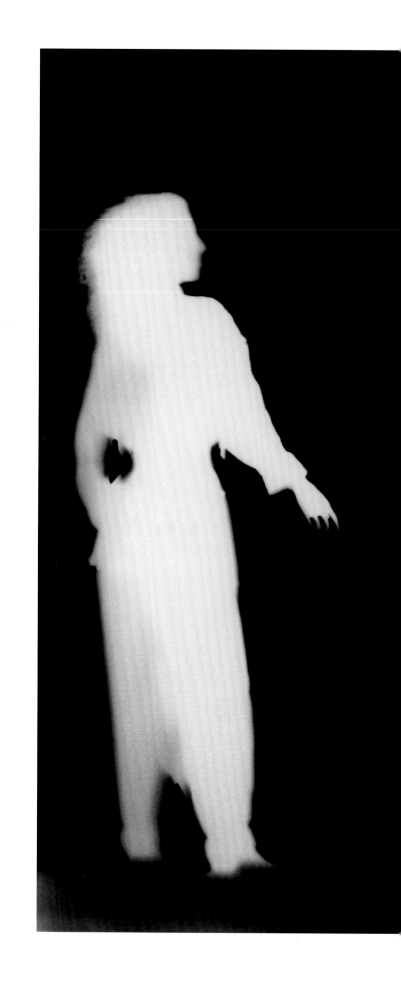

Orpheus, Kassel, 1983
Gelatin-silver print
223 × 318 cm (87 3/4 × 125 1/4 in.)
COLLECTION OF THE ARTIST

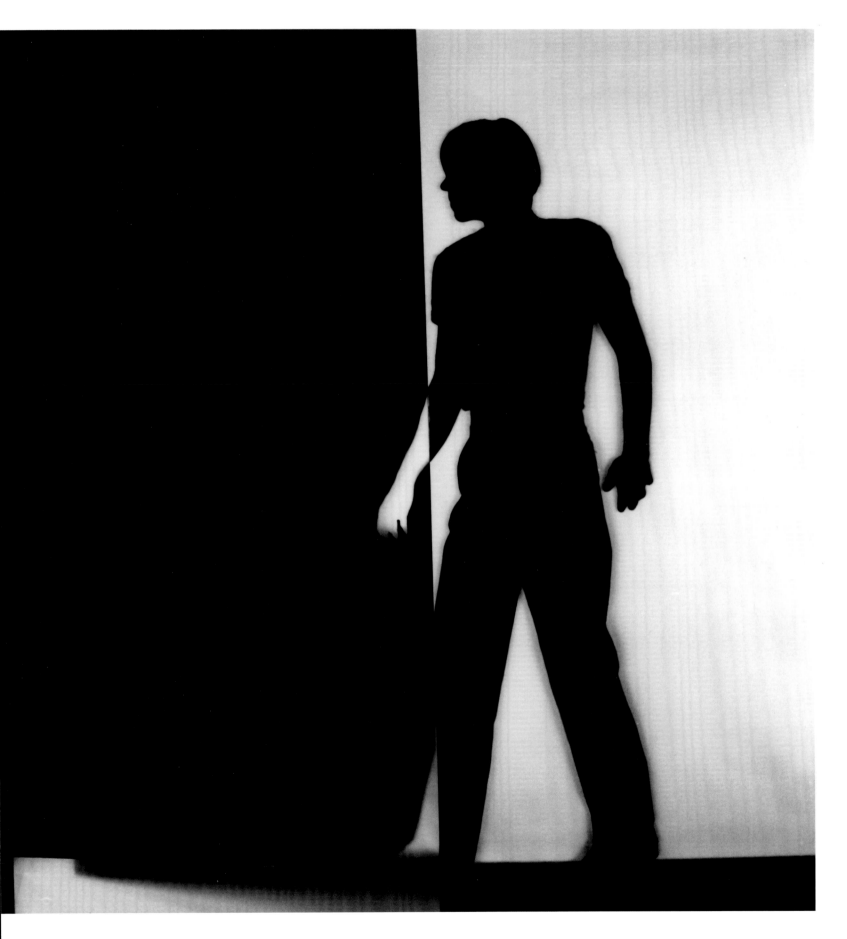

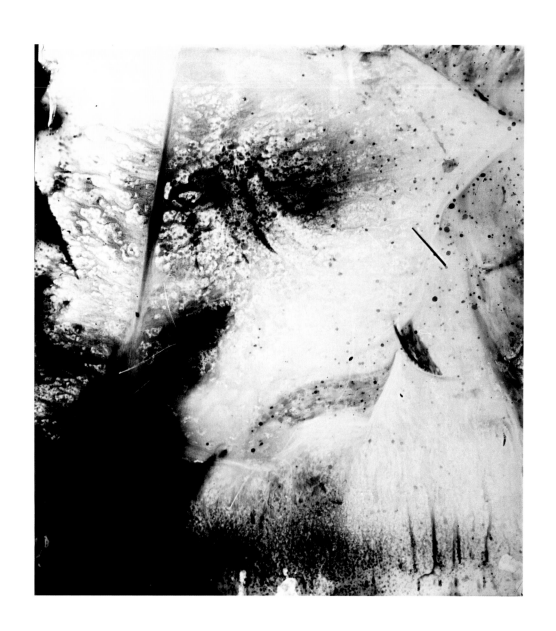

Gewitterbild, Kassel, 1984
Gelatin-silver print
57 × 53 cm (22¹/₂ × 20⁷/₈ in.)

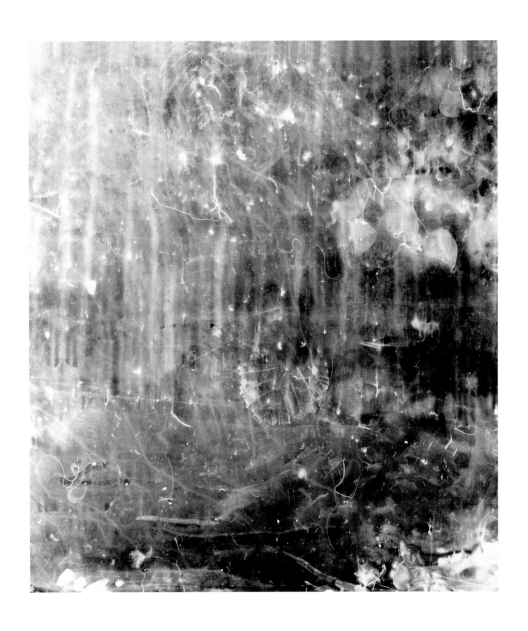

Gewitterbild, Kassel, 1984
Gelatin-silver print
69 × 68 cm (27 ⅛ × 26 ¾ in.)
COLLECTION OF THE ARTIST

Hebe 1796 (Skulptur von Antonio Canova 1757–1822)
Alte Nationalgalerie Berlin, made in collaboration with
Renate Heyne, 2004
Gelatin-silver print
201 × 105 cm (79^1/8 × 41^3/8 in.)
COLLECTION OF THE ARTIST

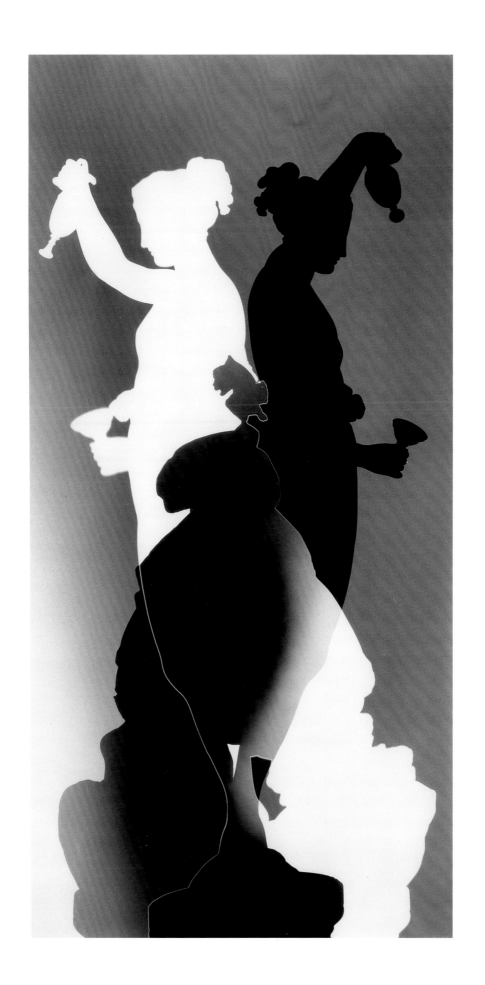

Bin Gleich Zurück (Be right back), made in
collaboration with Renate Heyne, 1984 and 1997
Gelatin-silver print and wooden chair
86 × 106.2 × 262.1 cm (33⁷/₈ × 41³/₄ × 103¹/₄ in.)
COLLECTION OF THE ARTIST

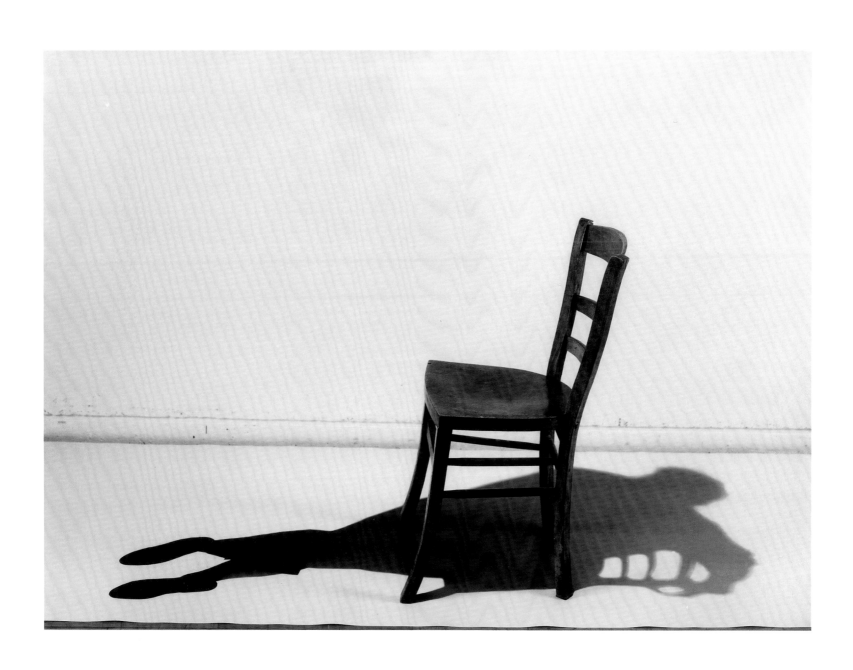

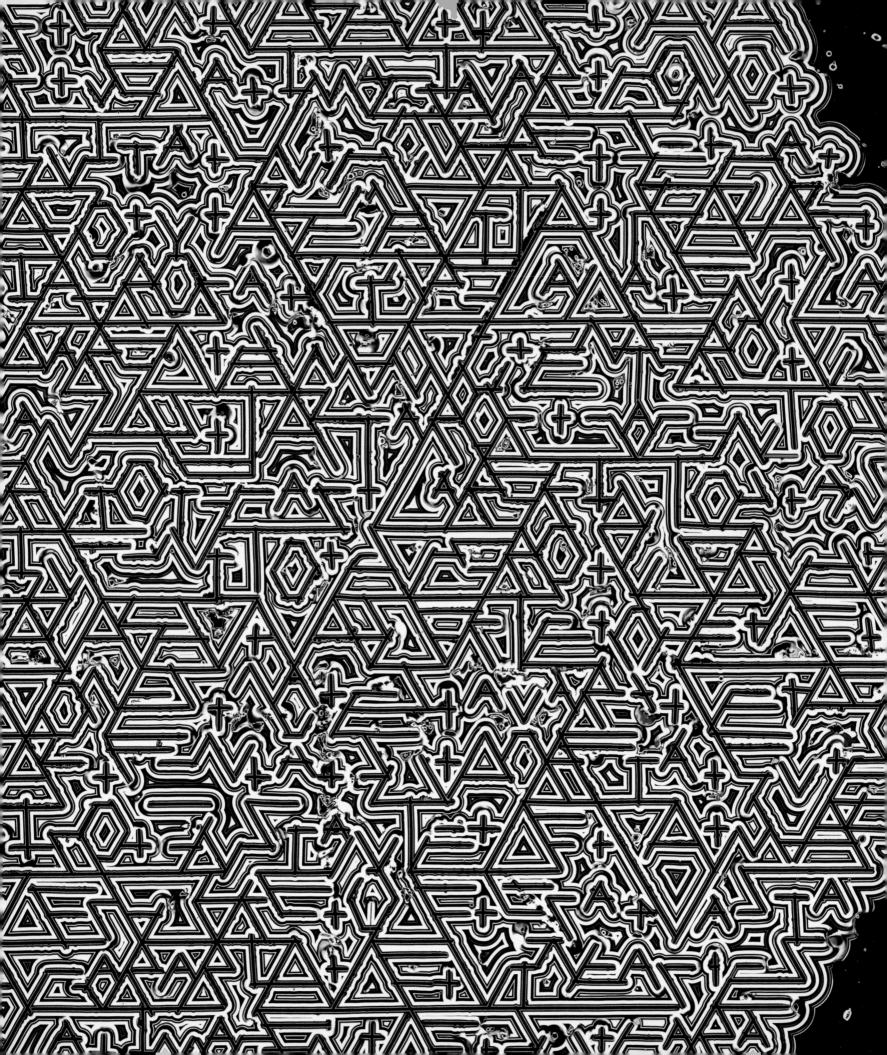

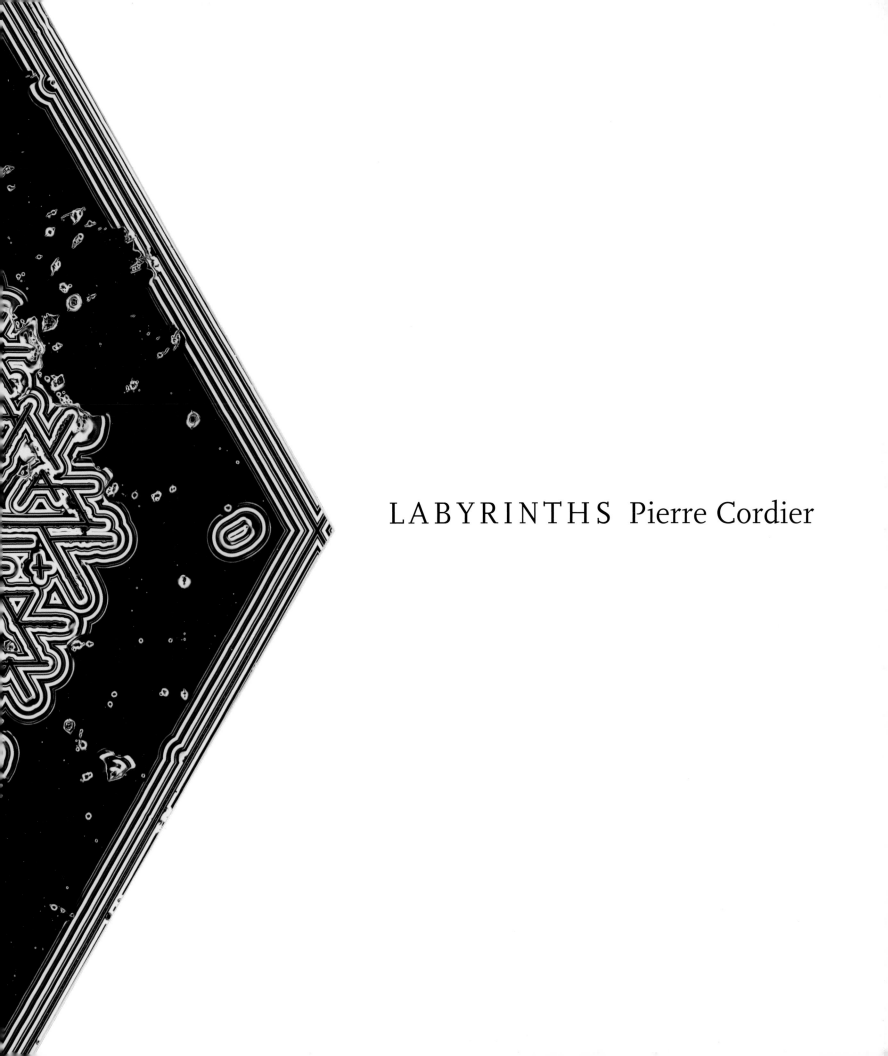

LABYRINTHS Pierre Cordier

PAGES 50–51
*Chemigram 20/3/92 'from La Suma of Jorge
Luis Borges'* (detail; see page 79)

Pierre Cordier discovered the chemigram – a physico-chemical form of camera-less photography that resists conventional classification – on 10 November 1956, and has pioneered its use, dissemination and artistic development ever since. A few others before him had obtained intriguing results using similar methods, and many of his contemporaries have utilized the medium to great effect.[1] However, Cordier has refined, championed and understood the technical variety, visual vocabulary and philosophical implications of the chemigram better than anyone. Working in many ways more like a painter or printmaker than a photographer, he replaces the canvas or printing plate with photographic paper. This process allows him to create entrancing images impossible to realize by any other means.

Although it allows the creation of gestured marks, the chemigram links photography and painting not by physical resemblance but by technique. This is charmingly exemplified by Cordier's allegorical tale *The Life and Times of Chemigram, or The Tale of Mr. Painting-Physics and Mrs. Photo-Chemistry's Illicit Love* (1987).[2] Chemigram is the son of Mr Painting-Physics (representing the camera and optics) and Mrs Photo-Chemistry (photographic emulsion, developer and fixer). At the end of the tale, technology – personified as Laser, Magnetic and Digital – free Mrs Photo-Chemistry from her reproductive tasks.

The chemigram is a camera-less medium, but it cannot be classed as a photograph or a photogram, for it does not rely solely on light to produce an image. Strictly speaking, cast shadows are not 'caught' in a chemigram; rather, the idea of the shadow is present in the form of the occlusion of an active force during the chemigram's making. Surprisingly, Cordier usually works in daylight, outside the darkroom. Chemigrams cannot even be described as 'prints' (unless compared with monotypes), because negatives or printing plates are not involved. As with the photogram, the result is unique.

It is the chemigram's resistance to technical and aesthetic classification that has resulted in the process being largely absent from the history of art and photography. While necessarily inhabiting the professional networks of photography, and having a deep understanding of photographic materials, Cordier nevertheless retains a distance: 'saying that I am a photographer because I make chemigrams on photo paper is like saying that Leonardo Da Vinci was a cabinet maker because he painted the Mona Lisa on wood'.[3] For some, the chemigram may be tainted by its relationship to the word 'chemistry', suggesting pollution, poison and things that are not natural but man-made. However, Cordier's works partake in a wider definition, in which the chemical elements of the periodic table are seen as the natural interconnected building blocks of all matter. In this way, he can be aligned with the 'chemical naturalism' of other contemporary artists, including Sigmar Polke and Anselm Kiefer. Cordier has described his works as a mutation, as hybrid and marginal – fake photographs of an imaginary, improbable and inaccessible world. His influences are extremely varied, ranging from such fine and applied arts and technology as modern painting (Paul Klee, Max Ernst and Saul Steinberg in particular), commercial silkscreen, historic photographs, African Kuba Shoowa textiles and computer art to such broader subjects as musical notation, written texts, poetry and philosophy.

It is the technique of the chemigram itself, however, that has forged Cordier's style. With over two thousand chemigrams to his name, he has built up a visual vocabulary with each successive controlled experiment. The unfamiliarity of chemigrams has continued to promote responses of unease mixed with wonder. Writing to Cordier in 1974, the photographer Brassaï (1899–1984) exclaimed: 'The result of your process is diabolical – and very beautiful. Whatever you do, don't divulge it!'[4] Yet it was not to shroud his process with intrigue that Cordier did not at first explain his technique; rather, he considered it to be simply self-evident to those who were willing to try the experiment for themselves and could think laterally about the usual rules of photography. In 1979, contrary to Brassaï's advice, Cordier organized his first demonstration workshop, at the annual photography festival in Arles, France. Revealing the technical methods of Cordier's chemigrams does not seem to undermine their mystery or visual appeal.

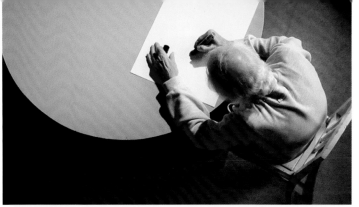

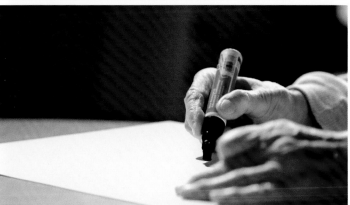

Cordier in his Brussels studio. His 'signature' style is the chemigram technique, which he pioneered in 1956.

There are numerous variations of the chemigram technique. The simplest involves the application of photographic developer and fixer to gelatin-silver photographic paper, using the chemicals like watercolours. Developer creates dark areas, while fixer produces lighter tones. Cordier used this method for *Chemigram 8/2/61 III* (1961; page 67), pouring rather than brushing the chemicals on to a lightly oiled sheet of photographic paper. The result is a collection of spectral, overlapping forms. Standing in contrast to these soft, organic shapes are the rigorous, rectilinear opposites of *Chemigram 26/2/70 I* and *Chemigram 1/3/70 III* (1970; pages 70–71), both subtitled *Minimal Photography 1970*. Here, Cordier selectively controlled the application of developer and fixer by attaching squares of adhesive plastic to the surface of the photographic paper.

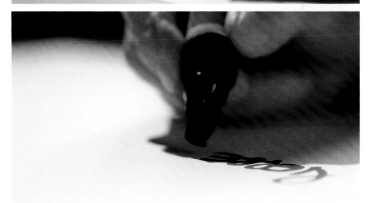

Additional changes to shape and pattern can be made by introducing what Cordier describes as 'localizing' products. These are readily available materials rather than specialized chemicals, and can include varnish, wax, glue, oil, egg and honey. Applied to the photographic emulsion, the localizing product protects its surface. Cordier makes incisions or lines in this 'localizing' surface layer, or creates on it a drawing, graphic motif or perhaps a written text. Repeatedly dipping the paper in photographic developer and fixer creates chemical and physical reactions around the lines that resemble peeling or erosion. The number of times a sheet of paper is subjected to this treatment gives different results. For example, dipping a sheet of paper in developer and then fixer once produces one dark and one light line on either side of an incision. As the frequency of dipping is increased, the surrounding lines expand, sometimes colliding into one another to create an interference pattern, new motifs dictated by a mixture of calculation and chance. The number of lines either side of the originating mark can be counted like the rings of a tree stump, and the frequency of dipping in chemicals deduced. The results are sometimes in a mosaic-like pattern, angular and rectilinear, or can take on more fluid and organic characteristics. The holes or imperfections in the irregular covering of a particular kind of varnish produce pleasing aberrations. Surprisingly, except for the marks made by the cutting

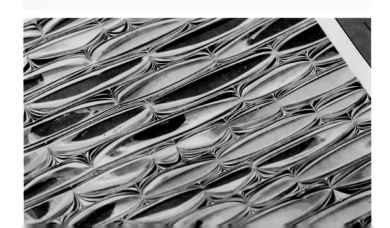

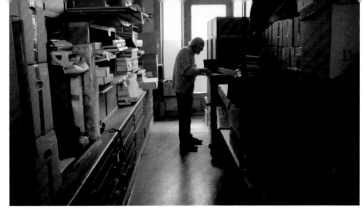

Cordier keeps extensive records of his paper tests. To create the unique forms of his chemigrams, he sometimes applies to the photographic paper a layer of such everyday materials as varnish or syrup.

instrument, the surface of the photographic paper shows little or no damage: the varnish acts as a protecting layer within which the chemical markings or physical erosions take place.

Tints are generally the result of chemical reactions with standard black-and-white photographic emulsions rather than with colour photographic paper. The pale lilacs, mauves and pinks, the dark purples, and the russet or golden browns seen in Cordier's works recall those of the earliest nineteenth-century photographs, made at a time when the chemistry was often untried and inconsistently mixed by hand. The traces of such chemicals as fixer, not washed thoroughly from the paper, give a characteristic pink-brown cast. Exposure to light produces photolysis, in which photographic paper turns blue, mauve, brown, reddish or ochre depending on the emulsion. Cordier's extensive notebooks, and his folders full of paper tests compiled over fifty years, show his painstaking examination of these and other phenomena and the nuanced and appealing hues they produce. Such phenomena are used by the artist to great creative effect.

While Cordier's chemigrams can be enjoyed without any technical knowledge, their appearance quickly prompts questions in most viewers about how they are made. Their details seem too minuscule to have been rendered by hand, and yet organic enough not to have been produced by computer. We search for the signature style of the artist. Explanation and comprehension of technical processes are necessary in Cordier's case because the deeper understanding of authorship and style that we crave may be found in his technique. The technical process itself becomes the artwork. Moreover, Cordier systematically follows every path that his technique allows. He is like a boy kicking a stone, following its trajectory with enjoyment and curiosity, examining where it lands and taking account of its position to enable the next kick. In this way, over many years, he has charted the random patterns and variations of deliberately authored marks produced in the chemigram.

There is something childlike and playful about Cordier's approach to his work. He has a love of visual puzzles and wordplay, as evidenced by the labyrinthine motifs of his chemigrams and the

subtitles he gives them, such as *Zigzagramme* (1982) and *Big Bangram* (1961; page 62). Such titles poke fun at technical classification and pun on the stamp of authorship of process asserted by, for example, Christian Schad's 'Schadography' or Man Ray's 'Rayographs'. While a gentle humour is never far from the surface, Cordier's playfulness is backed up by serious sustained enquiry carried out in the manner of experimental scientific research. Although he is not a scientist, scientific debate informs his work, such as the discourse around nanostructures, objects that exist on the molecular scale. As Cordier has written, 'To explore a chemigram, you often need eagle eyes, a magnifying glass or a microscope. Sometimes, a seemingly insignificant detail reveals a whole world. Like the messages hidden by spies in the dot of an i.'[5] Inspected closely, new worlds are revealed in the tiniest detail. The drips, cracks and geometrical forms yield labyrinths within labyrinths.

Cordier's experimental practice can be linked to his involvement with Otto Steinert and the *Subjektive Fotografie* series of exhibitions staged in Saarbrücken, Germany. Cordier exhibited his work in the last of these exhibitions, held in 1958. He later went on to become a founding member of the Generative Fotografie group, formed in 1968, which explored photography from the point of view of its essential elements: paper, emulsion, chemistry, time and light.[6] After the removal of the camera, and a subject to be photographed, light itself was released from its form-defining role. No longer being directed, as it is in a photogram, light was used only to affect the chemicals applied to the photographic emulsion. By resorting to the basic properties of the medium, the artist was enabled to reinvent it for new uses. Before the digital age, the chemigram was the final reduction, or refinement, of this systematic approach.

The experimental side of photography was recognized by curator John Szarkowski in his exhibition of 1967 at the Museum of Modern Art, New York, titled *A European Experiment*, which featured the work of Cordier, Denis Brihat and Jean-Pierre Sudre. Such experimentation became fused with, and to a large degree subsumed by, the conceptualism of much fine-art practice of the late 1960s, and indeed has continued to remain obscured by the mainstream until recently. Alongside lecturing from 1965 until 1998 at the École Nationale Supérieure des Arts Visuels de la Cambre, Brussels, Cordier has continued to make and exhibit his work internationally, although it has rarely been shown or collected in Britain. Perhaps this is because the chemigram remains difficult to locate culturally, part of a Continental experiment that seems too distanced from the social issues and documentary practice that have been the mainstay of photography in Britain until recent years. While Cordier's works can be seen as experimental realizations of Generative Fotografie principles, they are also aesthetic objects that carry his own visual vocabulary, invested with layers of culturally diverse references and philosophical meaning.

Among Cordier's earliest works, *Chemigram + Photogram* (c. 1958; page 61) combines the two forms of experimental photography. Fittingly, its cosmic yet small-scale appearance signals a new beginning, like a nucleus of energy before the Big Bang. Similarly primeval origins are expressed in *Chemigram 7/5/82 II 'Pauli Kleei ad Marginem'* (1982; page 75). The work takes the form of a memory of Paul Klee's painting *Ad Marginem* (1930; appropriately, a 'varnished' watercolour), in which prehistoric-looking creatures and foliage surround a solar motif. Cordier recasts Klee's painting diagrammatically, transforming the solar disc into a triangle, and retaining the placement of forms in the original composition but as if in an alien code. The idea of obscuring information that might lie beneath is suggested by the apparently scratched, multiple horizontal lines of *Chemigram 24/8/61 III* (1961, page 65), which resembles the visual white noise of pre-digital television between channels. *Chemigram 25/1/66 V* (1966; page 69) similarly draws attention to its surface. The image recalls shattered glass, either implying an attempt to break through to a world beyond the barrier of the window, or reminding us that, in reality, the surface is all there is to see. Cordier's *Chemigram 22/6/87 'Dedalogram V'* (1987; page 77) is based on the pattern of the labyrinth at the Abbey of St Bertin, in St Omer, France.[7] It also references Daedalus, of Greek mythology, who constructed the labyrinth on the island of Crete in which the Minotaur was kept.

Ideas of the labyrinth, but this time in the form or words, arise again in Cordier's *Chemigram 20/3/92 'from La Suma of Jorge Luis Borges'* (1992; page 79). Borges (1899–1986) – writer, poet and philosopher – was a master of exploring ideas of time and infinity, weaving together fact and fiction and blurring the notion of truth. His story 'The Library of Babel' (1941) concerns an expanse of interlocking rooms, each of which contains necessities for human survival and walls of books, some of which contain nonsense and others coherence, amounting to all the books in the universe. Cordier has made several pieces inspired by this and other works by Borges, including the hexagonal chemigram composed of letter forms that spell out Borges's poem 'La Suma'. The letters, however, are almost impossible to decipher, their shapes joining together as paths forking in different directions.

Another of Cordier's works inspired by literature is *Chemigram 31/7/01 'Hommage à Georges Perec'* (2001; page 80). Perec (1936–1982) was a French writer and filmmaker famous for experimental wordplay. His major work, *La Vie mode d'emploi* (Life: a user's manual, 1978), tells the story of a Paris apartment building and its inhabitants. Seen in elevation, the building's rooms form a 10 × 10 grid, and it is this grid that serves as the underlying structure of the narrative. Each apartment is dealt with according to the moves made in the 'Knight's Tour', a chess-based mathematical problem in which the knight must attempt to visit each square of the chessboard exactly once. While a normal chessboard has a grid of 8 × 8 squares, a 10 × 10 grid complicates the problem yet further. Perec's works, constructed within certain self-imposed writing constraints, find their counterpart in Cordier's chemigrams, in which random numbers create programmed chance, limiting subjective decisions.

Varying degrees of chance and control are part of the very nature of the chemigram process, which finds meaning in its moments of sudden crystallization, like a jazz improvisation, relying on repeats, motifs and intervals, and moving between dissonance and harmony. The beauty of the chemigram lies in its exploration of possibilities, probed by Cordier using photo-chemistry in the same manner as the writers he admires use

language. This results in a poetic experiment in which the major twentieth-century art movements of Constructivism and Surrealism meet. In terms of classification, the chemigram as a means of artistic expression hovers at the intersection of photography, painting and writing. Although the works may have the appearance of abstraction, they are not in any way abstracted from reality. Rather, they are a new physical reality, an original creation in themselves. Cordier embraces the liminal nature of his discovery:

> The question is not so much whether the chemigram is photography or painting, figurative or not, scientific or artistic, virtual or not, contemporary or obsolete, in or out … It is simply a visual 'something' that cannot be made any other way.[8]

NOTES

1 Those making documented use of the process before Cordier include, in 1929, Roger Parry (1905–1977); in 1935, Maurice Tabard (1897–1984); and, also in 1935, Miroslav Hák (1911–1978).

2 Reproduced in Pierre Cordier, *Le Chimigramme/The Chemigram*, Brussels (Éditions Racine) 2007, p. 253. The tale is dedicated to Hippolyte Bayard (1801–1887), inventor in 1839 of a photographic technique using paper negatives that has been largely overlooked in the later histories of photography.

3 Pierre Cordier, personal note, 15 April 1994, quoted in *ibid.*, p. 42.

4 Brassaï, letter to Pierre Cordier, 3 July 1974, quoted in *ibid.*, p. 47.

5 Pierre Cordier, personal note, 29 October 1987, quoted in *ibid.*, p. 46.

6 The Generative Fotografie movement was founded by Cordier, Gottfried Jäger, Kilian Breier and Hein Gravenhorst.

7 The abbey's original, fourteenth-century labyrinth no longer exists. However, a mid-nineteenth-century, half-size replica may be found in St Omer Cathedral, France.

8 Pierre Cordier, personal note, 19 January 2007, quoted in Cordier, *Le Chimigramme/The Chemigram*, p. 48.

Chemigram 29/11/57 I, 1957
Chemigram
23.8 × 17.7 cm (9⅜ × 7 in.)

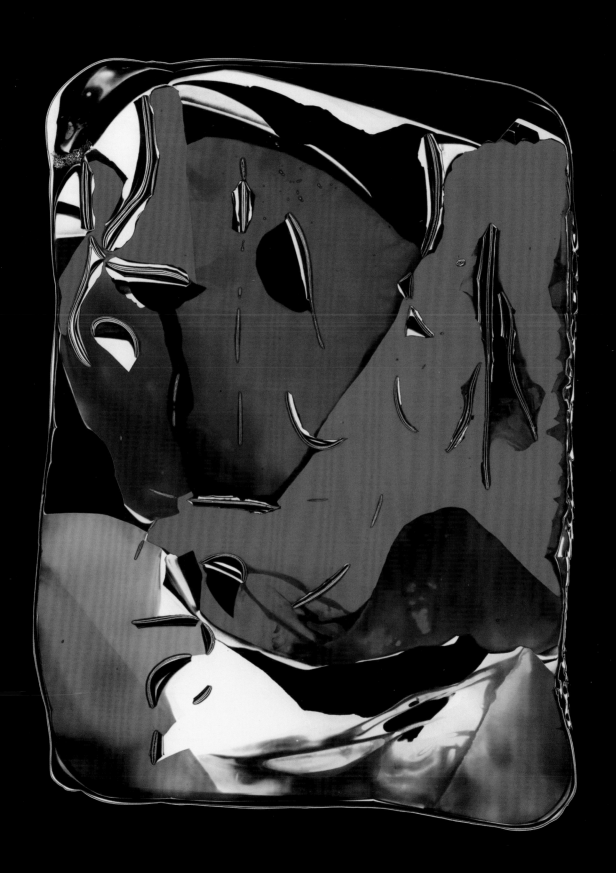

Chemigram + Photogram, c. 1958
Chemigram
13.2 × 13.2 cm ($5^1/4$ × $5^1/4$ in.)
VICTORIA AND ALBERT MUSEUM, LONDON

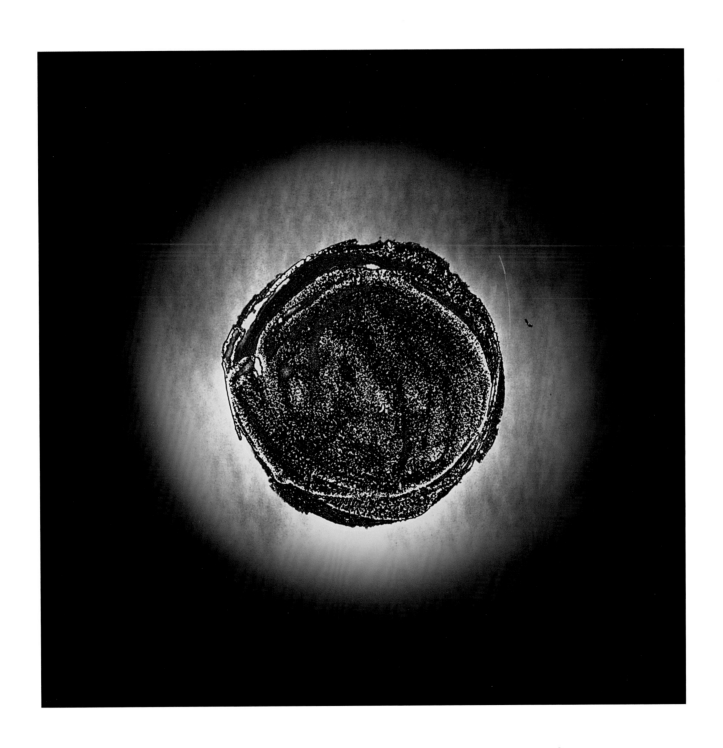

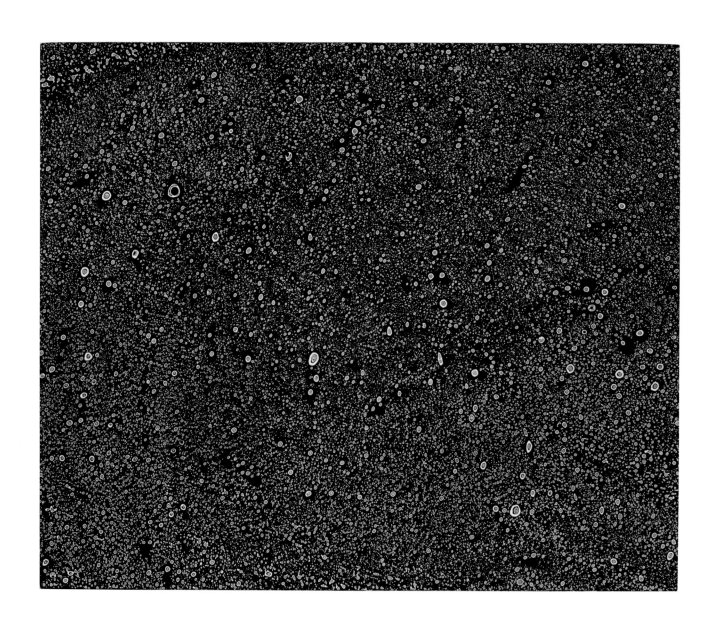

ABOVE (DETAIL SHOWN OPPOSITE)
Chemigram 24/8/61 III 'Big Bangram', 1961
Chemigram
24.1 × 29.1 cm (9$\frac{1}{2}$ × 11$\frac{1}{2}$ in.)
VICTORIA AND ALBERT MUSEUM, LONDON

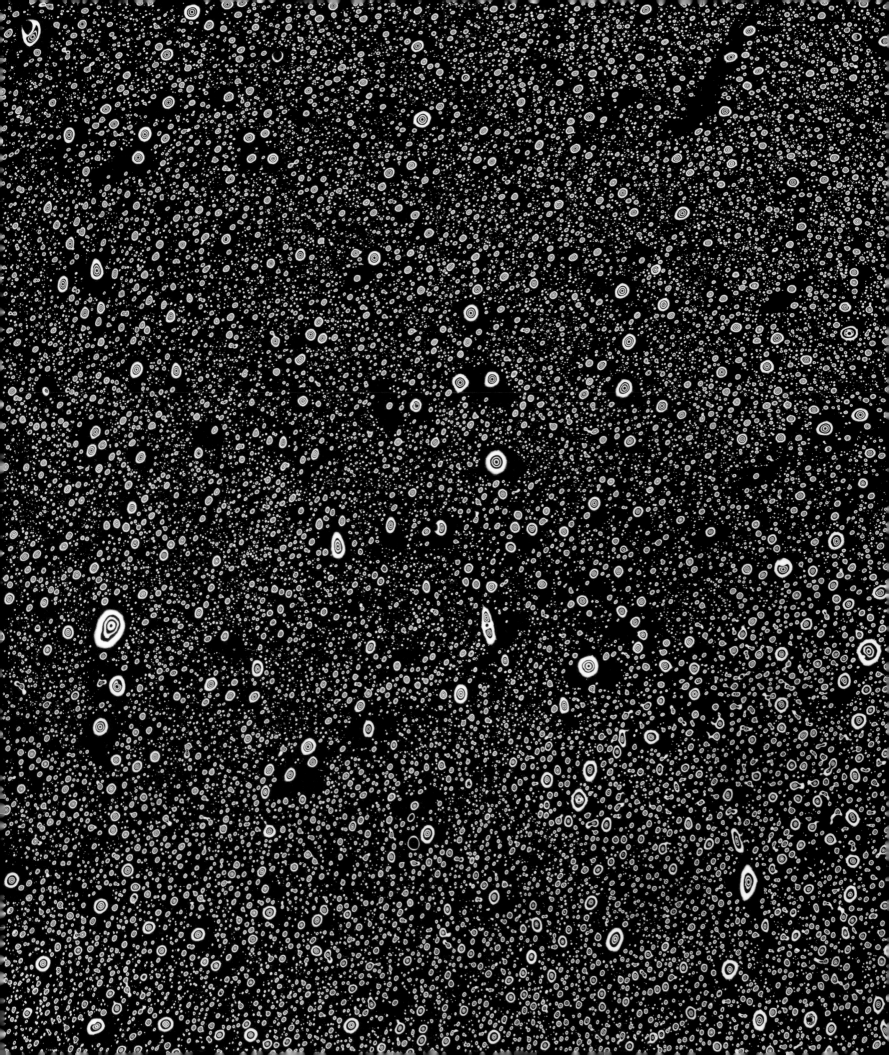

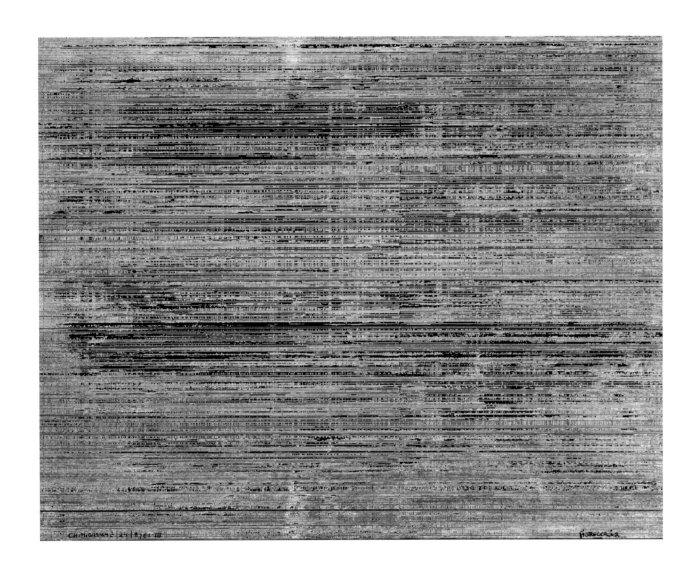

ABOVE (DETAIL SHOWN OPPOSITE)
Chemigram 24/8/61 III, 1961
Chemigram
28 × 36 × 2 cm (11 × 14$^{1}/_{8}$ × $^{3}/_{4}$ in.)
CENTRE POMPIDOU, PARIS

Pierre Cordier 65

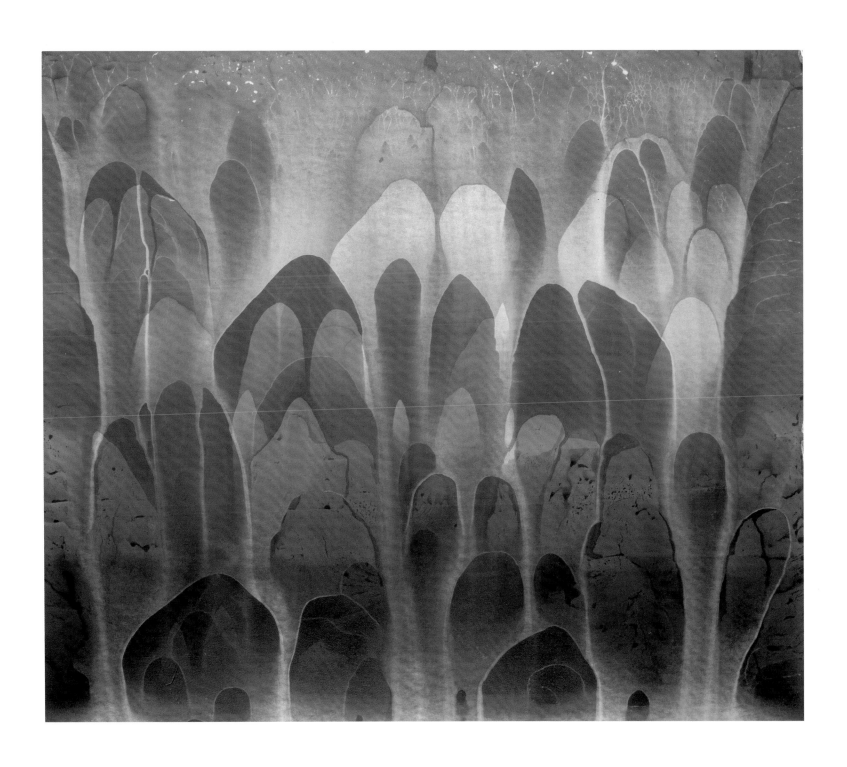

Chemigram 25/1/66 V, 1966
Chemigram
70.9 × 55.9 cm (27⁷/₈ × 22 in.)

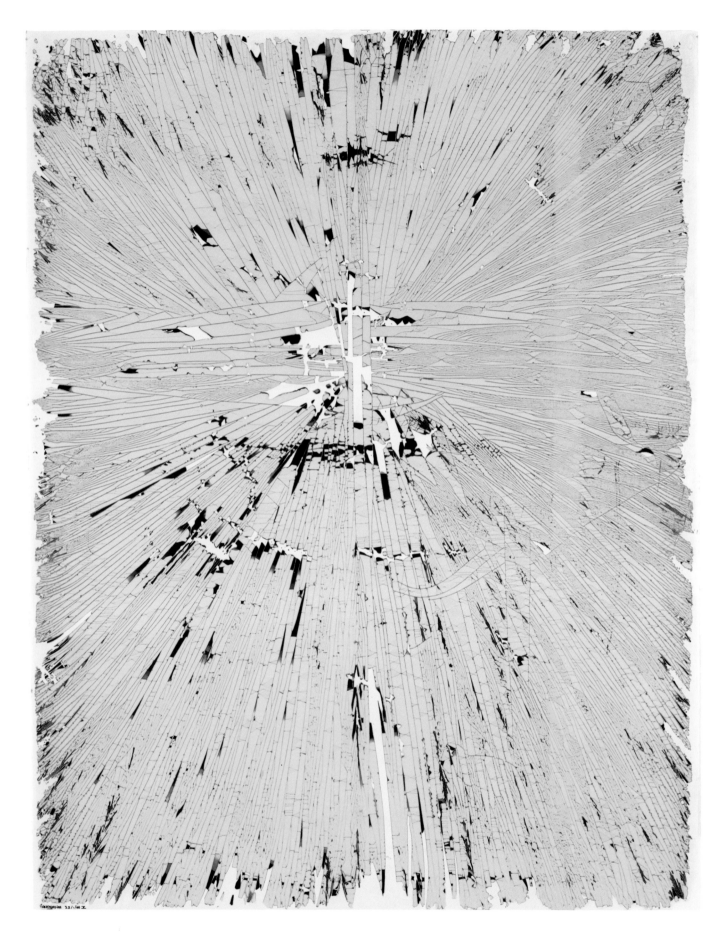

Chemigram 26/2/70 I 'Minimal Photography 1970', 1970
Chemigram
51.2 × 50.3 cm (20^{1}/$_{8}$ × 19^{3}/$_{4}$ in.)
COLLECTION OF THE ARTIST

70 LABYRINTHS

Chemigram 1/3/70 III 'Minimal Photography 1970', 1970
Chemigram
51.3 × 51.3 cm (20¹/₄ × 20¹/₄ in.)
COLLECTION OF THE ARTIST

Chemigram 30/12/81 I, 1981
Chemigram
50 × 50 cm (19⅝ × 19⅝ in.) framed

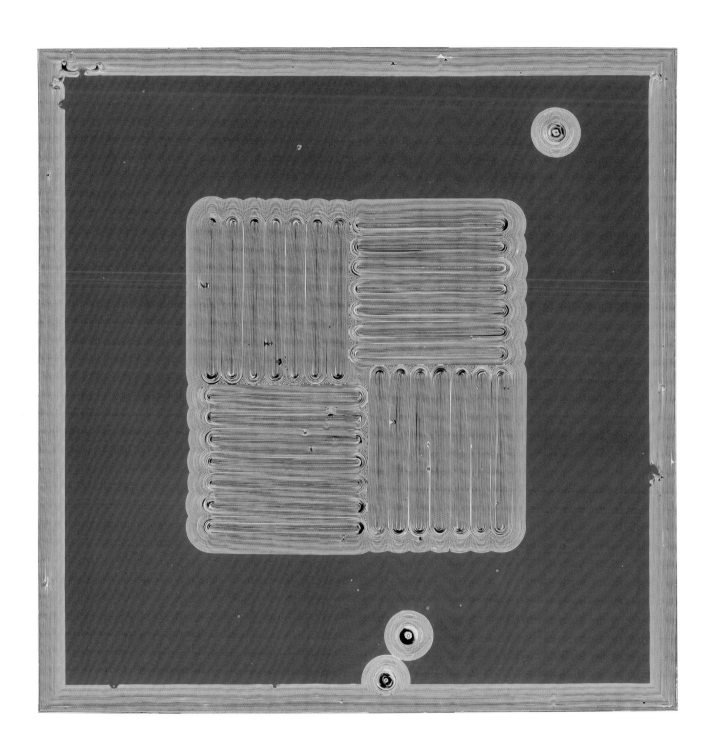

Chemigram 7/5/82 II 'Pauli Kleei ad Marginem', 1982
Chemigram
56 × 45 cm (22 × 17 ³/₄ in.)

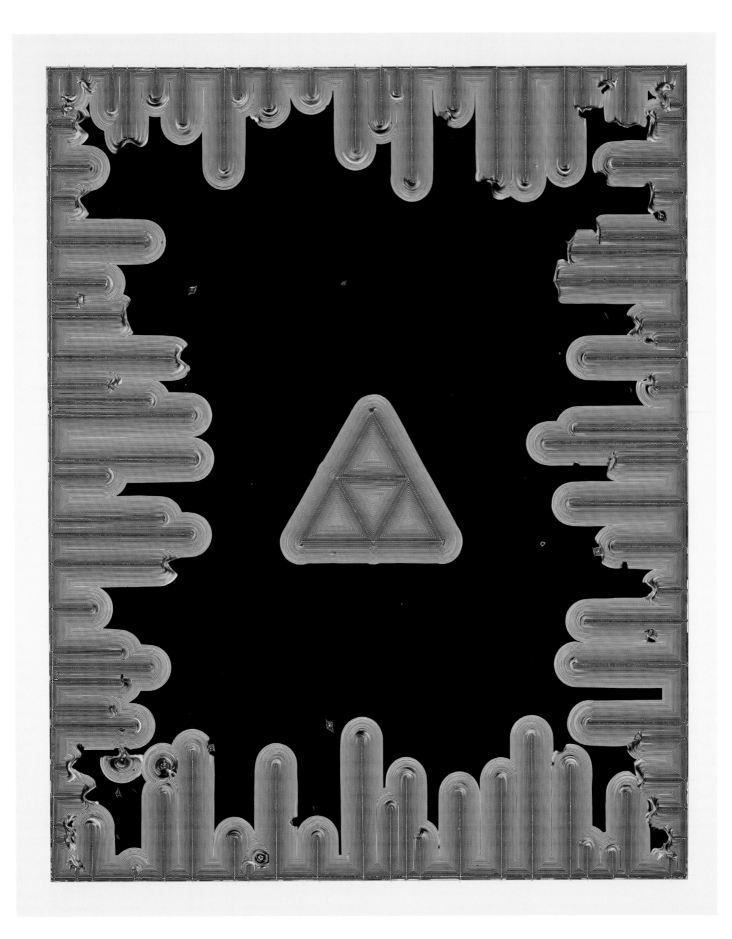

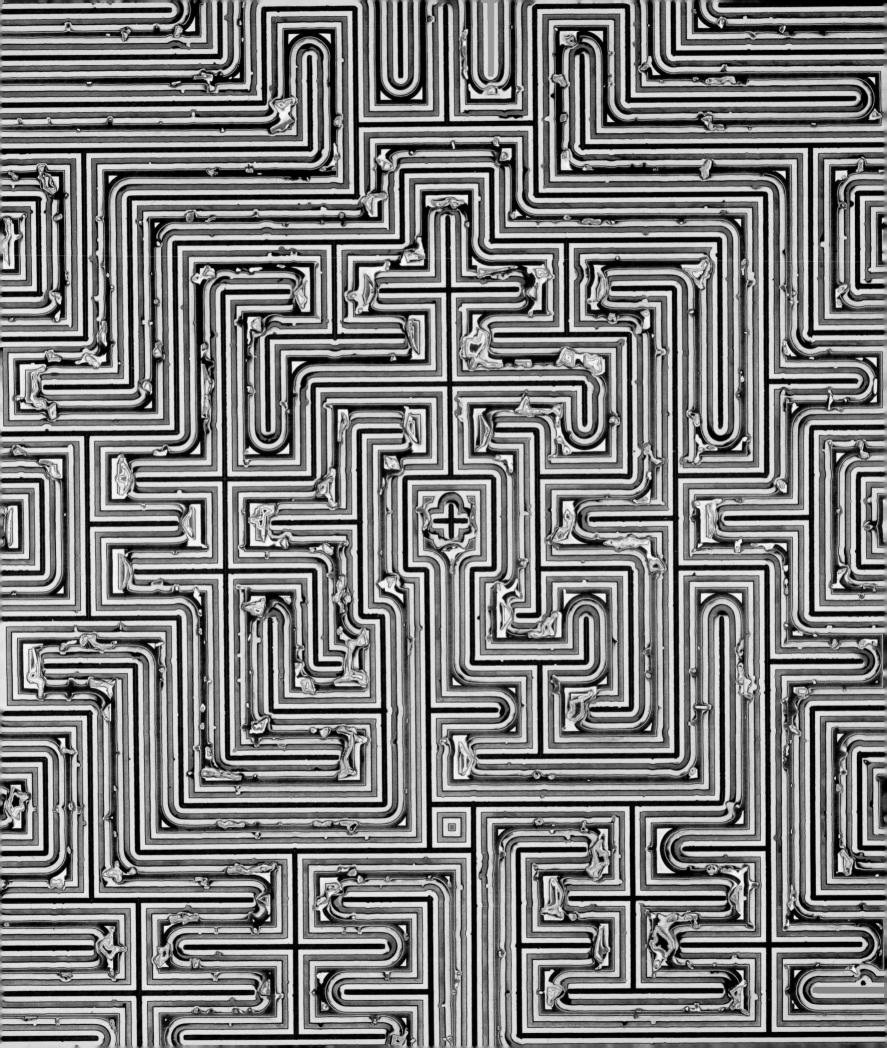

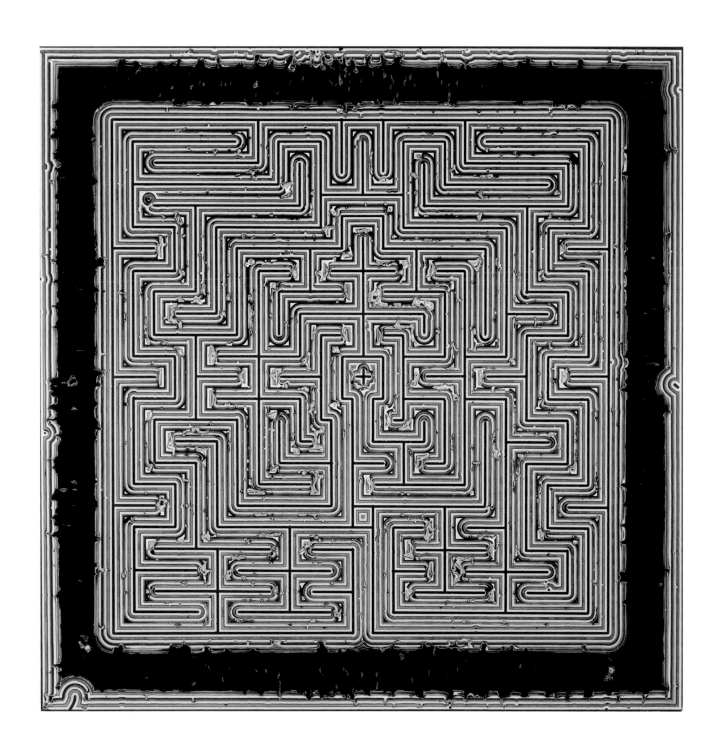

ABOVE (DETAIL SHOWN OPPOSITE)
Chemigram 22/6/87 'Dedalogram V', 1987
Chemigram
98.5 × 98.5 cm (38³/₄ × 38³/₄ in.)
PRIVATE COLLECTION, BELGIUM

Chemigram 20/3/92 'from La Suma of
Jorge Luis Borges', 1992
Chemigram
53 × 61 cm (20^7/$_8$ × 24 in.) framed

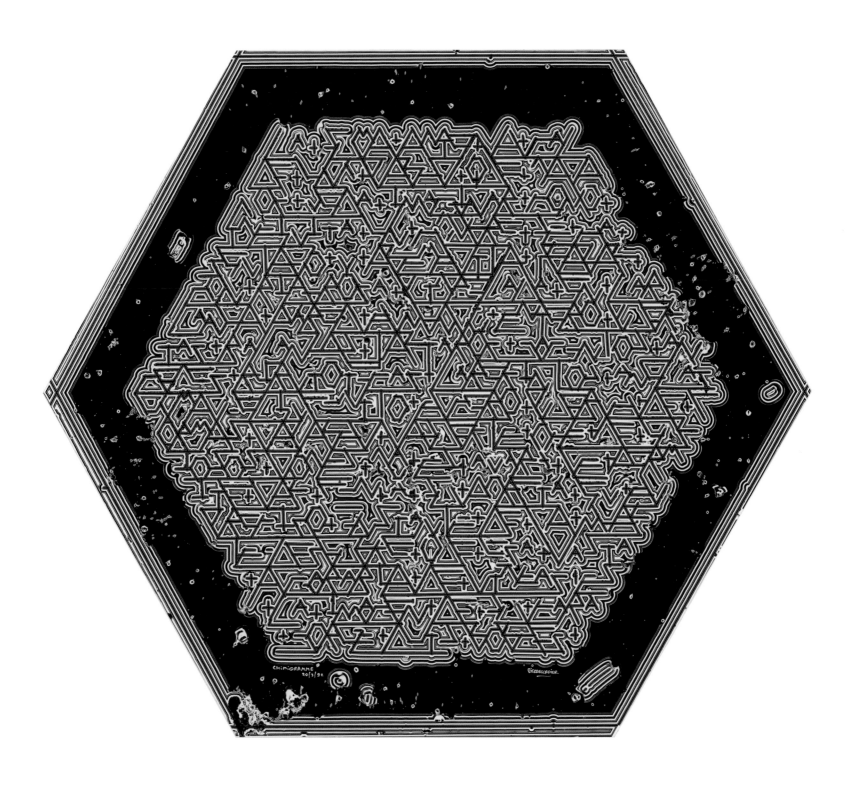

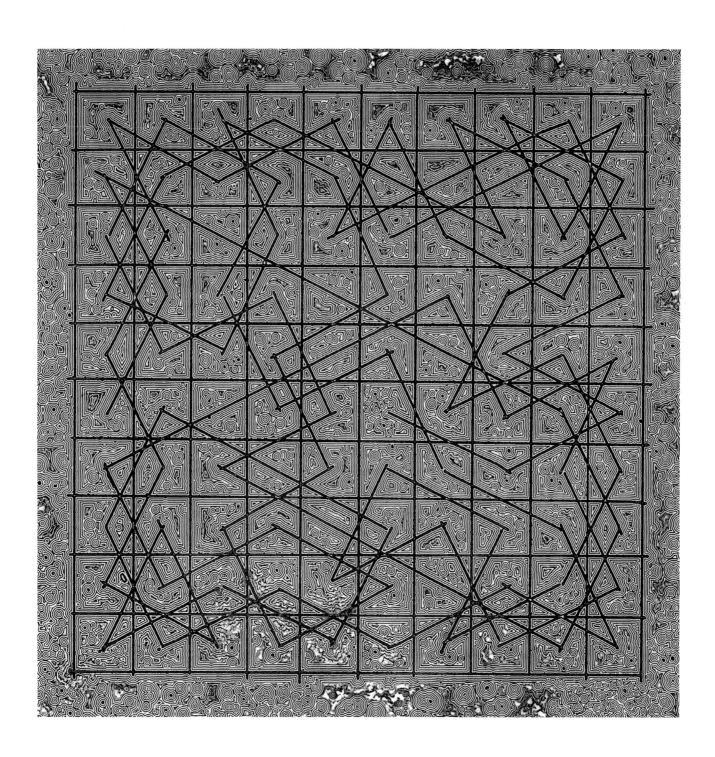

ABOVE (DETAIL SHOWN OPPOSITE)
Chemigram 31/7/01 'Hommage à Georges Perec', 2001
Chemigram
15.1 × 14.9 cm (6 × 5⁷⁄₈ in.)
VICTORIA AND ALBERT MUSEUM, LONDON

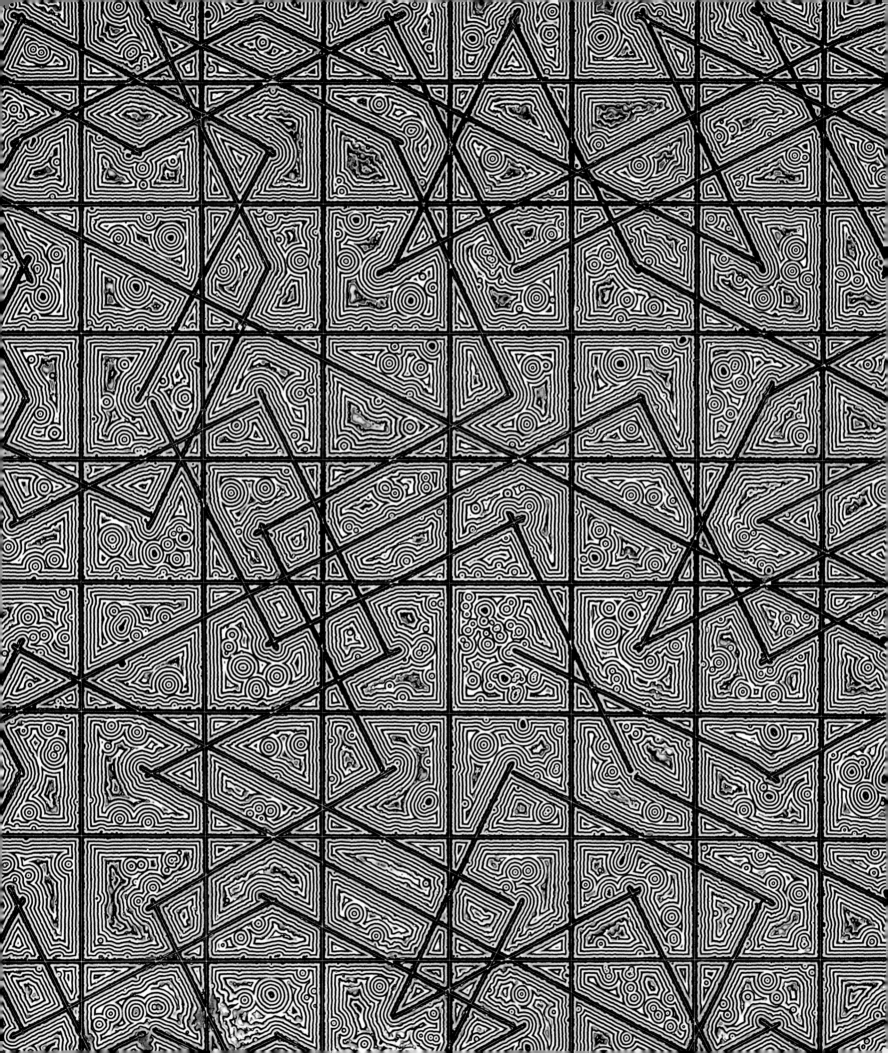

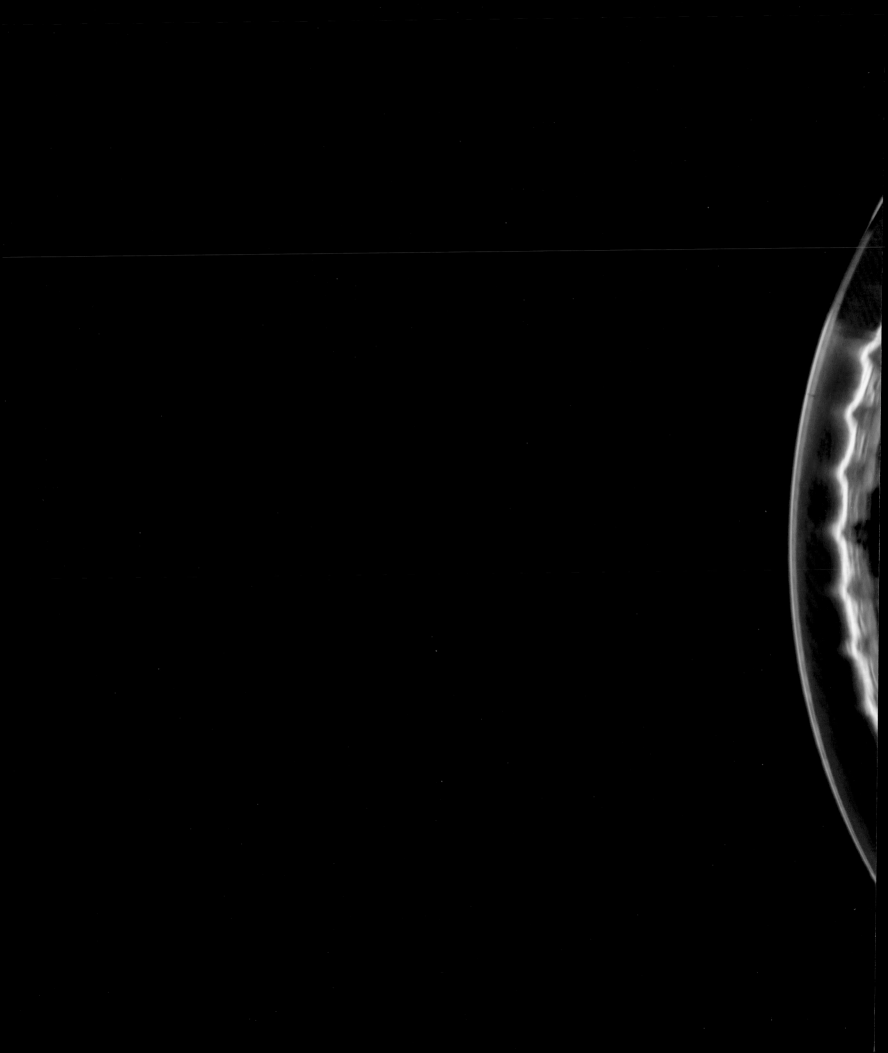

ELEMENTS Susan Derges

Susan Derges is best known for her entrancing images of water, a constant theme and metaphor in her work. She seeks to capture its ever-changing complexity, making direct translations of its turbulent and tranquil patterns by submerging the photographic paper in its depths at night and using a split second of flashlight to freeze its motion. As viewers looking at Derges's large-scale images, we cannot help but be immersed in their beauty. They capture patterns and forms that we recognize, yet they seem caught between describing this world and evoking a place that is otherworldly. Her images reflect a holistic system that encompasses the human psyche and finds its metaphors in the natural world.

Given its Romantic associations, it is perhaps at first surprising to learn that Derges's work was initially influenced by her training as a painter at the Chelsea School of Art in London (1973–76) under British Constructivists Anthony Hill (born 1930) and Gillian Wise (born 1936). Hill and Wise emphasized systems theory, the use of modern materials, a reduction to basic units and the use of colour only if integral to the objects being used. In addition, they were interested in the geometrics of light in industrial, especially transparent, materials. Derges absorbed these teachings, finding inspiration in the ideas of controlled experiment and exploring notions of hidden order contained in motion and sound. After moving on to study at the Slade School of Fine Art in London (1977–79) – and as the British Constructivists split – Derges found her own path, combining studies of sound, science and, increasingly, Oriental philosophy. In 1981 she moved to Japan as a research student, and continued to live and work there until her return to London in 1986. In Japan, Derges admired the tradition of representing nature as culture, for example, in Zen landscape architecture. She also found inspiration in Japanese aesthetics and a way of life that valued economy of means, lightness of touch and the clarity of communicating minimally.

Combining elements of Constructivist teaching and Japanese minimalism, camera-less photography provided Derges with a more direct connection to the intangible subjects she was seeking. During her stay in Japan, Derges completed her first major works, inspired by the research of German physicist Ernst Chladni (1756–1827) into the visualization of sound waves. In 1787 Chladni found that if he scattered fine sand on to a square metal plate and made it vibrate by drawing a violin bow across its edge, the sand shifted into geometrical patterns. He also found that further patterns could be created by touching the side of the plate at harmonic divisions of its length.[1] The phenomenon occurs because the sand is forced away from the centres of the plate's resonating activity, with a large portion of it accumulating at lines of stillness, where it settles to produce the pattern. These patterns are the shapes of invisible sound waves made visible. Chladni's 'Acoustic Figures' were recreated by Derges using modern methods. Electrically generated pure sine waves of varying frequencies were applied to an aluminium plate covered with photographic paper. The resultant patterns on the paper were formed by a fine coating of carborundum powder, a mineral often used in traditional printmaking. By carrying out the operation in the dark, flashing the paper with light and then brushing away the powder, the experiment was transformed into a photogram. Derges created eight unique *Chladni Figures* (1983; pages 90–93), which run in a linear sequence to highlight the changes of form in the same materials while implying the octave of a musical scale.[2] Subsequently, she developed her examination of vibration patterns by using liquids, employing mercury in the video piece *Hermetica* (1989), and water droplets in the camera-made series *The Observer and the Observed* (1991). As in these instances, Derges has occasionally used other media to create her work. However, she continues to return to camera-less photography as her mainstay.

Throughout 1992 Derges made a cycle of photogram works – *Full Circle*, *Spawn* and *Streamlines* – that traced the transformation of frogspawn (laid in cloud-like clusters) and toadspawn (laid in chains) into tadpoles, frogs and toads. The swarming clusters of creatures created dense natural patterns, their movements sometimes traced as ripples in the water. These pieces culminated in the series *Vessel No. 3* (1995; page 95), in which Derges used a toadspawn-filled jam jar as a kind of three-dimensional transparency. In the darkroom, she placed the jar above an enlarging lens and

Seen here working in her studio, Derges uses a tank of water and gathered foliage to create an image.

used flashlight to make the exposure on the paper below. The circular base of the jar creates the impression of looking into a microscope. Where the first image in the series shows dotted loops of well-ordered spawn, the final image shows the empty jar from which we presume the last toad has just hopped to freedom, ready to lay its own spawn elsewhere. With economy and gentle humour, this series of circles suggests the profound cycle of life.

Numerous commentators have drawn attention to the visual language and techniques of scientific investigation that Derges uses in her art.3 Meanwhile, a number of recent books and exhibitions appreciating the aesthetics of historic scientific photography have attracted considerable attention.4 While Derges's work has gained from these contexts, drawing some of its power from its association with science, it has retained a strong aesthetic stance, balancing systems of enquiry with a formal concern for beauty. While the *Chladni* and *Vessel* works were created in a laboratory-studio environment, the *River Taw* pieces from the late 1990s (pages 97–101) are the result of work carried out in the field. The three photograms shown here form part of a much larger series of images. Cumulatively, they create both a kind of extended portrait of a particular named entity (the River Taw) and an artistic morphology of water as a universally recognized force. Derges's increased interest in the natural world can be linked to her move in 1992 from the city to the rugged countryside of Dartmoor in the south-west of England. Characterized by dramatic moorland, this area – with its ancient history, unique flora and fauna, and geology exposed to the elements – remains a rich source of inspiration for the artist. The River Taw rises close to the village in which Derges's studio is situated, and flows to the Bristol Channel. Studying the river in all weathers and throughout the year, Derges gained an intimate knowledge of its ebb and flow, the areas where its waters are turbulent or calm, and where to find mesmerizing ornamentation in its current.

There is a poetic paradox in Derges's images of water, for they are the embodiment of a deep desire to fix ever-changing, constantly renewing forms. In *River Taw (ice), 4 February 1997* (1997; page 101), Derges shows the river literally frozen in time;

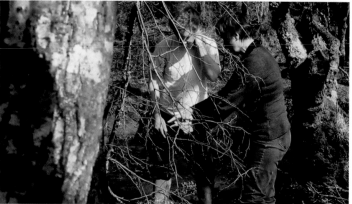

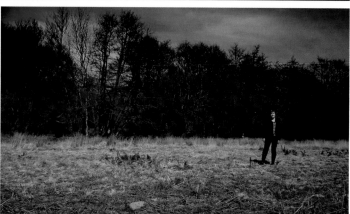

Derges has produced many of her works outdoors. Her River Taw *photograms, for example, were created by submerging the photographic paper beneath the surface of the water, and exposing it to flashlight after dark.*

more often than not, however, her interest lies in the patterns created by waves, ripples and drops. The attenuated form of a Japanese scroll is implied by the vertical arrangement of the river in *River Taw* (1997; page 99), rendered on the soft matt surface of black-and-white Kentmere paper like a charcoal drawing. Derges's dialogue with the river carried on throughout the 1990s, shifting to colour with the use of dye destruction paper. Derges carried the paper to the water's edge in an aluminium tray, which protected it from light and held it steady before and during immersion. Although her knowledge of the river's movement gave her a rough idea of the sort of images she would produce, the final results could be seen only after processing. Sometimes, the shadows of overhanging leaves and branches were cast on to the ripples in the water, combining solid and fluid organic forms. Occasionally diverting from the river, Derges also produced works at the beach, resulting in the *Shoreline* series of 1997–98. Each piece was created by waves breaking on the paper, at the point where water meets the land, and some show evidence of the presence of sand or pebbles. Inevitably, the paper is sometimes damaged or scratched in the process, producing a patina of singular authenticity. Colour tints are the result of ambient light: the pink cast of light pollution from nearby towns reflected off clouds in the sky; the green tinge of a new moon; and the blue of a full moon.

A golden-brown hue created by deposits of peat in the river is suffused with inky dark forms in *Eden 5* (2004; pages 104–105). After nearly a decade of making photograms in flowing water, this work is Derges's *tour de force*. Lines to the left of the picture trace the pull of a waterfall, while its plunge into deep water is indicated by the dense 'cloud' and whorls of turbulence to the right. Concentrated in this single piece are the many differing wave forms that Derges has examined over the years. The work was made as part of a residency at the Eden Project in Cornwall, which allowed Derges to combine her interests in scientific experiment and ecology. The complexity and variety of *Eden 5* make it the linchpin in a series of works that explores the hydrological cycle: the transformation of water into vapour, which condenses into clouds and then falls back to Earth as rain. Derges's photograms

were used as patterns for a series of glass panels that form the edge of a solar terrace on the roof of one of the Eden Project buildings. The originating photograms represent an element in the process of design manufacture and applied-art design, as well as being fine artworks in their own right.

The extreme horizontality or verticality of Derges's river and shoreline works is based on the human scale, so that the viewer feels confronted by an imposing presence of equal, and sometimes larger, size. Since in each piece the paper was beneath the surface of the water, and the impression of the latter was cast from light above, the works imply a viewpoint of both looking down at the water and up from beneath its surface. The paper and the viewer are fused and immersed in a suspended world of liquid form. This aspect of Derges's work has been described by one critic as 'environmental romanticism ... an antidote to human-centered vision, a brake on the imperialism of the self'.5 To some degree, Derges is sampling the natural world, lifting pieces of rivers and waves out of their natural environment to be honoured as marvels of nature in the context of art. Yet her sampling is not random, indiscriminate or devoid of personal control, for her selection of the most pleasing compositions and rejection of others is a primary part of the creative process. The pieces that she knows work best are those that, from a distance, can often be read as a single gesture, a whiplash shape, a drawn-out spiral or a veil that seems to be drawing back from the image. On closer viewing, however, the same image must stand up to detailed inspection.

With their play on interlinked motifs at both the large and the small scale, and their orientation between above and below, Derges's river images suggest a pantheistic reading. Among the many books in her library encompassing the fields of art, physics, nature, psychology and theology is Theodore Schwenck's *Sensitive Chaos: The Creation of Flowing Forms in Water and Air* (1965). In it, Schwenck examines *Urformen*, common patterns in the physical world, and links them to human and spiritual values. This practice is a form of natural theology in which the existence and attributes of a divine or guiding force can be understood by collecting common appearances in nature. Although these appearances are sometimes conspicuous, others are hidden and require detective work to be found. In Derges's case, camera-less photography provides a compelling tool for this investigation. Derges is one of a number of artists and philosophers who have explored the idea that conspicuous natural patterns are the signs of deeply hidden affinities, visible signs that point to the invisible. In the Romantic period of the eighteenth and early nineteenth centuries, these patterns were understood as hieroglyphs, a kind of divine signature.6 Derges's images can equally be placed in the context of such discourses of modern scientific investigation as chaos theory and quantum physics, which point to an unknowable but implicit order.

A residency at the Museum of the History of Science in Oxford in 2001 allowed Derges to study some of the collection's alchemical apparatus and the interrelationship between the elements of fire, water, earth and air. The resulting *Natural Magic* series of that year depicts reactions in the glass alembic vessels used for distillation – attempts to transform base elements into precious metals. Derges was attracted by the circular narrative of continual change and transformation; she was also drawn to the alchemists' imaginative involvement in the process of observation and exploration. This holistic fusing of observation and imagination has been the subject of much of the artist's recent work. As she has noted, 'I wanted to visualise the idea of a threshold where one would be on the edge of two interconnected worlds: one an internal, imaginative or contemplative space and the other, an external, dynamic, magical world of nature.'7 Once again, camera-less photography provided the most apposite means of achieving this goal. Derges has also returned to depicting the natural world, using the characteristic terrain of Dartmoor as a source, and gathering plants outdoors for arrangement later in the studio.

Derges has used some of her recent Dartmoor-inspired works as studies for a set of four monumental images resembling pantheistic altarpieces. Each of the four works that make up *Arch* (2007–08; pages 107–13) depicts a dreamlike landscape that represents one of the four seasons. The landscapes are framed by

an arch, so that the viewer has the feeling of looking out through a window or architectural opening of some kind. The shape recalls the form of the bell jar that Derges used in her *Natural Magic* series.[8] Are we looking in on some vast alchemical transmutation? At more than 200 cm (79 in.) tall, and with the foliage at true scale, the imposing images assert their physical presence to demand a dialogue with the viewer. At first, a sense of dislocation, and perhaps unease, accompanies our perception of spaces that are neither wholly real nor completely imagined. In *Arch 1 (autumn)*, the autumnal ferns and bracken have been rendered using photograms, although they appear to have been created using frottage or by dipping the plants in paint and pressing them on to the surface of the paper. To achieve a layered effect, Derges pre-exposes the paper to create a mottled base, what in painting would be a ground on which other colours lie. The golden bracken at the base of the image forms arabesques, while the dark-red ferns create an unusual inner frame surrounding white 'clouds' (actually photograms of ink in water on negative film) floating in a blue space. A similarly framed composition is used in *Arch 2 (winter)*, but this time windswept grasses or rushes occupy the base of the image, and the overall tonality has darkened to a wintry purple-black. The cloudy sky is shown reflected in water, with ripples moving across the latter's surface, perhaps caused by a breeze. An ethereal white mist of early spring appears in *Arch 3 (spring)*, with ferns and bracken apparently reflected around the fringes of a pond. A dense wall of foliage reaches into an azure sky in *Arch 4 (summer)*, the plants almost past their full flourish at the close of a summer's day. The low perspective implied in these images provides a child's-eye view. We are at ground level, conscious of the earth, but looking either across or down into a reflecting pool; or we look beyond the frame of ferns, bracken and grasses cupping the sky and project into the heavens. Rooted to the surface of our world, we nevertheless participate in the cosmos. Here, Derges conjures up a magical prelapsarian garden, communicating powerfully with images of a subconscious, almost pre-verbal state. This is not so much landscape, but what English poet Gerard Manley Hopkins termed 'inscape'.

Derges has made explicit use of the special ability of the photogram and camera-less methods of working to make links between the physical world and the psyche:

> Working directly, without the camera, with just paper, subject matter and light, offers an opportunity to bridge the divide between self and other – or what is being explored. There is a contact with the materiality of things that allows a different kind of conversation to happen. One is changed and in turn changes – a kind of dialogue between inside and outside unfolds.[9]

The artist's working practice and philosophy act at the divide between inside and outside – between the studio and the landscape, the body and the mind. It is here that she seeks a still point and finds creative renewal. In this way of working, she also encounters verification, sometimes observing and capturing what she recognizes inside, but also creating through intuition what she recognizes later in the phenomena and harmonies of nature.

NOTES

1 Ernst Florenz Friedrich Chladni, *Entdeckungen über die Theorie des Klanges*, Leipzig, 1787. See also Charles Wheatstone, 'On the Figures Obtained by Strewing Sand on Vibrating Surfaces, Commonly Called Acoustic Figures', *Philosophical Transactions of the Royal Society*, 123, 1883, pp. 593–633; and Anthony Ashton, *Harmonograph: A Visual Guide to the Mathematics of Music*, Glastonbury (Wooden Books) 2005.

2 Derges's *Chladni Figures* are numbered 1 to 8, and correspond to the following frequencies: 1 = 200 Hz; 2 = 250 Hz; 3 = 300 Hz; 4 = 400 Hz; 5 = 500 Hz; 6 = 800 Hz; 7 = 900 Hz; 8 = 1000 Hz.

3 See, for example, Kelley Wilder, *Photography and Science*, London (Reaktion Books) 2009, p. 109, in which Wilder points out the long tradition of using the frog or toad as an experimental animal; and Martin Kemp, *Susan Derges: Liquid Form 1985–99*, London (Michael Hue-Williams Fine Art) 1999, in which Kemp draws on a wealth of scientific subject-matter, from fractal patterns to chaos theory.

4 See, for example, *Beauty of Another Order: Photography in Science*, exhib. cat., ed. Ann Thomas, Ottawa, National Gallery of Canada, October 1997 – January 1998; and, more recently, *Brought to Light: Photography and the Invisible, 1840–1900*, exhib. cat., ed. Corey Keller, San Francisco Museum of Modern Art, October 2008 – January 2009; Vienna, Albertina, March–June 2009.

5 Lyle Rexer, *The Edge of Vision: The Rise of Abstraction in Photography*, New York (Aperture Foundation) 2009, pp. 190–91.

6 The Romantic arabesque, cipher or hieroglyph – discussed in the writings of Paracelsus, Novalis and Jacob Böhme – is examined in the context of artistic practice in Keith Hartley *et al.*, eds., *The Romantic Spirit in German Art, 1790–1990*, London (Thames & Hudson) 1994, pp. 147–53.

7 Susan Derges interviewed by David Chandler, in *Susan Derges*, exhib. cat., London, Purdy Hicks, June–July 2006, p. 7.

8 See *Aëris* (2001), from the *Natural Magic* series, reproduced in *ibid.*, p. 13.

9 Personal communication with the author, 2010.

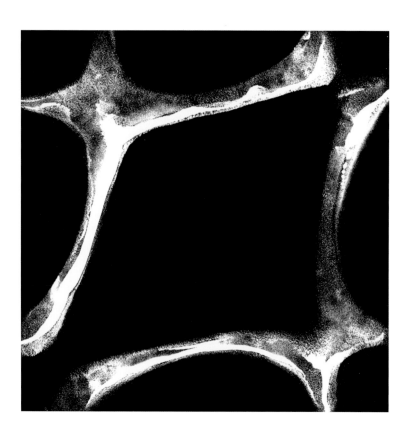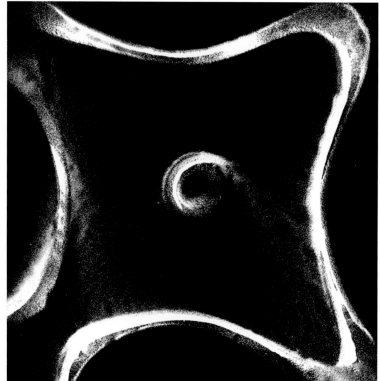

Chladni Figures 1–4, 1983
Gelatin-silver prints
Each 45 × 45 cm (17 ³/₄ × 17 ³/₄ in.)
VICTORIA AND ALBERT MUSEUM, LONDON

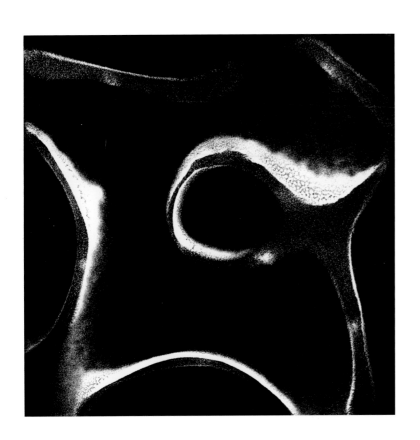
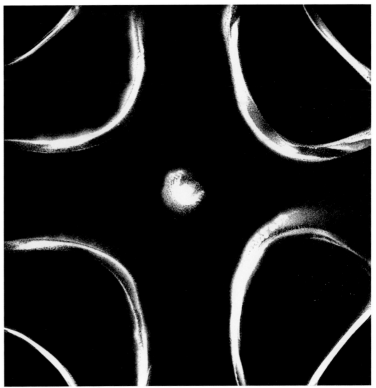

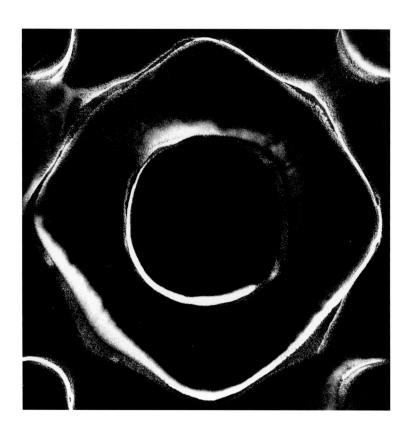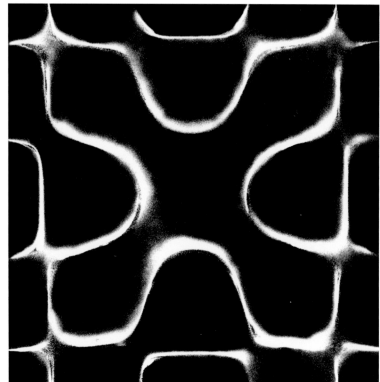

Chladni Figures 5–8, 1983
Gelatin-silver prints
Each 45 × 45 cm (17 ³/₄ × 17 ³/₄ in.)
VICTORIA AND ALBERT MUSEUM, LONDON

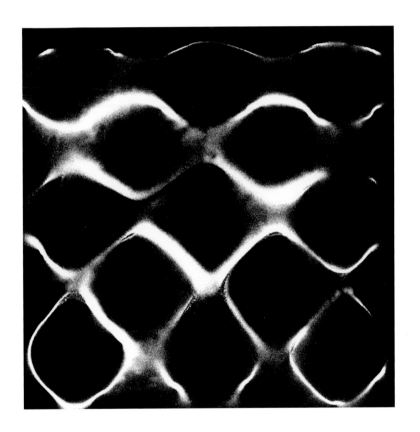

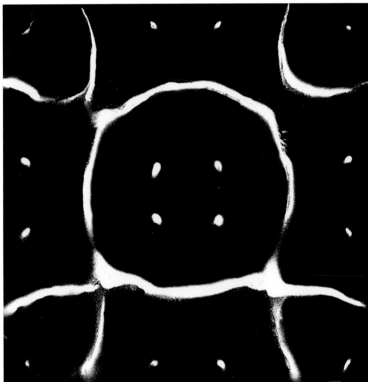

From *Vessel No. 3*, 1995 (top row: *(1)*, *(2)*, *(4)*;
middle row: *(5)*, *(6)*, *(7)*; bottom row: *(9)*, *(10)*, *(11)*)
Dye destruction prints
Each 46 × 46 cm (18$^1/_8$ × 18$^1/_8$ in.)

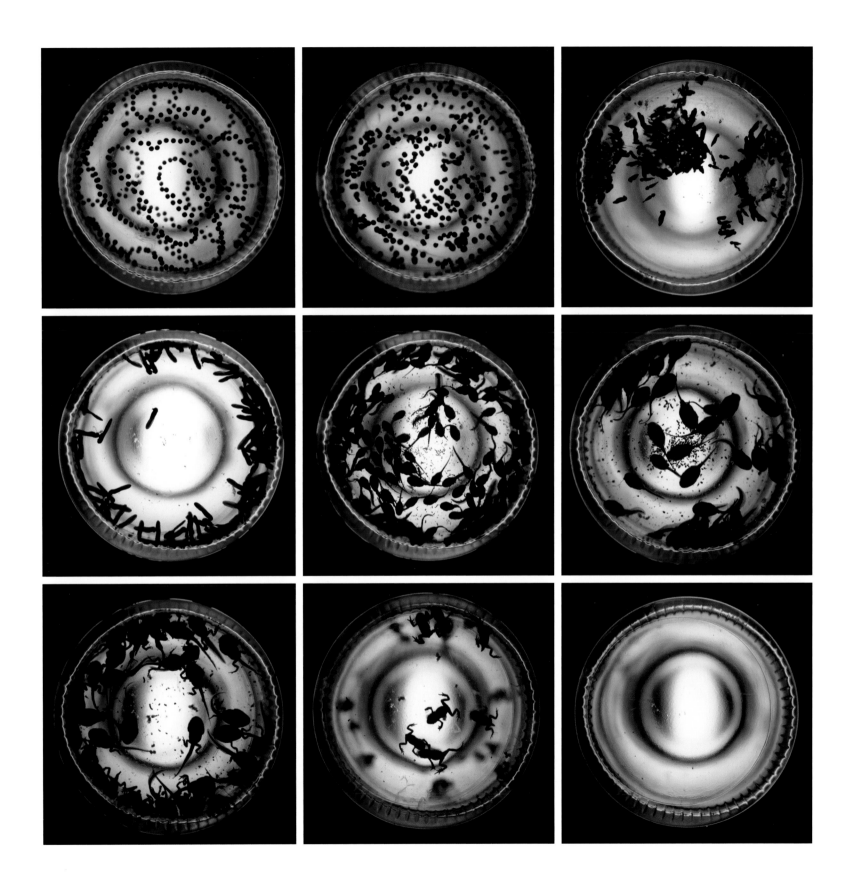

Spawn, 1998
Gelatin-silver print
169 × 61 cm (66 ¹/₂ × 24 in.)

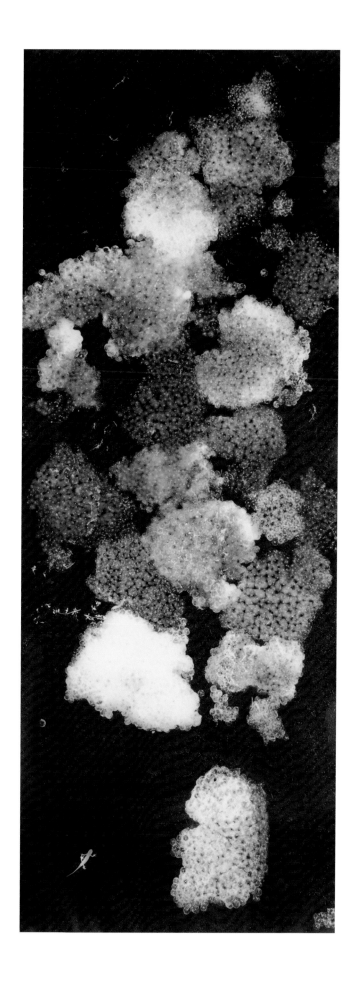

River Taw, 1997
Gelatin-silver print
170 × 61 cm (66 7/8 × 24 in.)
COLLECTION OF THE ARTIST

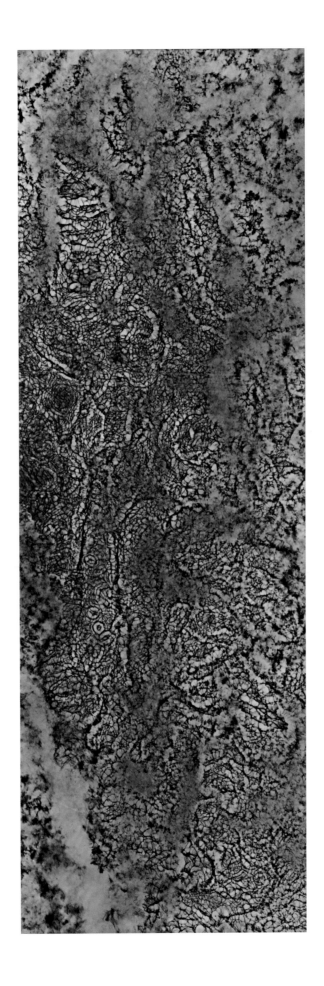

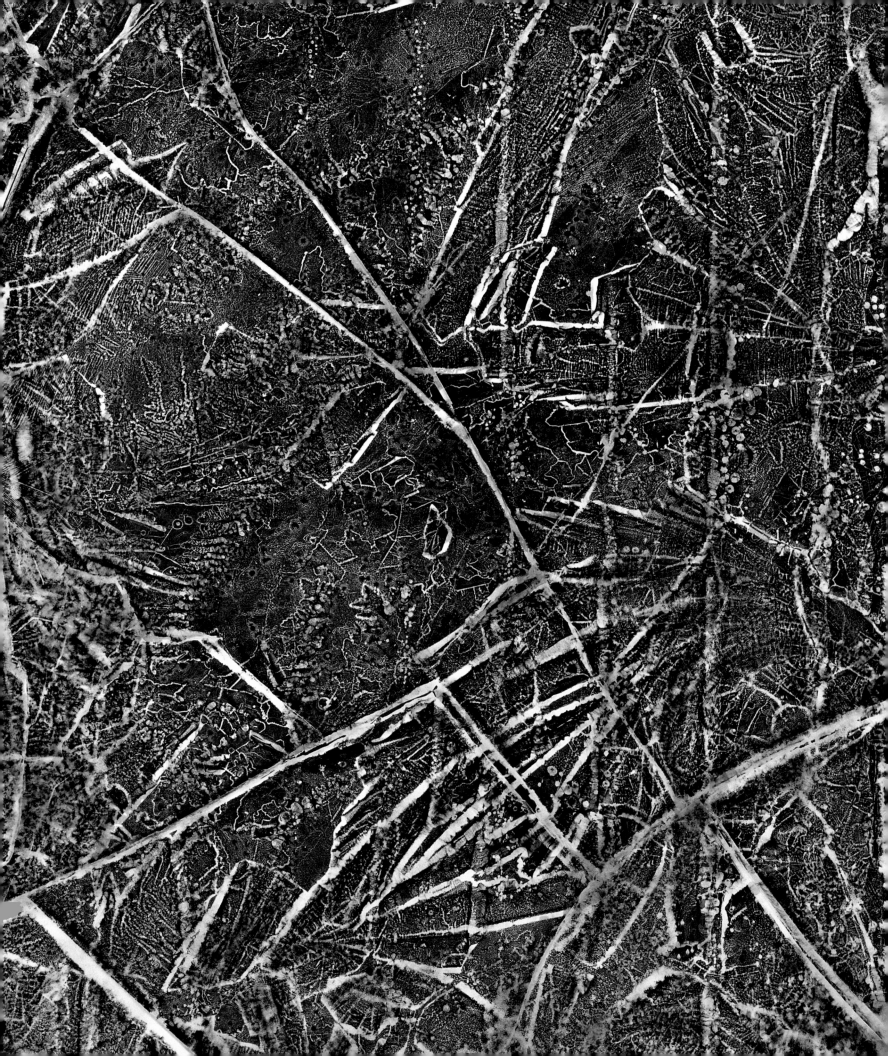

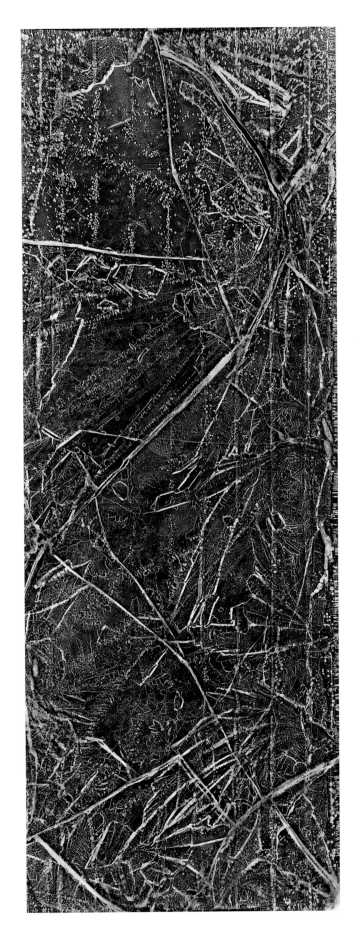

RIGHT (DETAIL SHOWN OPPOSITE)
River Taw (ice), 4 February 1997, 1997
Gelatin-silver print
169 × 62 cm (66 $^1/_2$ × 24 $^3/_8$ in.)
COLLECTION OF THE ARTIST

PAGES 102–103
Shoreline, 2 October 1998, 1998
Dye destruction print
101 × 229 cm (39 $^3/_4$ × 90 $^1/_8$ in.)
PRIVATE COLLECTION, UNITED KINGDOM

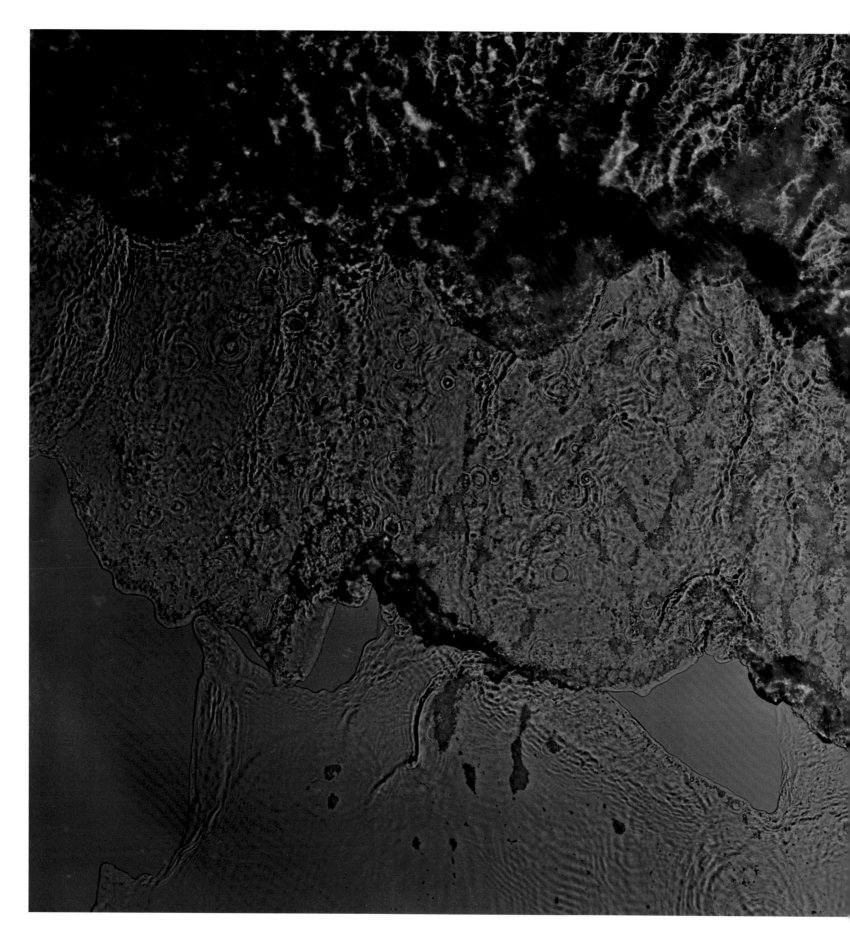

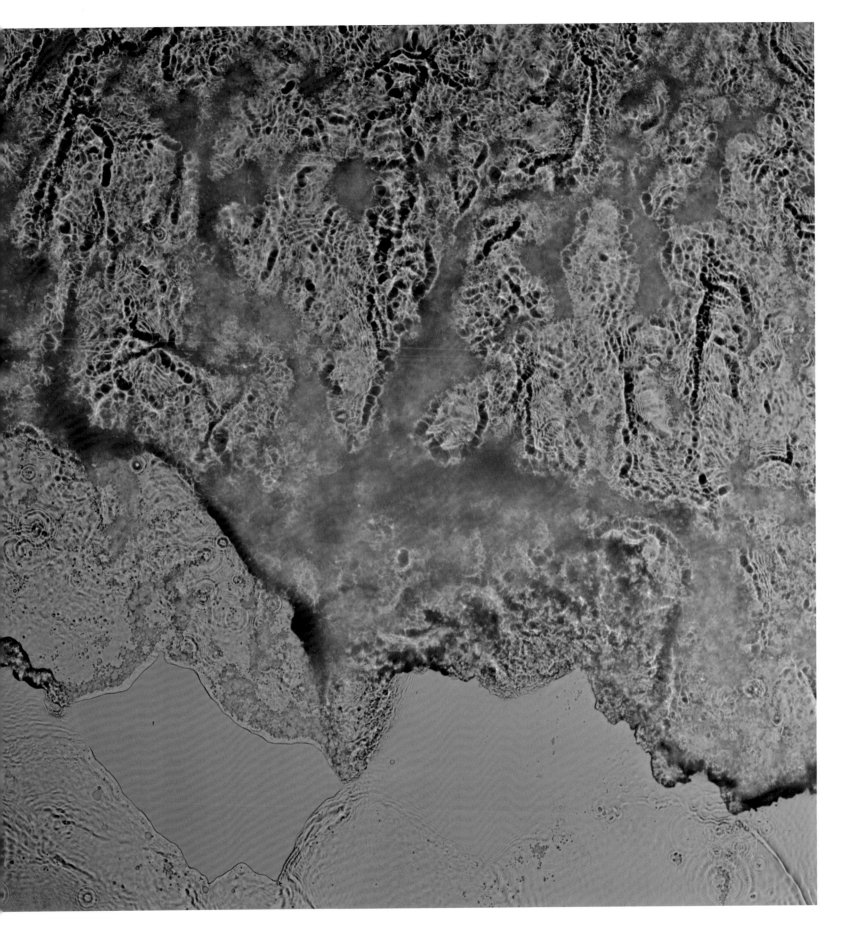

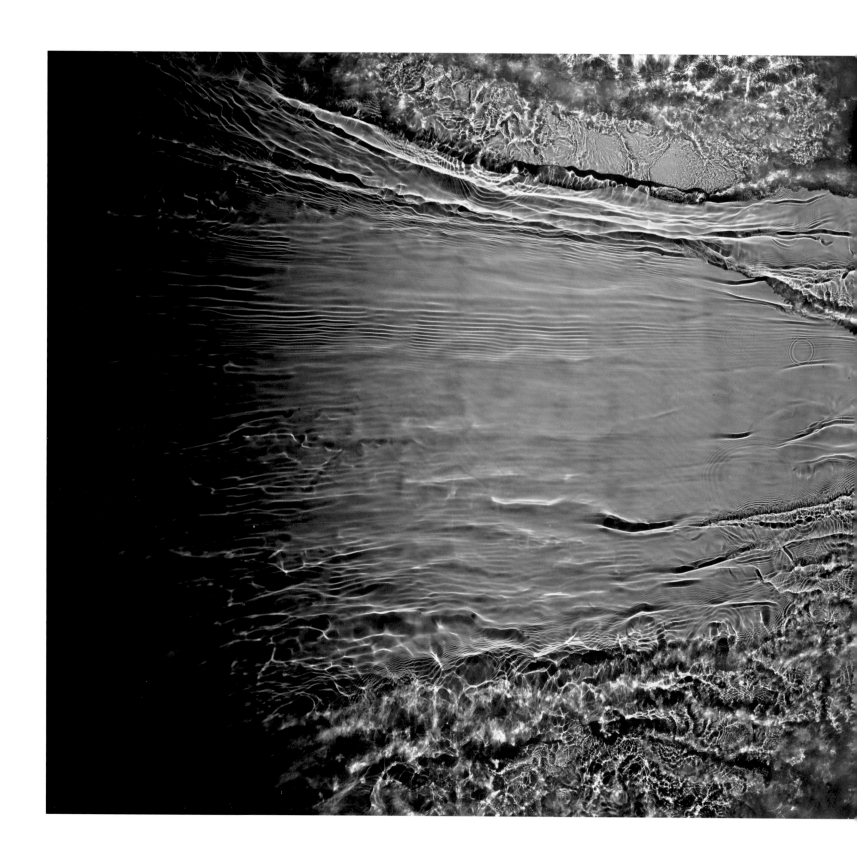

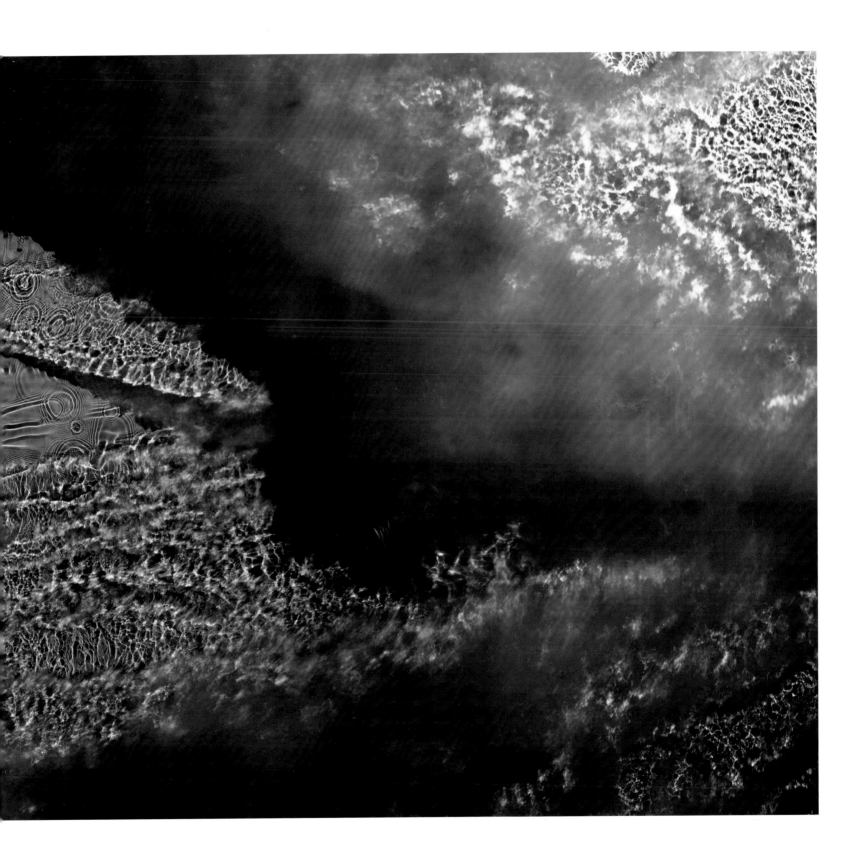

Eden 5, 2004
Dye destruction print
101.5 × 243.8 cm (40 × 96 in.)
VICTORIA AND ALBERT MUSEUM, LONDON

Arch 1 (autumn), 2007–08
Digital C-print
220 × 150 cm (86⅝ × 59 in.)
COLLECTION OF THE ARTIST

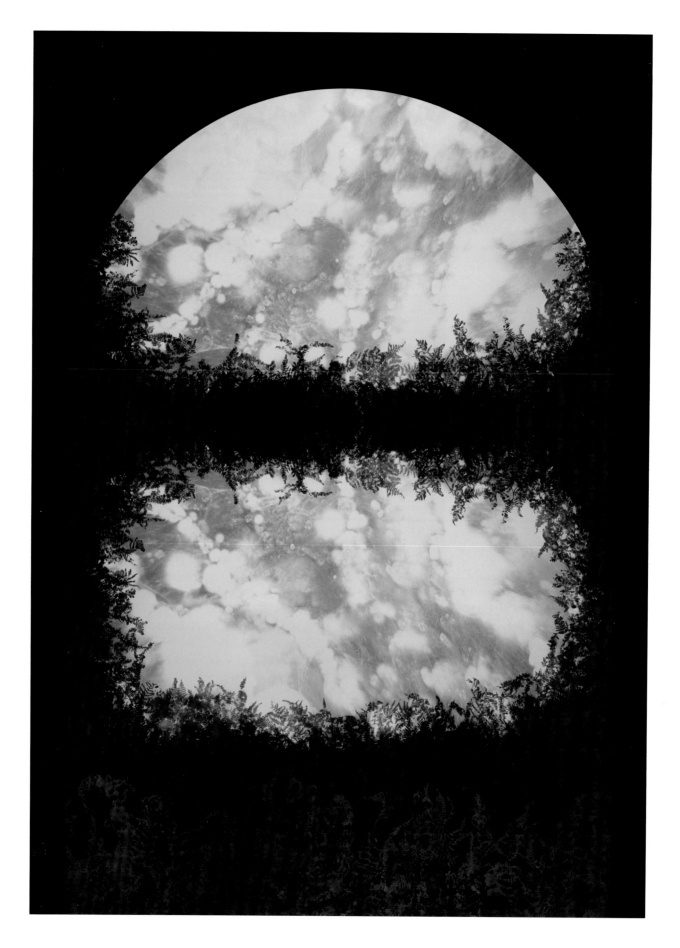

Arch 2 (winter), 2007–08
Digital C-print
220 × 150 cm (86⅝ × 59 in.)
COLLECTION OF THE ARTIST

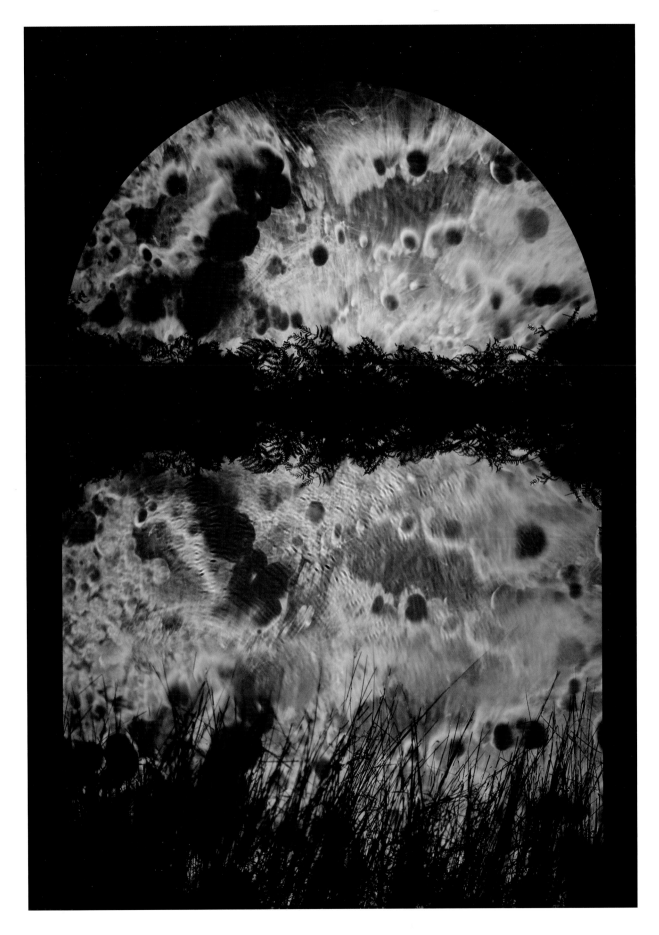

Arch 3 (spring), 2007–08
Digital C-print
220 × 150 cm (86⅝ × 59 in.)

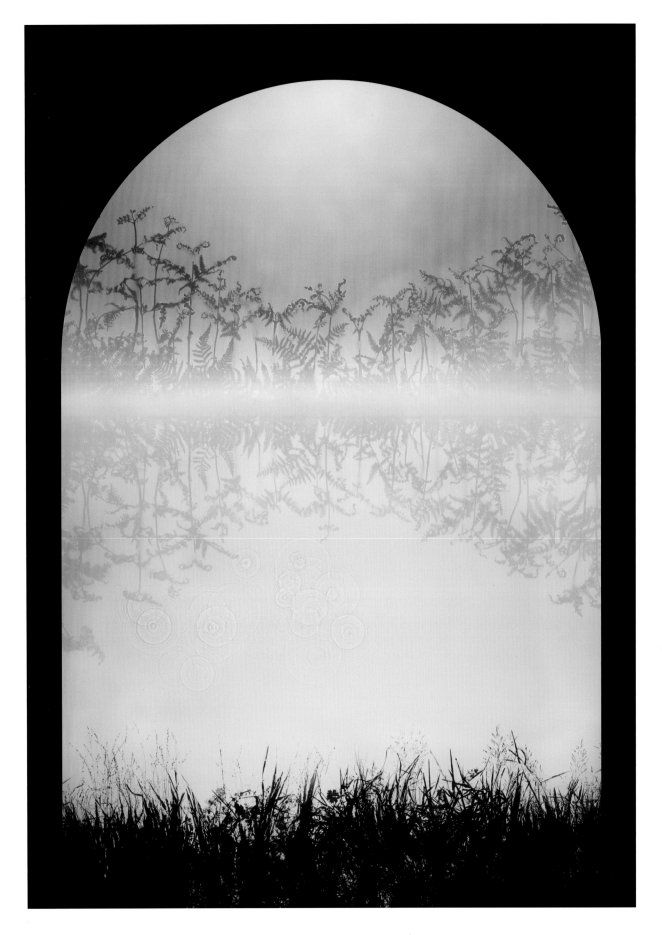

Arch 4 (summer), 2007–08
Digital C-print
220 × 150 cm (86⅝ × 59 in.)
COLLECTION OF THE ARTIST

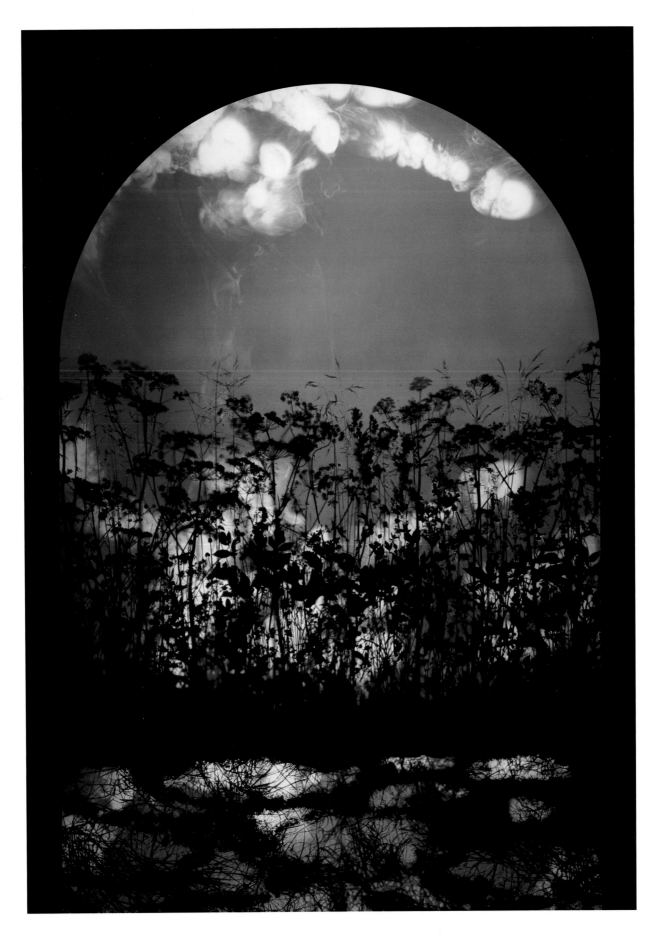

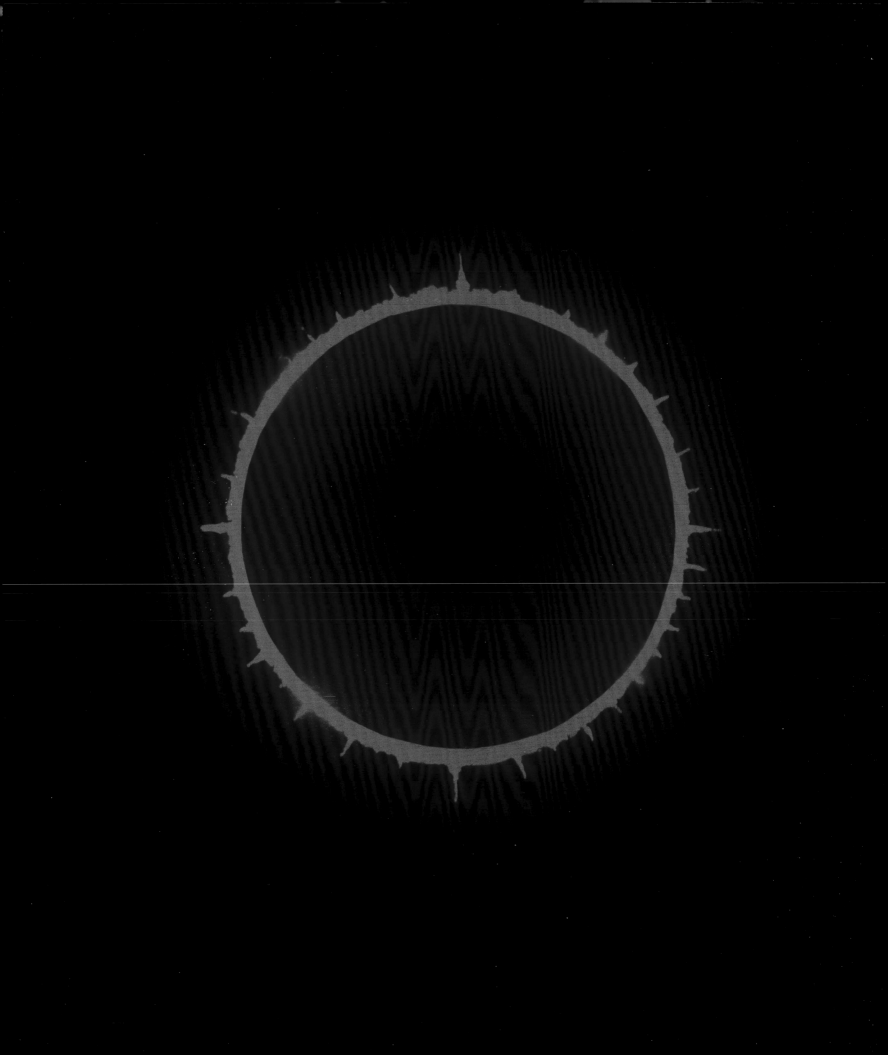

ILLUMINATIONS Garry Fabian Miller

Garry Fabian Miller's primary interest is in the investigation of the properties of light and time. Many of his works explore the cycle of time over the period of a day, month or year; but they also suggest the deep time of history, space and the unknown. Allied to his interest in time are his working processes, which unfold as controlled experiments with varying durations of light exposure. His works are enriched by being seen in sequences in which the viewer is led through the exploration and resolution of a single motif and colour range. The images are often conceived as remembered landscapes and natural-light phenomena. However, Fabian Miller distils these memories through the filter of personal reflection and insight, giving rise to an abstracted visual language that nevertheless retains a vestige of the visible world.

At the heart of Fabian Miller's vision is a belief in the contemplative existence of the artist, whose practice and life outside metropolitan culture are intertwined. For him, the works he creates offer a personal opportunity for reflection and emotional response, rather than social or academic readings: they are simple yet multi-layered, tranquil yet energized. On one level, they can be absorbed and enjoyed simply for their visceral pleasures, calling up evocative associations with light, colour, shape and symbol. In addition, his images can be placed in wider contemporary and historical contexts, alongside the work of artists and thinkers in fields ranging from science to spirituality. Various commentators have made links between Fabian Miller's works and the paintings of J.M.W. Turner (1775–1851), noting especially the shared veneration for light that breaks down form towards abstraction.[1] The pioneers of photography, British land art, the paintings of the Abstract Expressionists and theosophical teachings have also been cited as influences, among others.[2] Fabian Miller himself has acknowledged that a variety of sources have influenced his approach to, if not the visual appearance of, his work. These include such diverse subjects as Charles Darwin's research methodology and the craft of studio pottery.

From 1976 Fabian Miller gained success as a fine artist through his camera-made minimalist views of seascapes and landscapes, often with a symmetrical balance and a central horizon. In 1980 he moved from his native Bristol to a farm in Lincolnshire, opening a barn to exhibit his and other artists' works. His engagement with the land there, observing the cycle of growth, prompted him to seek out a means of getting closer to nature and light. Towards the end of 1984, he discovered a way of working that would satisfy this desire on both a conceptual and a practical level. Using such transparent plant matter as leaves, petals, reeds or seed pods as photographic negatives or transparencies in the head of a photographic enlarger, he projected an image of the chosen plant on to the photographic paper below. By using dye destruction print paper, he was able to produce remarkably clear and detailed results. From this point on he abandoned the camera altogether.

The piece *Tear, Autumn 1988* (1988; page 122) shows a single, life-size leaf within the expanse of a white, hand-painted wooden frame. The small scale and humble nature of this work signalled a distinctive artistic stance, one that prized quiet sincerity. Fabian Miller found inspiration in the Quakers, in particular their acknowledgement of the power of stillness and silence to uncover a light of conscience within. His works at this time were often suggestive of the Quaker way of life, and sometimes employed religious symbolism, as in the series *Reed with Eight Cuts* (1985; page 123), a trinity of spear-like forms that show the plants in different colours as the seasons change from summer to autumn to winter. The photographs act as analogues of the plants themselves, created just as miraculously through the action of light, and revealing the process of photosynthesis.

In 1989 Fabian Miller returned to the south-west of England, moving to a rural location on Dartmoor. There, he built a studio in a large garden. He divided his days in half, working in the darkroom and studio and then in the garden, which provided material for his pictures. In particular, he extended his examination of photosynthesis by gathering comparative grids of leaves from a single tree, mostly during the spring, when the leaves change rapidly from pale yellow to deep green. This resulted in such works as *Breathing in the Beech Wood, Homeland, Dartmoor, Twenty-four Days of Sunlight, May 2004* (2004; page 125). The cycle of

Fabian Miller often walks on Dartmoor, the location of his home in south-west England. The artist has taken much inspiration from the moorland's dramatic landscape and changing light conditions.

emergence is also the subject of an earlier work, *Delphinium 1–8* (1990; pages 126–27). Made from a single delphinium petal over the course of a day, this sequence of images begins as almost imperceptible tracings of form, gathering weight and deepening in colour until the petal becomes visible. It is concerned with the transformation of light into matter, suggesting the perceptible stage of a natural and cyclical process while hinting at events occurring beyond the visible spectrum.

Fabian Miller has tended towards minimalist reduction in his art, distilling the essence of methods and meaning to achieve powerful results. His plant pictures, for example, became increasingly abstract, until in 1992 he mostly stopped using plants, concentrating instead on making images in the darkroom using only dye destruction print paper, beams of light, cut-paper forms and glass vessels filled with liquids. The colour in the works made without plants is produced by different means. A beam of light shone at the photographic paper through clear glass vessels filled with oil gives varying shades of orange; red and blue are produced by the colour of the glass vessels themselves, usually filled with water to refract the light. Sometimes, Fabian Miller constructs simple cut-paper shapes and places these on wooden columns at varying distances from the light source to cast shadows on the paper. Exposures can last from a few minutes up to several hours. The works in his *Exposure* series (2005; pages 132–33) were specifically subtitled to reveal the exposure times, including one, nine, ten and fifteen hours. The results can be thought of as a kind of performance, the record of skilfully controlled light events caught in time.

The majority of Fabian Miller's works are closely related to the photogram, but differ in one important respect: the glass vessels and cut-paper shapes used to create form rarely touch the photographic paper. Instead, they either block light at a distance from the paper, casting shadows of varying degrees of sharpness depending on how far they are from it; or allow light to pass through them, creating the bright parts of the image. The resulting works are technically known as 'luminograms'. Since some of Fabian Miller's works are the record of light that has been

filtered by transparent objects, the form on the paper might more accurately be described as a 'filtow' rather than a shadow.3

For Fabian Miller, the importance of both his darkroom and the studio space connected to it cannot be underestimated. After working in the darkroom, he displays the results in the large, white-painted studio, which is flooded with natural light. It is here that he edits his works, leaving them to hang for several days while assessing the impact of their shape, density, luminosity and presence. It is this investment of time spent in looking, and the level of visceral engagement with the works, that lends them a sense of considered 'rightness'.

An examination of various states of equilibrium runs throughout Fabian Miller's art. When speaking about his work, he notes the quality of light 'gathering' in a room, like a cumulative and benevolent force. He equates this process with a form of gradual psychological enlightenment:

> When we're born, our brain is like a dark rock. Each day you live it is exposed to the light and thus it slowly fills with light and the light accumulation becomes our mind and our thoughts ... and each day's acts are precious as those acts ... work with the light to form the beauty and the intent and the integrity of our forming mind, and the actions we choose to make in the world. So each day's acts must be treasured. Each action considered as it contributes to the light accumulation, our light deposit, our forming mind, the turning of the dark rock into a light sensitive cell that radiates energy – and if carefully built it can radiate goodness and beauty within the world.4

The dark space of the mind is often realized in the trope of a room. In photography, this has powerful associations, with the *camera obscura* (dark room) being the precursor of the photographic camera, as well as the laboratory-like domain of the darkroom necessary for development, printing and, in Fabian Miller's case, the essential site of production. The room in which light gathers is a site of creativity and metaphorical illumination. These themes permeate the works made by Fabian Miller for a commission at

Petworth House, a seventeenth-century country house in West Sussex, England. The house is famous for its collections of fine art, for its long façade of windows facing its landscaped park, and for playing host to Turner, who made light-flooded watercolours there in the 1830s. Works from Fabian Miller's *Petworth Windows* series (2000; page 129) reference numerous subjects, including Petworth's glazing bars; the latticed window of William Henry Fox Talbot's first photographic negative of 1835 (also the subject of a piece by Neusüss; see pages 37–39); cruciform patterns; and accounts of Turner's attempts to struggle from his deathbed to observe the light through his window.

A subsequent series of images, *Night Towers* (2001; page 131) – often grouped together as *Night Cities* – continued and developed the ideas explored in the *Petworth* series. Here, however, the windows of the latter have become clusters of imagined tower blocks. The verticality and sometimes diffuse light of the *Night Towers* series convey the soaring rush of an elevator ride, or the sensation of looking out at the myriad lights of the metropolis. The gridiron shapes also suggest the mapping of streets from above, or the pattern of lighted windows, each one reminding us of the thousands of individuals who make up the energy of the city. The *Night Towers* works also bear an uncanny resemblance to images of DNA sequences, the holders of genetic information. It is as if we see in *Night Towers* a blueprint for human existence.

One of Fabian Miller's hallmarks is his sustained enquiry into a single form or colour. Completing one avenue of investigation, he often chooses a completely contrasting subject for his next project. After the blue rectilinear explorations of *Petworth Windows* and *Night Towers*, he turned to a circular motif and the colour red. The works from the series *Becoming Magma* (2004–05; page 133) make a tangential reference to the ancient landscape of the artist's home. Magma is molten rock found beneath the Earth's surface, which erupts as lava and cools to form distinctive rocky outcrops, as can be seen on Dartmoor. Fabian Miller's burning reds breaking through dark brown and black suggest a fearsome volcanic energy. The circular shapes are appropriately planetary or solar in nature,

implying unfathomable elemental forces both beneath our feet and in the heavens above.

After making the large-scale works of *Becoming Magma*, Fabian Miller sought a more intimate project that would still allow him to continue his nuanced investigation into the cycles of time. For the series *Year One* (2005–06), he produced one work every day over the course of a year. Discoveries made with each piece informed the next. At the end of the year, the artist selected ninety-six of the images for publication in the form of a book. After arranging the selected works chronologically, he divided them into twelve equal sections, one for each month. He then titled each section according to the Celtic 'Coligny' calendar, one of the oldest of its kind.5 For example, the autumnal 'Samonios', meaning 'seed-fall', is named after the first month of the Celtic year; 'Elembiuos', which includes images of a full moon, bears the name of one of the summer months. Refining his selection still further, Fabian Miller chose one work to represent each month, presenting his choices in twelve separate drawers of a purpose-built walnut display cabinet (pages 134–43).

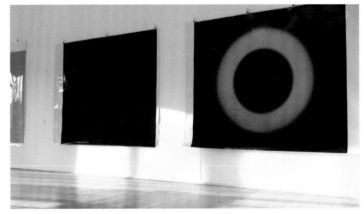

Year One, like the subsequent *Year Two* series (2007–08), is a compendium of daily studies, the evolution of Fabian Miller's journey with camera-less photography for more than twenty-five years. The artist now views these pieces as a form of intense fieldwork, and continues to build on the knowledge he has obtained through their making. His discoveries parallel the prolonged studies of form and colour carried out by Josef Albers (1888–1976), whose book *Interaction of Color* (1963) advocated practical experiment and observation over reliance on theory alone. Fabian Miller's recent works pairing rectangles and squares of complementary colours – such as *Orange Aqua. Late Summer* (2009; pages 144–45) – owe a debt to, but are also a development of, Albers's *Homage to the Square* paintings and prints begun in 1949. For Albers, as for László Moholy-Nagy during the same period, the technology available at the time prevented a full exploration of the possibilities of colour abstraction in photography. While Moholy-Nagy made attempts to create abstract colour photographs, he felt that, without apparatus on a larger and more

scientific scale, it was difficult fully to resolve them. For him, the light-sensitive layer of photographic paper was a clean sheet on which music-like notes could be written in light. In the context of an article defending abstract art, he made the following comments on pre-Renaissance painting: 'It admitted that it had been painted to express moods, devotion, wonder, and ecstasy with the sensuous and emotional power of colour. It emphasised less the "story" and more the vital performance of colour to which the spectator could react directly without reasoning and conscious analysis.'[6] Fabian Miller's works realize Moholy-Nagy's desire for unleashed photography, a 'vital performance of colour' that appeals to the heart as much as to the head. Unlike Albers's works, Fabian Miller's display an incandescent quality of light, which seems to emanate from the images. Where two colours meet, they create their own shape, appearing to vibrate and float in an indeterminate space. The mixing of colours is surprising: at the junction of blue and yellow, for example, a glowing margin of almost neon pink is generated. Fabian Miller's works appear to fix liquid light, in which the viewer is aware of an illusionary three-dimensional space. Recently, as a result of his use of digital technology, the scale and sculptural quality of Fabian Miller's work have increased: after scanning original sections of dye destruction prints, he then stitches them together – working closely with a digital re-toucher – to produce larger works. While they remain camera-less, these pieces are a hybrid of the most basic and most modern forms of photographic image production.

Fabian Miller's recent work, which focuses on the interaction of light, colour and space between two forms and colours, suggests a third way. The point of meeting is a kind of threshold, a space between that is the fusion of its generating elements. Although as viewers we often seek, and sometimes find, recognizable forms in his works, the images simultaneously move away from a representational mode of seeing. In such works, as one commentator has recently observed, 'the photograph becomes an occasion for seeing and travelling mentally'.[7] Often comparable to moving retinal afterimages, in which colour and shape are generated by the mind in total darkness, Fabian Miller's works

allow a mental projection into the image: 'The pictures I make are of something as yet unseen, which may only exist on the paper surface, or subsequently may be found in the world. I am seeking a state of mind which lifts the spirit, gives strength and a moment of clarity.'[8] It is as if we are seeing the workings of a mind rather than the mind's interpretation of the world outside. The journey within this threshold demands surrender, concentration and silence. It is a sublime, otherworldly silence, one that is evoked by Fabian Miller's favoured circular shapes, such as an iris, as in *Gaze (i)* (2009–10; page 146), or a planetary body, as in *The Night Cell* (2009–10; page 147). These recent works offer a location that is both within the mind and an imagined place far beyond its bounds. Could *Gaze* be a knowing eye looking back at us? Or could both pieces be the genesis or dying remains of a distant planet? It is a territory caught between uncertainty and hope.

Even in Fabian Miller's darkest works, illumination finds a way through the occlusion (see, for example, page 141). The light is so strong that it cannot be held back by the darkness. In a recent essay on the artist's work, writer Adam Nicholson positions him in a long line of English visionaries, mystics and poets. These include John Milton (1608–1674), whose description of the divine from *Paradise Lost* (1667), 'Dark with excessive bright', aptly describes Fabian Miller's emerging stellar orbs.[9] For Fabian Miller, light is the only tangible thing that can be traced back to the beginnings of creation. It is therefore not a symbol for something else but the very embodiment of creative energy.

NOTES

1 See David Alan Mellor and Garry Fabian Miller, *Tracing Light*, Maidstone (PhotoWorks) 2001; and *Exposure*, exhib. cat. by Ian Warrell, Edinburgh, Ingleby Gallery, September–November 2005.

2 For a deeper examination of Fabian Miller's art and influences, see Martin Barnes, *Illumine: Photographs by Garry Fabian Miller: A Retrospective*, London and New York (Merrell) 2005.

3 I am grateful to Marina Warner for drawing my attention to the concept of the 'filtow', a term coined by analytic philosopher Ray Sorensen. See Marina Warner, 'Adynata: Time's Colour, Impossible Beauty', in Marina Warner *et al.*, *The Colour of Time: Garry Fabian Miller*, London (Black Dog) 2010.

4 Garry Fabian Miller, quoted in Barnes, *Illumine*, p. 108.

5 Garry Fabian Miller, with essay by Edmund de Waal, *Year One*, Edinburgh (Ingleby Gallery) 2007.

6 László Moholy-Nagy, 'A New Instrument of Vision' [1932], quoted in *Moholy-Nagy: An Anthology*, ed. Richard Kostelanetz, New York (Da Capo Press) 1970, p. 46.

7 Lyle Rexer, *The Edge of Vision: The Rise of Abstraction in Photography*, New York (Aperture Foundation) 2009, p. 193.

8 Garry Fabian Miller, e-mail message to author, 27 March 2009.

9 Adam Nicholson, 'The Otherworld', in Warner *et al.*, *The Colour of Time*.

Tear, Autumn 1988, 1988
Dye destruction print
30.5 × 30.5 cm (12 × 12 in.) framed

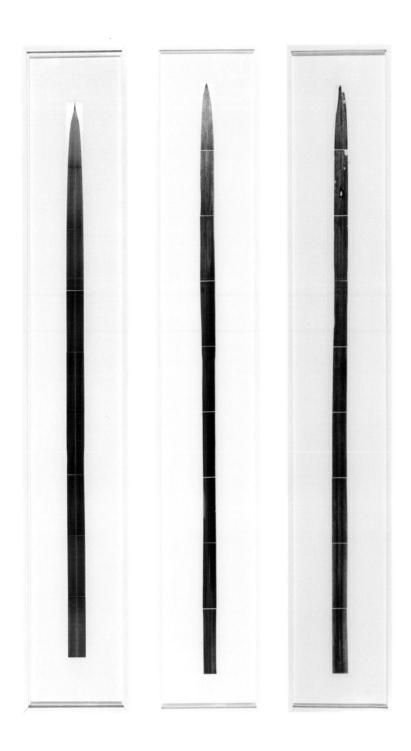

Reed with Eight Cuts, Lowfield Farm,
Summer, 1985, 1985
Dye destruction prints
198 × 33 cm (78 × 13 in.) framed
VICTORIA AND ALBERT MUSEUM, LONDON

Reed with Eight Cuts, Lowfield Farm,
Autumn, 1985, 1985
Dye destruction prints
198 × 33 cm (78 × 13 in.) framed
VICTORIA AND ALBERT MUSEUM, LONDON

Reed with Eight Cuts, Lowfield Farm,
Winter, 1985, 1985
Dye destruction prints
198 × 33 cm (78 × 13 in.) framed
VICTORIA AND ALBERT MUSEUM, LONDON

Breathing in the Beech Wood, Homeland, Dartmoor,
Twenty-four Days of Sunlight, May 2004, 2004
Dye destruction prints
162 × 162 cm (63³/₄ × 63³/₄ in.) framed
VICTORIA AND ALBERT MUSEUM, LONDON

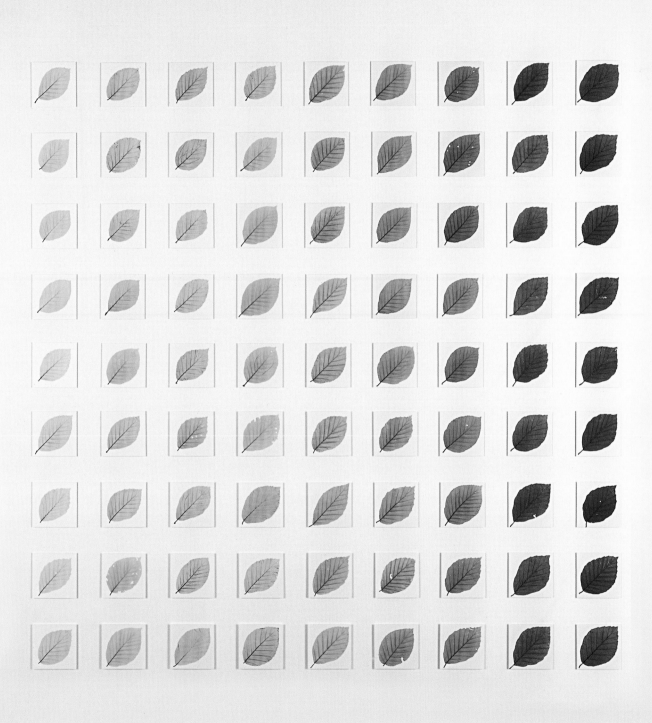

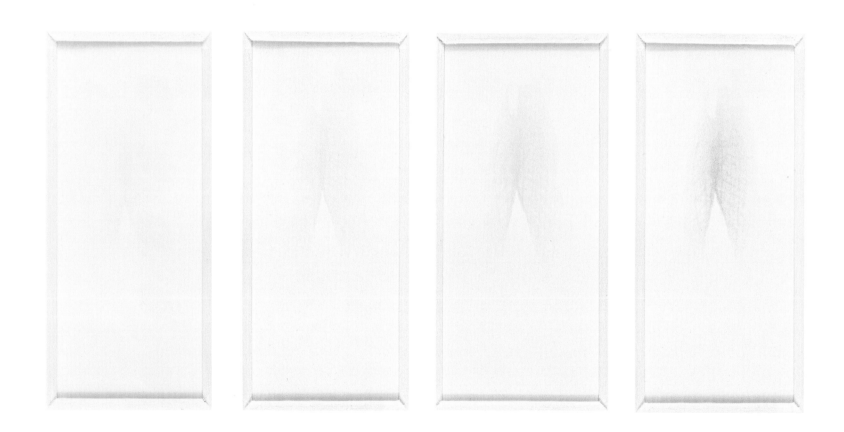

Delphinium 1–8, 1990
Dye destruction prints
8 panels, each 28.5 × 28.5 cm
(11 1/4 × 11 1/4 in.) framed
COLLECTION OF THE ARTIST

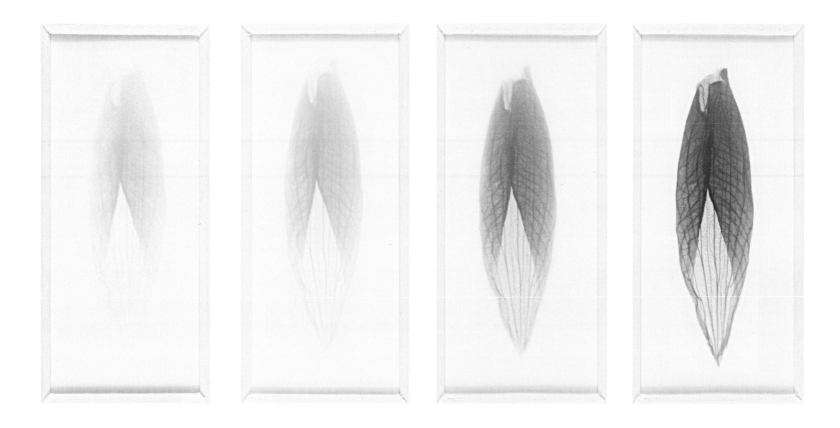

Petworth Window 12 February 2000, 2000
Dye destruction print
74.5 × 60.5 cm (29⅜ × 23⅞ in.) framed
COLLECTION OF THE ARTIST

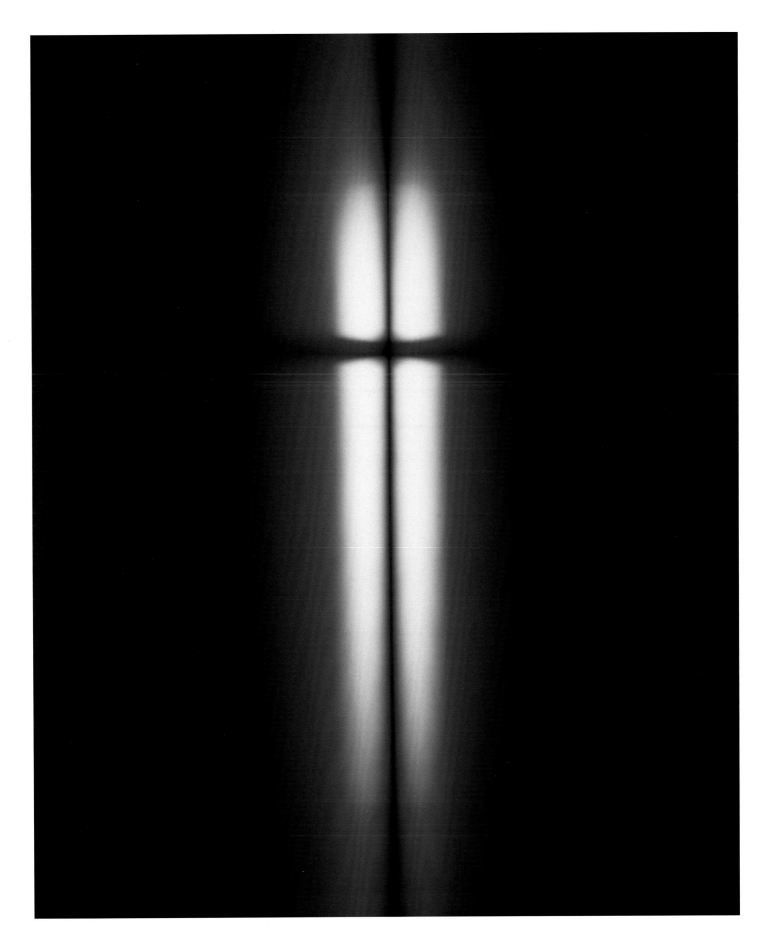

Night Tower 3, 2001
Dye destruction print
179 × 47 cm (70$^{1}/_{2}$ × 18$^{1}/_{2}$ in.)

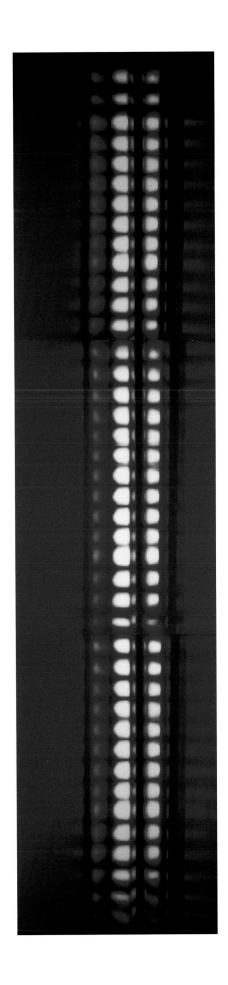

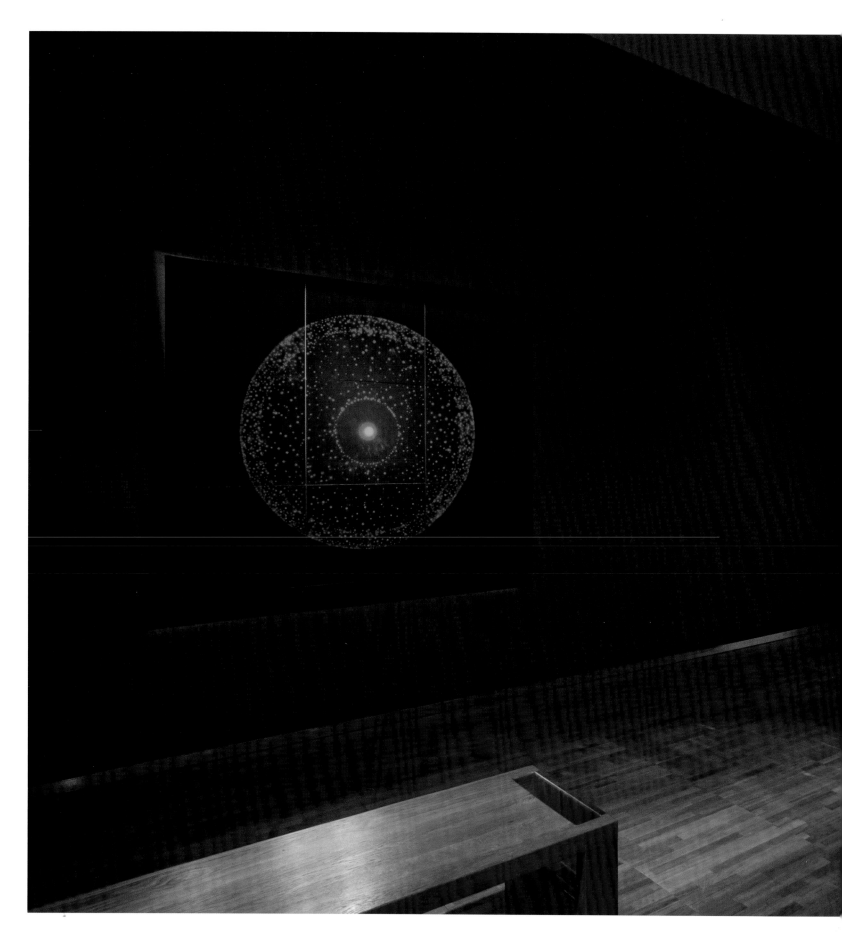

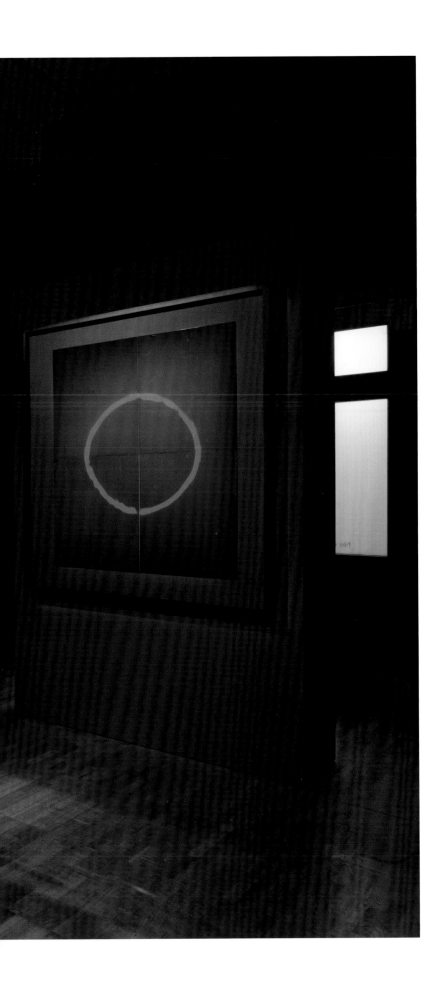

Installation view of *Exposure (Nine Hours of Light)*,
March 2005 (left), 2005, and *Becoming Magma 2*,
June 2004, 2004
Dye destruction prints
Exposure: 153 × 183 cm (60^{1}/$_{4}$ × 72 in.);
Becoming Magma 2: 128 × 147 cm (50^{3}/$_{8}$ × 57^{7}/$_{8}$ in.)
VICTORIA AND ALBERT MUSEUM, LONDON

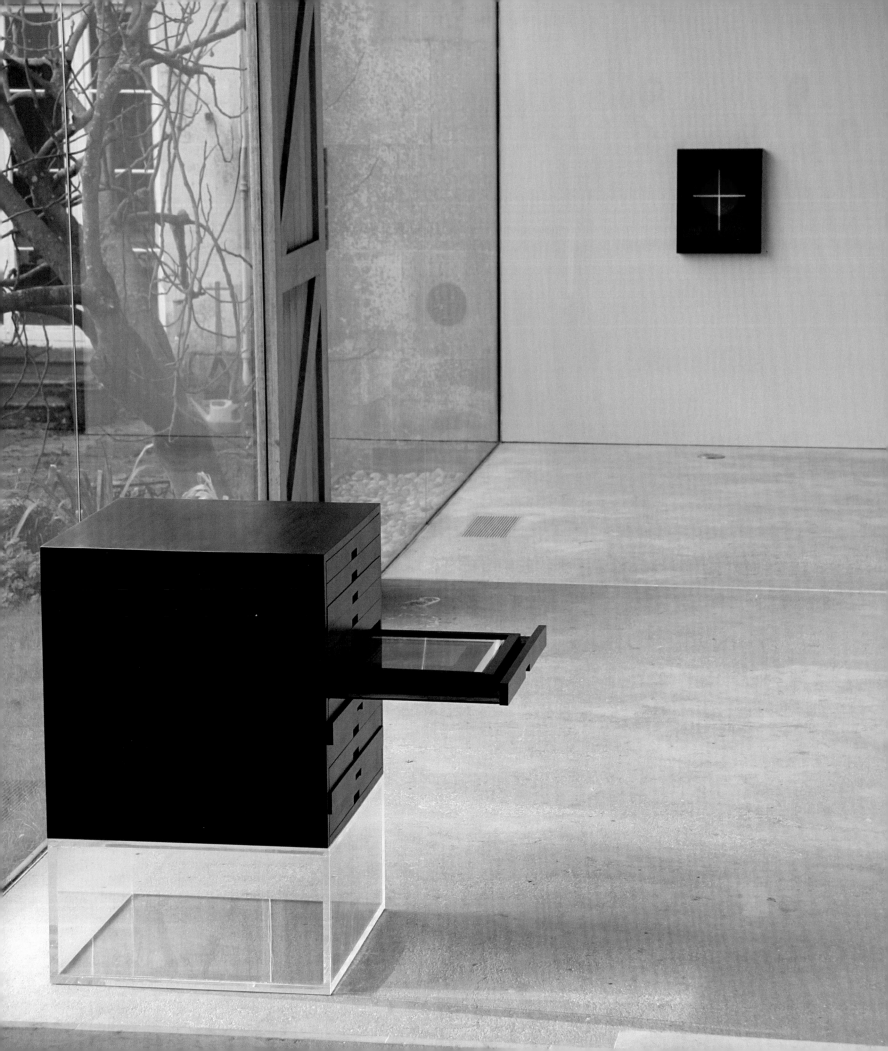

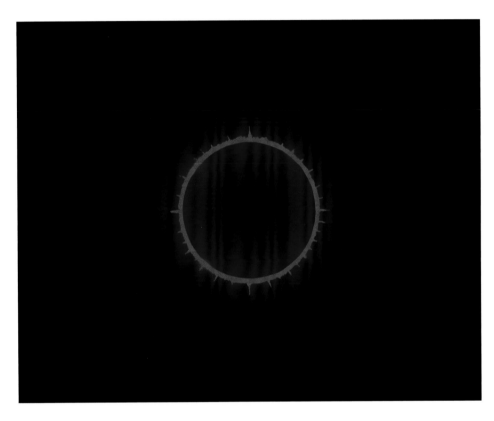

Year One: Samonios
30.5 × 40.5 cm (12 × 16 in.)

OPPOSITE
Installation view (at New Art Centre, Salisbury) of
Year One, 12 dye destruction prints in wooden cabinet, 2006
12 dye destruction prints in walnut cabinet on
perspex stand
71.1 × 72 × 71.5 cm (27 × 28⅜ × 28⅛ in.)
INGLEBY GALLERY, EDINBURGH

ABOVE AND PAGES 136–43
Year One, 2005–06
12 dye destruction prints
INGLEBY GALLERY, EDINBURGH

Year One: Dumannios
30.5 × 40.5 cm (12 × 16 in.)

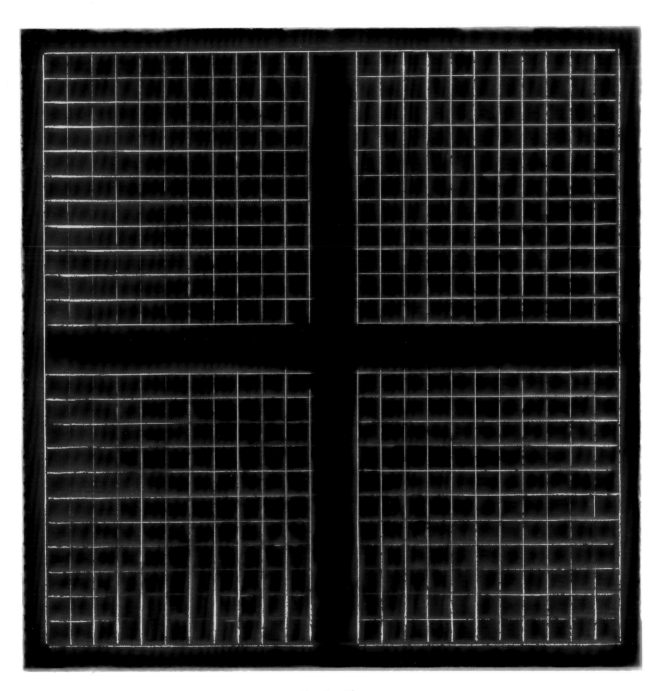

Year One: Riuros
40.5 × 40.5 cm (16 × 16 in.)

Year One: Anagantios
40.5 × 40.5 cm (16 × 16 in.)

Year One: Ogronios
40.5 × 40.5 cm (16 × 16 in.)

Year One: Cutios
40.5 × 40.5 cm (16 × 16 in.)

Year One: Giamonios
40.5 × 40.5 cm (16 × 16 in.)

Year One: Simivisionios
40.5 × 50.5 cm (16 × 19⁷/₈ in.)

Year One: Equos
40.5 × 50.5 cm (16 × 19⁷/₈ in.)

Year One: Elembiuos
50.5 × 40.5 cm (19⁷/₈ × 16 in.)

Year One: Edrinios
50.5 × 40.5 cm (19⁷/₈ × 16 in.)

Year One: Cantios
50.5 × 40.5 cm (19⁷/₈ × 16 in.)

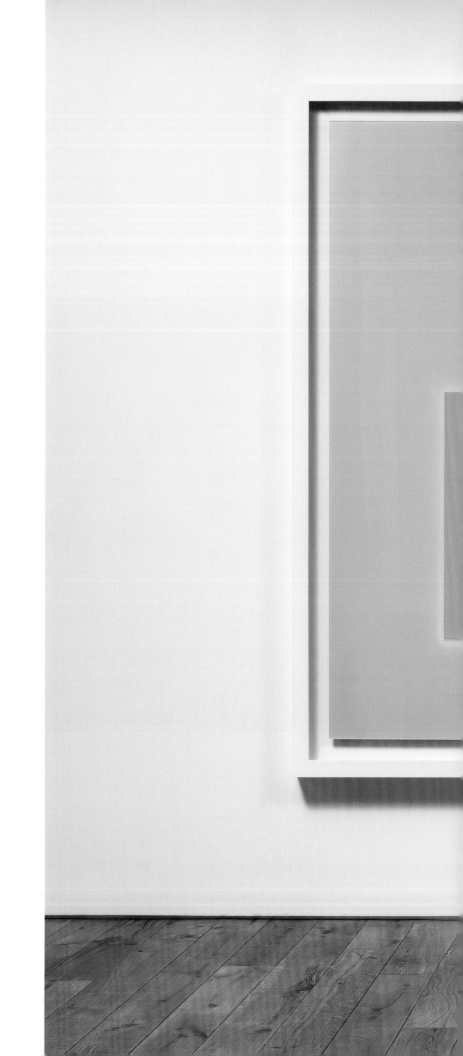

Installation view of *Orange Aqua. Late Summer,* 2009
Digital C-print
183 × 244 cm (72 × 96 in.)
INGLEBY GALLERY, EDINBURGH

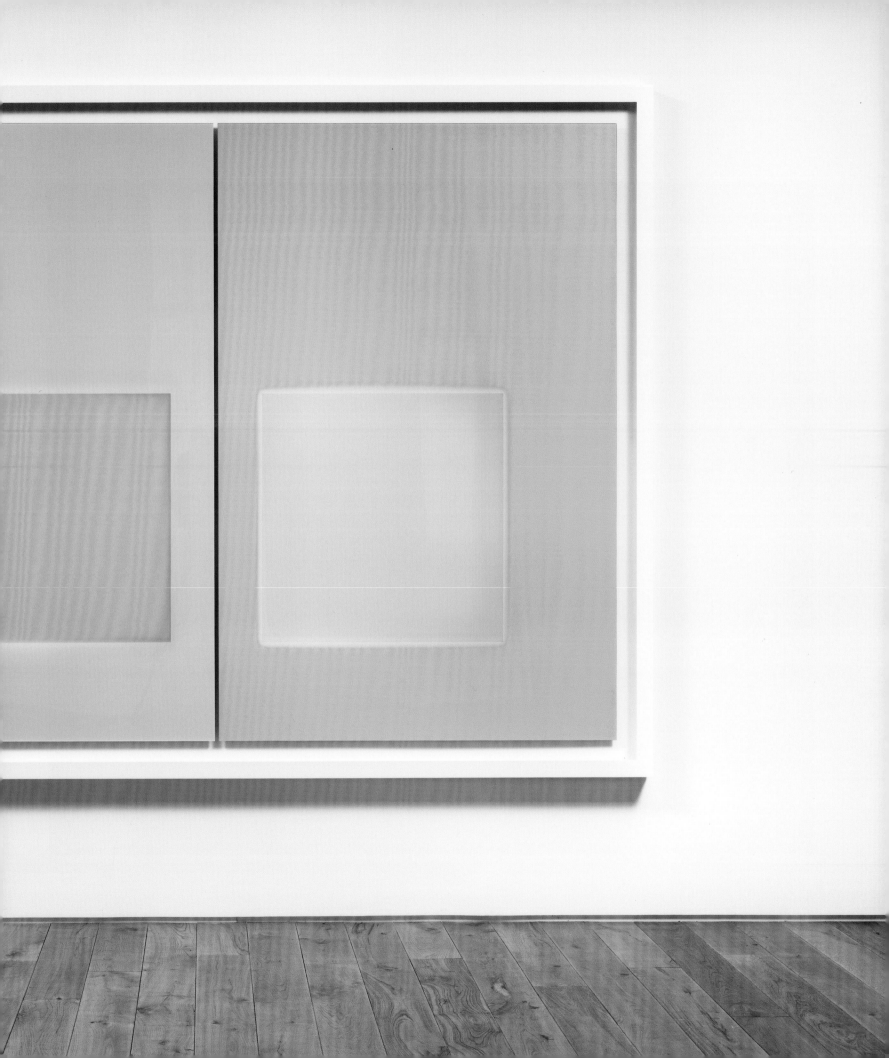

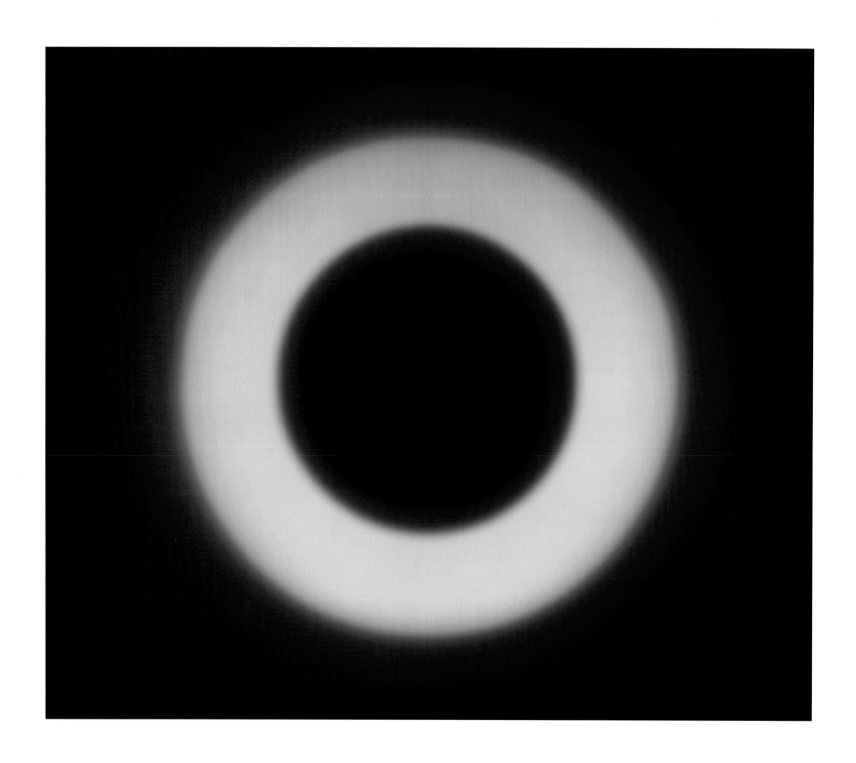

Gaze (i), 2009–10
Digital C-print
224 × 254 cm (88¹/₄ × 100 in.) framed
HACKELBURY FINE ART, LONDON

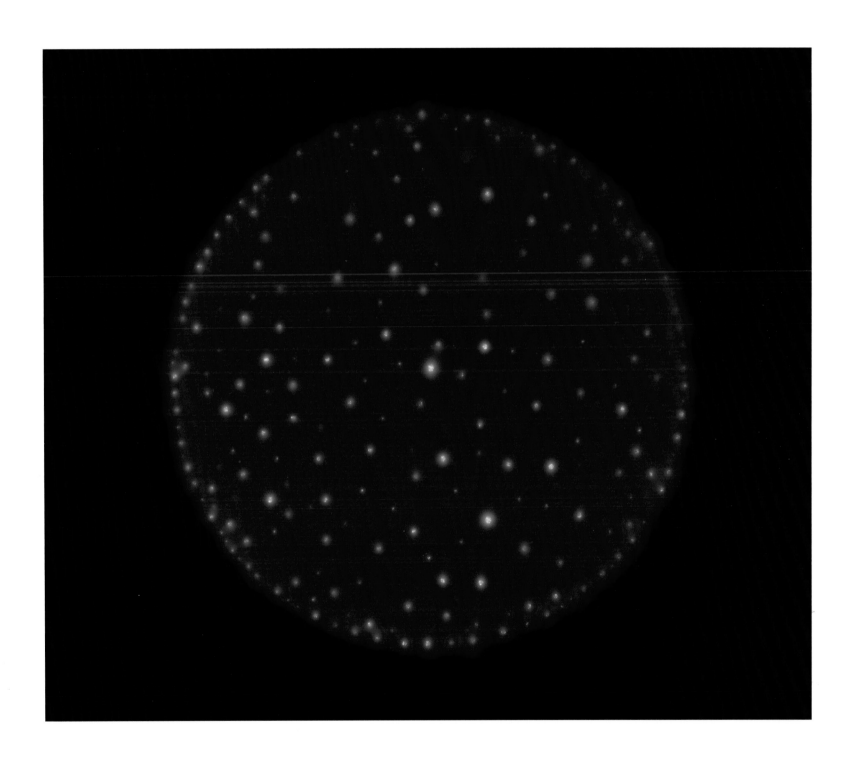

The Night Cell, 2009–10
Digital C-print
193 × 224 cm (76 × 88¼ in.) framed
HACKELBURY FINE ART, LONDON

EMBLEMS Adam Fuss

PAGES 148–49
From the series *In Between*
(detail; see page 161)

The work of Adam Fuss seeks to catch our attention and make us pause, through a combination of exquisite craft and compelling imagery that cannot easily be explained, in terms of either its origin or its method of production. For more than twenty years, alongside his mastering of numerous historic and modern photographic techniques, Fuss has developed, revised and refined an array of recurring emblematic motifs. He uses these emblems to provoke a seductive emotional encounter between the picture and the viewer. For Fuss, the visual attraction of an artwork, prompting in the viewer a sense of yearning or desire, is crucial in its making: 'It's only when I make a picture that I have to keep looking at that I feel I've succeeded ... Like the sensation of looking into the face of someone very beautiful.'[1]

In Fuss's work, various processes and techniques, and a knowing use of their inherent visual properties, are satisfyingly fused. They become a physical and conceptual part of the finished image as object. For those who are intrigued by methods of making, Fuss has explained many of his techniques, heading off questions about process even before they arise. Yet, like a magician revealing how a trick was performed, he reveals the mechanics but not the magic. His aim is to make the artifice so artful that we either cease to question it, or accept its mystery, and focus instead on the responses and readings his images provoke.

Fuss grew up between rural Sussex in the south of England and Australia before moving to New York in 1982. While acting as a commercial photographer in the city, he accepted a job taking photographs of Old Master prints for an edition of an extensive and scholarly encyclopedia, *The Illustrated Bartsch*.[2] Immersing himself in the history of such masterpieces must have left an impression, even if subliminally. Around this time Fuss began making his own work, breaking into and photographing inside abandoned New York warehouses. He was already seeking the marginal spaces outside the norm that would become a theme in his later work.

As in the case of the other artists discussed in this book, Fuss chose to work with camera-less photography as it provided a means of getting straight to the heart of his artistic concerns. He discovered the medium by mistake, in 1986, while already using

a rudimentary form of photography: a home-made pinhole camera. Light leaking accidentally into the camera cast the shadows of specks of dust on to the light-sensitive emulsion. Captivated by the results, Fuss immediately began to explore the possibilities offered by the production of photographic images without the aid of a camera. The method matched his underlying interests: not the reproduction of what can be seen in a documentary sense, but the discovery of the unseen. Since then, his art has dealt with time and energy rather than material form. Although he occasionally uses other means to produce his work, including the camera, Fuss has consistently used camera-less photography to engender a visual reawakening, to achieve a sense of vitality: 'We're so conditioned to the syntax of the camera. We don't realise we're running on only half the visual alphabet. It's so boring this way of seeing. It's killing us. In their simplicity, photograms give the alphabet unfamiliar letters. What is seen has never been in a camera. Life itself is the image. Viewers sense it. They feel the difference.'[3]

Among Fuss's first photograms was a series of images of concentric circles, begun in 1988, and he has continued to work with this circular motif. The piece *Ark* (1990; page 159) was created by placing a sheet of photographic paper in a tray of water, letting a single drop from a pipette fall into the still surface and firing a flash to record the event. The black-and-white image has a finely calibrated range of grey tones delineating the subtly undulating spread of the wave. The image has many sources of reference. Fuss's formative years in the English countryside – roaming the outdoors, observing pond life and camping out in ancient stone circles – left a deep impression on him. *Ark* links to such boyhood influences, but also encompasses metaphysical meanings. It is 'The One', a single drop of liquid energy that expands as a wave infinitely. Fuss has described how '"The One" is so big that everything can fit inside "The One".'[4] Hence, it is a kind of totality, a Noah's Ark, able to contain all the species of the world during the flood. It is the first drop of rain that signals the deluge; but it is also an arc, a crescent, the rainbow, God's covenant after the flood. Equivalent circles can be found in the paintings of Hilma af Klint (1862–1944), a Swedish mystic greatly admired by Fuss. For

Working in his darkroom and studio,
Fuss creates a series of daguerreotypes/
photograms of butterflies. Now a largely
obsolete photographic medium, the
daguerreotype was first used in the 1840s.

Af Klint, the spreading circles signified the infinite possibilities of development.

While the circle is the single inner eye of developmental serenity, its opposite is *Untitled 1988* (1988; page 157), a chaotic multitude made by climbing a ladder and hurling a bucket of water at the paper. Here is a restless surfeit of information, the plunging water resulting in what could be the creation of a new landscape, the splitting of atoms or the birth of a solar system. If *Ark* is 'forever', this explosion is 'now'.5 As in Susan Derges's *Vessel No. 3* series (1995; page 95), symbols of creation and nascent life may be found in Fuss's images of babies. For *Invocation* (1992; page 165), a mother briefly placed her child on a sheet of photographic paper that had been submerged in a tray of shallow water. The resulting image – created by firing flashlight directly at the paper – captures not only the child's outline but also the ripples in the water caused by its movements. (It is interesting to note that, even at four weeks old, a baby still moves as it did in the amniotic fluid of the womb.) Where the baby was making contact with the paper, the body has a darker mass; where light was able to seep around its form, the body is less solidly shown. The vibrant yellow of the image resembles the yolk of an egg or the light of the sun, a fitting colour for its theme of birth and life. Fuss's image is a kind of baptism, but its title, *Invocation*, also means an earnest appeal or prayer to a supernatural being for psychological or spiritual inspiration.

While the energy of emerging life has been the subject of Fuss's works discussed so far, it is the haunting evocation of a life lost that permeates the series *My Ghost* (1995–2001). This set of interlinked images unfolded as he made them, like chapters in a story, and were sequenced in the form of a book with the same title. The book includes poetry and prose by Arseny Tarkovsky, Neville Wakefield, Leonid Aronzon and Rainer Maria Rilke, all concerning the themes of love, grief, loss and mourning.6 Their words are printed in a pale blue-grey on the edge of legibility, forcing the reader to linger over the pages. Fuss's images address the same themes as the text, gaining affirmation through their frequency. Flocks of birds scatter in flight. In one of the images,

a bird is singled out, surrounded by a halo of others, as if being protected and guided on its ascent (page 169). A collection of children's christening robes appears as shrouds devoid of bodily forms. Closer inspection reveals a serpentine figure, one of Fuss's recurring emblems, woven into the pattern of one of the robes (page 167). Throughout the history of art, the snake has symbolized a loss of innocence, the coming of a self-reflective state, an ecstatic struggle. The rabbit also features often in Fuss's work: a symbol of innocence, reproduction, fertility and sacrifice. For *My Ghost*, the skinned face of a rabbit was projected on to photographic paper using wavering candlelight, giving the image a soft, pulsating quality; the ears, for example, look like flames (page 171). The book also includes funereal columns of rising smoke. Fuss's photograms give the immaterial smoke a solidity it should not have, its serpentine coils tracing eddying patterns in the air. Emerging from one of the smoke columns is an eerie spectre in vaguely human form (page 175).

Another of the motifs in *My Ghost* is the butterfly, a classic symbol of the brevity of life, its flight standing for the passage of the soul (page 173). In addressing the butterfly's perennial potency, Fuss chose to resurrect an obsolete historic photographic process, the daguerreotype, thus investing his image with added meaning. Daguerreotypes were formed directly on copper plates, which were silvered to become photographic, polished like a mirror and developed using mercury vapour. Depending on how light strikes the plate, and the angle from which it is viewed, the image flips between negative and positive. Daguerreotypes were used from the 1840s until around the 1870s, often as *memento mori*, keepsake portraits of deceased loved ones. The plates were made to be exposed in a camera, and no photograms on daguerreotype plates from the nineteenth century have so far been found to exist. Daguerreotypes were more expensive and time-consuming to produce than paper negatives and prints, and were prized for their precision and ability to record detailed images. To squander them as photograms would have seemed foolish. Fuss's daguerreotype photograms, such as that of the evanescent butterfly, are therefore like a missing link in photographic history, something that could

have been done but seemed counterintuitive at the time. In his butterfly image, the insect occupies only a fraction of the surface area of the entire plate, most of which has been intentionally overexposed, producing a shimmering blue. The overexposure, and the imbalance between the subject depicted and the size of the plate, would have been considered errors in the nineteenth century. However, Fuss finds beauty in this excess, and in the unique colour that is so suggestive of eternity. Having learned and understood the historic rules of the daguerreotype, he breaks nearly every one of them. Looking at the actual plate (rather than its reproduction on paper, which can never do it justice), the viewer sees the delicate fleeting image and his or her own reflection simultaneously. The photogram of the butterfly frozen in time mingles with the changing current moment. It is like seeing the past in the present.

The images in the *My Ghost* series express in visual terms the idea of a human presence that is lost and can be recalled only momentarily by its traces. These traces can be physical and emotional. As Fuss has said of the series, 'The work is about the passage of that quality of presence, which is not physical, but is still real.'7 Both morbid and exquisite, *My Ghost* moves through its sequence of emblems, at once a personal story and a universal pattern. Its underlying tone of sorrow is mixed with hope. This can be seen in the upward gesture of many of the images: the flight of birds, the butterflies or the rising smoke.

The vertical impulse in *My Ghost* is also apparent in an impressive, untitled life-size photogram of a ladder (1994; page 161), from the series *In Between* (1994–). Working for a time among the members of a Shaker community, Fuss was inspired by their hand-built ladders. Set against a bright, dematerialized white background, the rungs of Fuss's photogram equivalent shimmer with a look of oxidized silver. For Fuss, of course, the ladder is much more than a practical tool: it is an emblem of aspiration. Like the ladder of Jacob's dream in the Book of Genesis, it is the route via which angels ascend and descend. It also provides a means of moving away from Earth towards the cosmos, into the 'in between' space of the title of the series from which the work

The snake is a recurring motif in Fuss's work. Using live animals in his studio, he explores the snake's many symbolic and metaphorical manifestations, as in snakes and ladders.

is taken.[8] As in the case of many of Fuss's works, the ladder image implicates the viewer in a journey towards an out-of-body experience, a kind of revelation. In the artist's words, 'I feel I want in the picture some kind of revelation in a visual way ... it is really a moment where you are not yourself, where you can go out of yourself. So that could happen when you are in front of something you don't understand.'[9]

Fuss's mesmerizing spiral images, such as *Untitled* (2001; page 177), are an attempt to symbolize, or even induce, the out-of-body experience that can be the precursor to a moment of revelation. To make these pieces, he suspended a light coated with a coloured gel a short distance above the photographic paper. He then swung the light in a roughly circular motion, and left it to come to a standstill; depending on the force of the initial swing, the light was in motion for anything between fifteen minutes and two hours. The ever-decreasing ellipses of the resulting image create the impression of a tunnel, the centre of which has been exposed to light for longer and is therefore transformed into a blazing hole of white light. With minimal intervention from the artist's hand, a vortex is created through the action of gravity, time and light.[10] The vortex is an axis of ascension, seen through the image rather than being implied from above. It recalls the meditative whirling dances of the followers of Sufism, the mystical branch of Islam in which Fuss finds inspiration.[11] The shadow also plays an important role in Sufism. To reach a state of transcendence, one must first orient oneself. Orientation takes the form of discerning and then locating the shadow within, which is a projection of our own lower ego or soul. The shadow is a veil that separates us from light consciousness and a pacified soul.[12]

Fuss's work alerts us to the existence of our inner shadow, and can be seen as a means of locating it. His images act as reminders, and draw us towards light, so embedded in the primary language of photography as an explicit metaphor for spiritual illumination:

> Light is a metaphor: where you have a dark place, and where that place becomes illuminated; where the darkness becomes

visible and one can see. The darkness is me, my being.
Why am I here? What am I here for? What is this experience
that I am having? This is darkness. This is a question I
ask, and when I ask it, it's like looking into a black space.
Light provides an understanding. Not physical light, but
understanding the question is like light. I have this dark
space in me, and when I ask a question, that is desire for
light, and perhaps the light will come.[13]

The overarching concerns of Fuss's emblematic lexicon,
conceived as a visual elegy, are the expression of the ephemeral
and the universal themes of life, death and spirit. His work is both
the expression of desire and the framing of a question. Through
outward sensory vision, it explores ideas of non-sensory insight.
It is a call to the consciousness to rise and awake.

NOTES

1 Adam Fuss, quoted in press release by Jonathan Lewis for Deborah Ronnen Fine Art, New York, 2002, Victoria and Albert Museum Word and Image Department, Photography Section files.

2 *The Illustrated Bartsch*, New York (Abaris Press) 1982.

3 Adam Fuss, quoted in Eugenia Parry, *Adam Fuss: Less of a Test Than Earth*, Santa Fe, N. Mex. (Arena Editions) 1999.

4 Adam Fuss, from an interview with Paul Arden for a film directed by Sam Hodgkin, Timothy Taylor Gallery, 2005.

5 A piece by Fuss entitled *Now!* (1988), made using the same method, is held by the Metropolitan Museum of Art, New York.

6 Adam Fuss, *My Ghost*, Santa Fe, N. Mex. (Twin Palms) 2002.

7 Adam Fuss, interview with Daniel Pinchbeck, *Art Newspaper*, no. 95, September 1999.

8 The nine spaces articulated between the rungs of the ladder may represent the nine divisions of the Great Chain of Being, a classical concept of medieval Christian teaching familiar to Fuss. In ascending order, the divisions are earth, minerals, plants, animals, man, elements, Heaven, angels and God. Another version of the ladder image features seven differently coloured spots, each one corresponding to one of the seven major chakras (in Indian thought, centres of spiritual energy in the human body).

9 Adam Fuss, interview with Rut Blees Luxemburg, *Next Level*, 5, 2006, p. 49.

10 For a fascinating overview of the significance of the spiral form, see Theodore Andrea Cook, *The Curves of Life: Being an Account of Spiral Formations and Their Application to Growth in Nature, to Science and to Art* [1914], New York (Dover) 1979.

11 Of all the esoteric references and influences drawn on by Fuss, it is perhaps Sufism and the teachings of G.I. Gurdjieff, derived in part from Sufism, that provide the greatest insight into his work. See, as a start, Henry Corbin, *The Man of Light in Iranian Sufism*, tr. Nancy Pearson, Boulder, Col., and London (Shambhala) 1978; and P.D. Ouspensky, *In Search of the Miraculous: The Teachings of G.I. Gurdjieff*, San Diego, New York and London (Harcourt) 1949.

12 For a fuller explanation of the concept of orientation in Sufism, see Corbin, *The Man of Light in Iranian Sufism*, pp. 61–97.

13 Interview with Adam Fuss, undated, Victoria and Albert Museum Word and Image Department, Photography Section files.

Untitled 1988, 1988
Gelatin-silver print
154.9 × 142.2 cm (61 × 56 in.)
CHEIM & READ GALLERY, NEW YORK

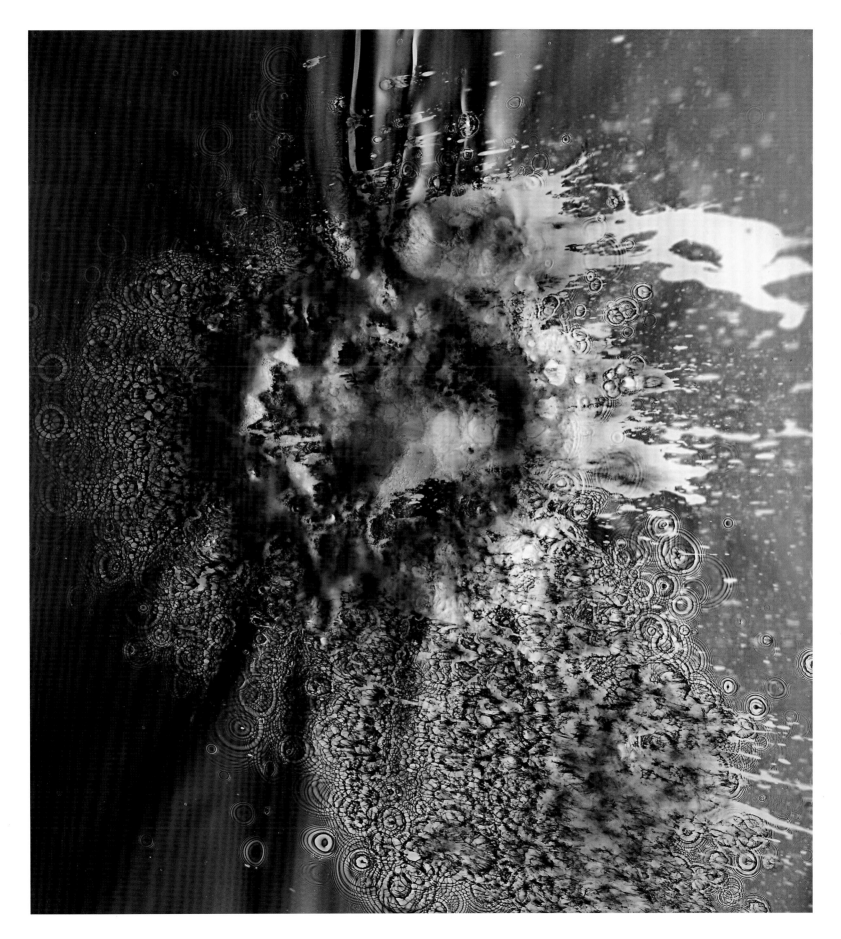

Ark, 1990
Gelatin-silver print
140 × 140 cm (55^1/8 × 55^1/8 in.)
VICTORIA AND ALBERT MUSEUM, LONDON

From the series *In Between*, 1994
Gelatin-silver print
533.4 × 152.4 cm (210 × 60 in.)
VICTORIA AND ALBERT MUSEUM, LONDON

Untitled, 2007
Gelatin-silver print
182.4 × 135 cm (71 3/4 × 53 1/8 in.)
TIMOTHY TAYLOR GALLERY, LONDON,
AND CHEIM & READ GALLERY, NEW YORK

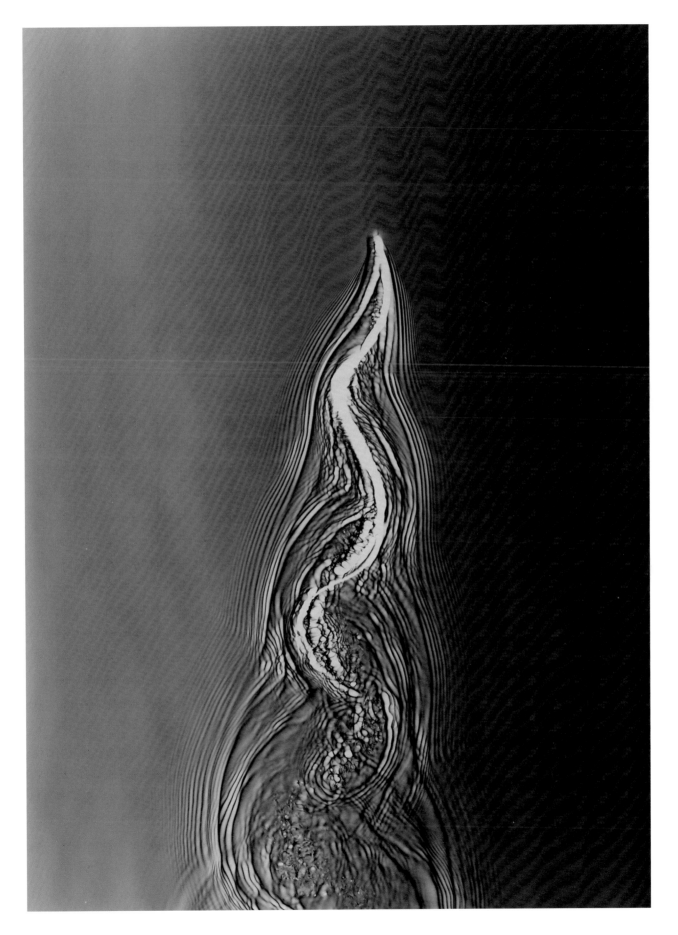

Invocation, 1992
Dye destruction print
99.6 × 72.3 cm (39¹/₄ × 28¹/₂ in.)

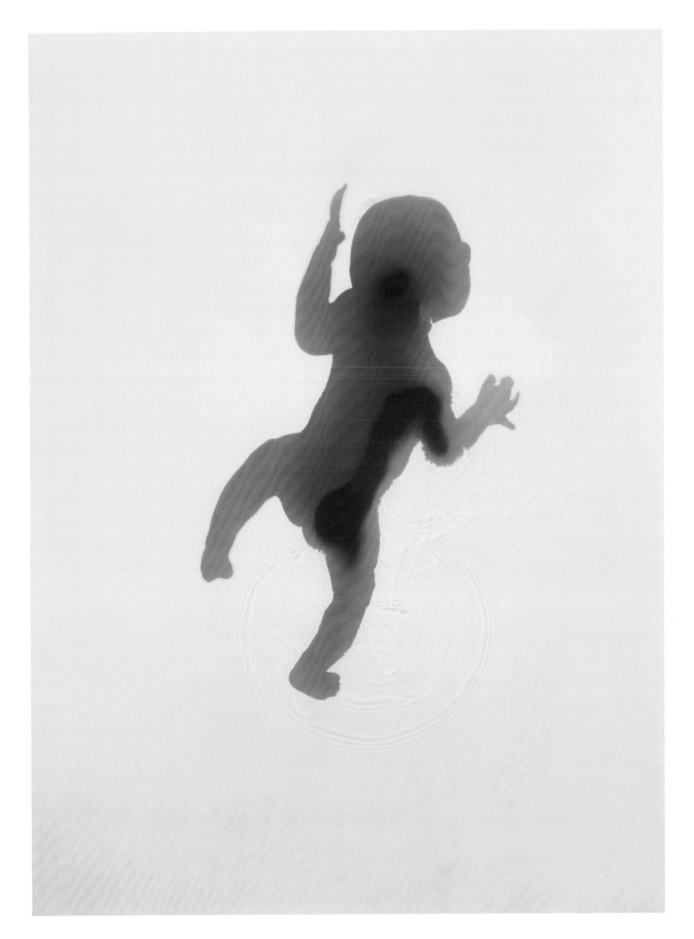

From the series *My Ghost*, 1997
Gelatin-silver print
160 × 104.1 cm (63 × 41 in.)
CHEIM & READ GALLERY, NEW YORK

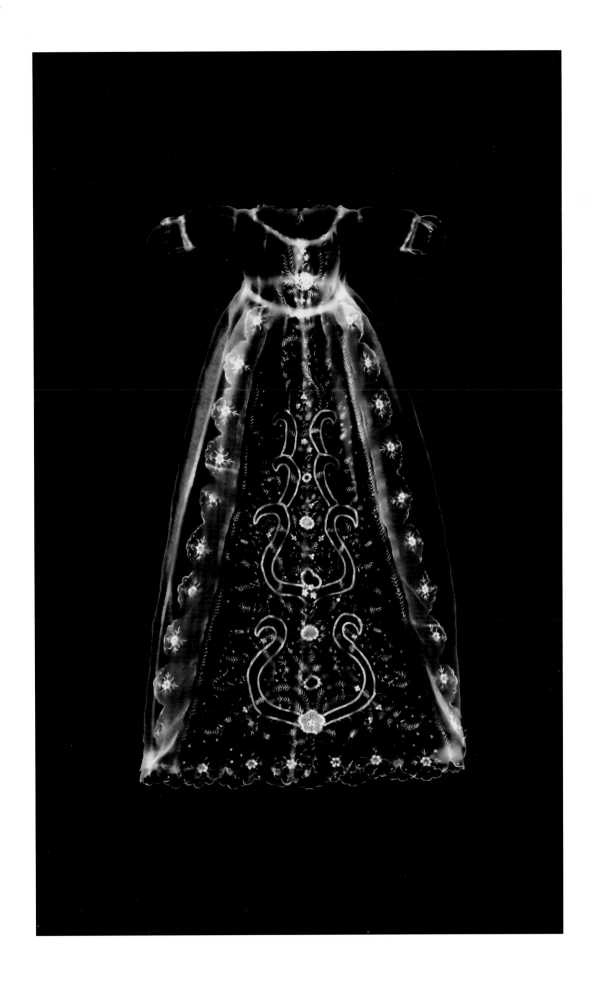

From the series *My Ghost*, 1999
Gelatin-silver print
134.6 × 113 cm (53 × 44 1/2 in.)
CHEIM & READ GALLERY, NEW YORK

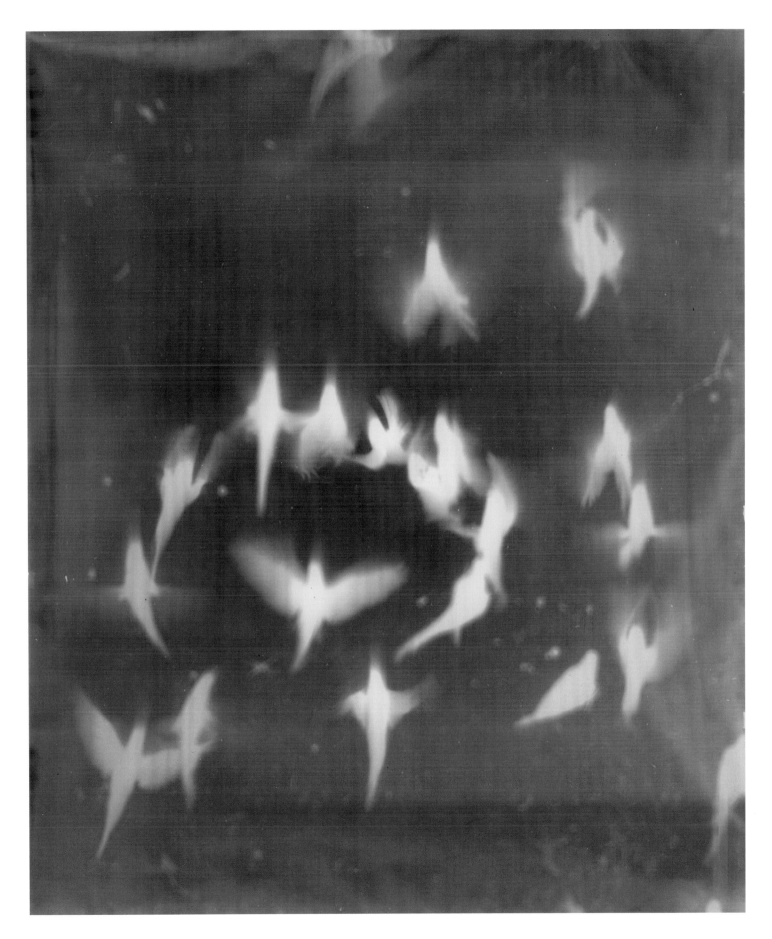

From the series *My Ghost*, 1997
Gelatin-silver print
149.2 × 99.1 cm (58³/₄ × 39 in.)

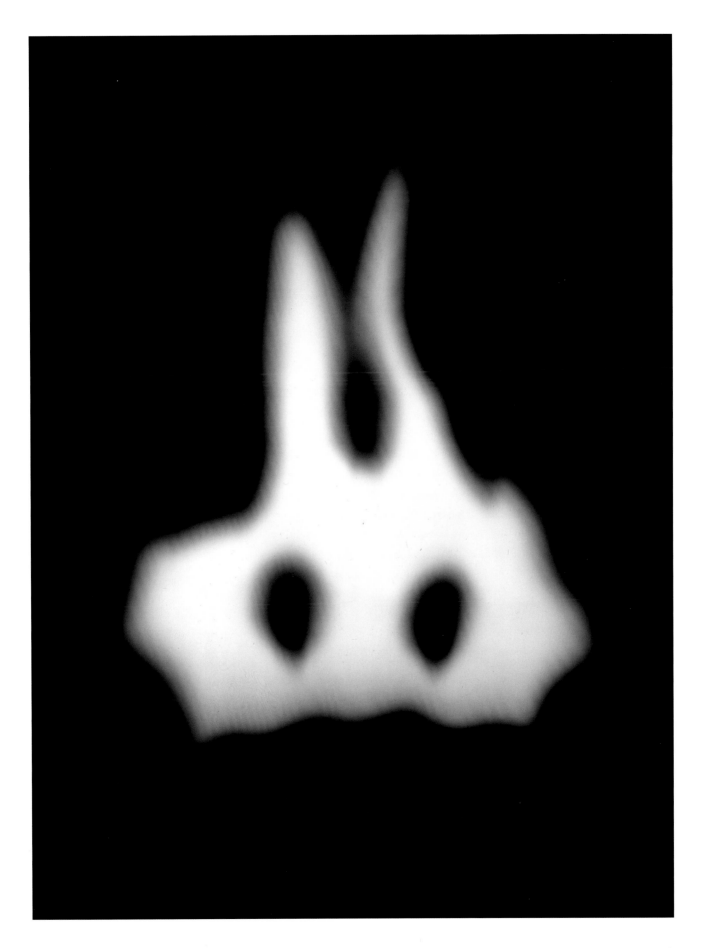

From the series *My Ghost*, 2001
Daguerreotype
61 × 50.8 cm (24 × 20 in.)
CHEIM & READ GALLERY, NEW YORK

From the series *My Ghost*, 1999
Gelatin-silver print
186.1 × 145.4 cm (73 1/4 × 57 1/4 in.)
CHEIM & READ GALLERY, NEW YORK

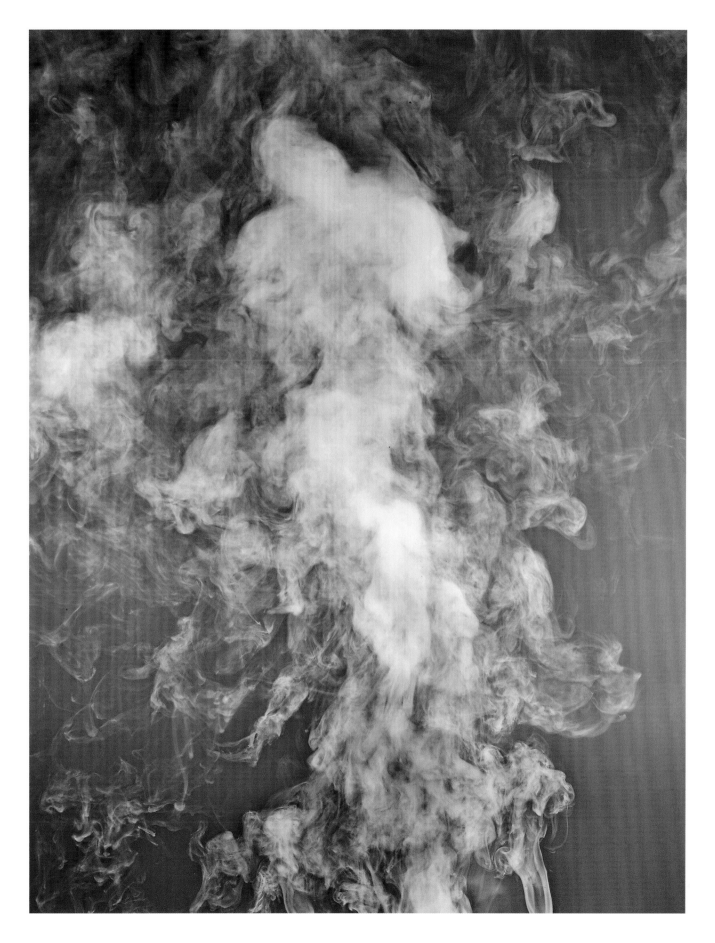

Untitled, 2001
Dye destruction print
159.4 × 127 cm (62³/₄ × 50 in.)
CHEIM & READ GALLERY, NEW YORK

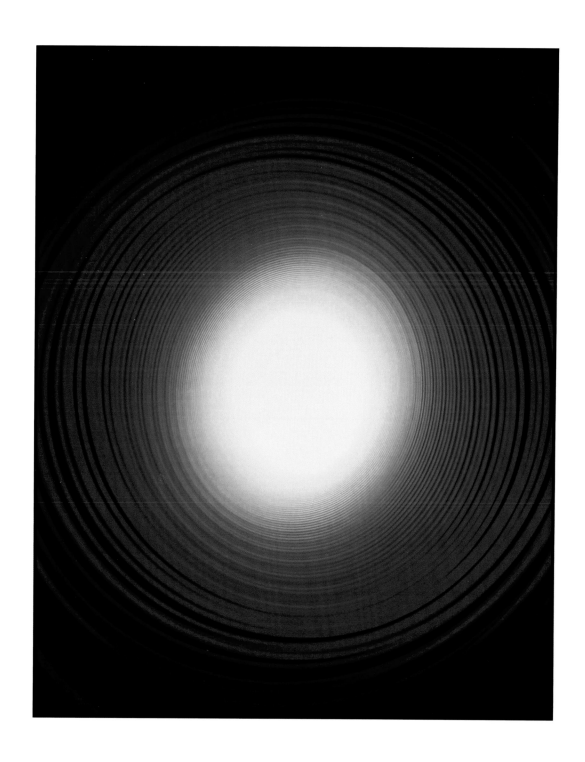

AFFINITIES

Each of the five artists considered in this book has created a unique body of work that stands distinctively on its own merits. However, the artists are also linked by similar working practices and conceptual preoccupations, which run like an undercurrent in the flow of photographic history. There are many differences between them, but they share a common interest in alternative ways of seeing brought about by a liberation from the camera, finding affinities through notions of translation and transformation. The works they create distil photography to its basics and inhabit an evocative border between familiar and unfamiliar subject-matter. In so doing, they cut through a world saturated with camera-made imagery. They prompt us to look again and question what we think we see and understand.

The technical processes used in camera-less photography confound the usual photographic criteria of focus, lighting and point of view. Despite increasingly sophisticated attempts at veracity, camera-made photographs are akin to a mirror, mimicking but inevitably distorting the world they reflect. In his book *A Short History of the Shadow* (1997), art historian Victor I. Stoichita recounts the differing perceptions of the shadow in philosophy and psychology. He suggests that mirror-like images can be identified with 'the self', while shadows relate to an awareness of 'the other'. In Plato's allegory of the cave, a group of prisoners compelled to gaze at the wall of a cave come to perceive as reality the shadows cast on the wall by people passing in front of a fire that burns behind them. Unable to turn their heads, the prisoners remain unaware of the true nature of reality beyond the confines of the cave. While Plato's tale posits the shadow as a form of ignorance or negativity, it is nevertheless an indicator of where enlightenment may lie. In contrast, Pliny the Elder's story about the origin of representation tells of the Corinthian maid who traces on a wall the shadow of her departing lover. The consciousness of this shadow is borne out of resistance to loss – and of love.

The rising interest in camera-less photography today can be seen as part of a wider interest in gaining a closer connection to origins, questioning single viewpoints, and embracing partial and transitory states; it can also be regarded as a way of commenting on

FIG. 1
Laura MacKenzie (*fl.* early 19th century)
An Unknown Family Group, c. 1800–20
Cut-paper silhouette
15 × 20 cm (5⁷/8 × 7⁷/8 in.)
VICTORIA AND ALBERT MUSEUM, LONDON

FIG. 2
Saint Veronica Holding the Vernicle, c. 1490
Ceramic tile, panel for a wall incrustation,
possibly made in Romagna
Tin-glazed earthenware
27 × 27 cm (10⅝ × 10⅝ in.)
VICTORIA AND ALBERT MUSEUM, LONDON

the death of analogue photography.[1] Using camera-less methods is often like trying to connect with a distant ancestor, to bring them into the present. The camera-less image, especially the photogram, becomes an indexical sign belonging to the family of traces that includes cut-paper silhouettes (fig. 1), fingerprints, fossils or tracks in snow. One of its strengths is its haptic quality, that is, a value relating to the sense of touch. The lineage of images made by physical transfer can be followed back to the prehistoric handprints found on the walls of some French and Cantabrian caves. Like these poignant records of human presence, camera-less photographs are less examples of physical contact than evocative traces of touch.

Another potent concept associated with camera-less photography is that of acheiropoiesis, images not made by mankind, from the Greek *cheiros* (the hand) and *poiein* (to make). This term is used to classify Orthodox icons, the origin of which is said to be divine. The idea of the miraculous image as a kind of proto-photography is embedded in the Christian tradition. One need only think of such famous relics as the Shroud of Turin, imprinted with what is believed by some to be the image of Jesus's body after it had been removed from the cross. (Scientific analysis has since proposed a late medieval date for the shroud's creation, yet it still defies scholars as to its method of production.) The original example of such images may be found in the legend of Veronica (the patron saint of photographers), who accompanied Christ on his march to crucifixion on Calvary, and was so moved by his suffering that she wiped his face with her veil. And there the imprint of his features remained (fig. 2).

Like icons or relics passed down through generations, the subjects and motifs of camera-less photography signal a state of metamorphosis but retain their core integrity. For this reason – and because of their chemical associations – allusions to alchemy, whether covert or explicit, provide the platform for poetic suggestion. The outcomes often lie within the dynamics of the process itself. In French, the word *révélateur* is used to denote the photographic developing bath, suggesting that the image is not necessarily grown or developed, but is already formed, waiting to

be revealed. While relatively simple once understood (although often requiring skill and practice), technical processes can remain an enigma to non-practitioners. We might therefore imagine an artist-creator figure controlling, with an almost godlike power, the realization and accidents of matter. In her book *Phantasmagoria: Spirit Visions, Metaphors, and Media* (2004), Marina Warner examines the recurring ingredients of expressions of the spirit, metaphors from history that have persisted into modernity. These include such things as wax, air, light, ether, shadow, breath and cloud. The works of Neusüss, Cordier, Derges, Fabian Miller and Fuss utilize many of these ingredients, reflecting a shared and age-old concern within the arts that is above the material and beyond the cerebral. Whether we invest their images with alchemical and esoteric properties or not, their works make us aware of the things that, ordinarily, we find difficult to see and elusive to describe, but which nourish our curiosity and creative spirits.

As an optical instrument, the camera extends the faculty of sight as a reflection of reality and an organ of sense. But it is used by only a few as an instrument of imagination. Bypassing the camera and lens that replicate the outer eye, the artists in this book deal instead with visions of the inner eye. Their works can act as both objects and signs. They show what has never really existed, posing as many questions as they answer. Yet, with a combination of technical delicacy and observational subtlety, they convey a vital sense of life.

NOTE

1 Contemporary artists addressing these themes include Marco Breuer (born 1966), Wolfgang Tillmans (born 1968) and Walead Beshty (born 1976). All of them have recently gained wide recognition for their use of camera-less photography.

TECHNICAL NOTES

Camera-less photographs can be made using a variety of techniques, the most common of which are the photogram, the luminogram and the chemigram. These techniques are sometimes used in combination.

Exciting elements of chance are often at play in camera-less photography, and are embraced as part of the creative process. The photogram artist is not able to predict the results in the viewfinder of a camera, and often works in the dark. The final image becomes apparent only after physical and chemical manipulation or development.

The following notes provide explanations for the processes discussed and illustrated in this book. For further technical information, see Luis Nadeau, *Encyclopedia of Printing, Photographic and Photomechanical Processes*, New Brunswick, NJ (Atelier Luis Nadeau) 1989, and the related website, photoconservation.com; and Gordon Baldwin, *Looking at Photographs: A Guide to Technical Terms*, Los Angeles and London (J. Paul Getty Museum in association with the British Museum Press) 1991.

AUTO-REVERSAL PAPER
A type of gelatin-silver print paper that reverses the action of the silver salts, so that light striking them turns the paper dark instead of light.

CHEMIGRAM
Chemigrams are made by directly manipulating the surface of photographic paper, typically with varnishes or oils and photographic chemicals. Chemigrams are produced in full light, and rely on both the maker's skill and their understanding – gained through documented experiments – of how chance can be harnessed for creative effect.

CYANOTYPE
A photographic process introduced in 1842 by Sir John Herschel. Paper impregnated with iron salts is placed in contact with an object or negative and exposed to daylight. This produces an image in insoluble Prussian blue, which is fixed by washing in water.

DIGITAL C-PRINT
Digital C-prints are produced from digital images using digital printers. Inside such printers, chromogenic (or 'C'-type) photographic paper is exposed to red, green and blue lasers; the paper is then processed in the traditional, chemical-based manner. Digital C-prints are also known by certain trade names, including 'digital Lambda' (after Durst Lambda printers) and 'Laserchrome print' (another type of digital printer). Digital C-prints of images created by camera-less methods can be made from digital files derived from the original image. When processed in this way, camera-less images can be retouched, enlarged and reproduced as multiples.

DYE DESTRUCTION PRINT
A print made using direct positive colour paper, which was originally introduced – in 1963 – for printing colour transparencies or negatives. The paper is coated with at least three layers of emulsion, each of which is sensitized to one of the three primary colours (red, green and blue); each layer also contains a dye related to that colour. During development of the image, any unexposed dyes are bleached out (hence 'dye destruction'); the remaining dyes, perceived as one against the white support, form a full-colour image.

The dye destruction print is highly regarded because of its relative permanence. Also known by its technical description, 'silver dye bleach process', and its trade name, Ilfochrome (formerly Cibachrome).

GELATIN-SILVER PRINT
A print made using paper that has been coated with gelatin containing silver salts. The silver salts contained in the gelatin emulsion are principally silver bromide or silver chloride. Where light strikes the silver salts, they become dark; the image is then developed out using chemical developer. The sensitivity of the salts is such that it is possible to make enlargements by projecting the negative. The paper itself can have a matt or gloss surface, and the image can be toned. Introduced in 1871, the gelatin-silver print is still in general use today.

LUMINOGRAM
A variation of the photogram in which the objects obstructing the light to form an image are not in direct contact with the photographic paper. Instead, the objects either cast a shadow on the paper if opaque, or filter light if transparent.

PHOTOGENIC DRAWING
The name given to a camera-less photographic process invented by William Henry Fox Talbot in the 1830s. A compound of common salt and silver nitrate is applied to a sheet of paper to produce a light-sensitive layer, on which an image may then be formed. Talbot's photogenic drawings were made using what is now known as the photogram process.

PHOTOGRAM
Photograms are made by placing an object in contact with, or at a short distance from, a photosensitive surface and, in the dark, exposing both to light. Where the object blocks the light, either partially or fully, its shadow is recorded on the paper. The term 'photogram' seems to have appeared around 1925. Christian Schad used the term 'Schadograph', and Man Ray 'Rayograph', to describe the same technique.

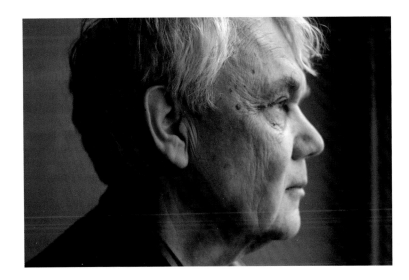

Floris Neusüss
(German, born Lennep, 1937)

Neusüss made his first photograms in 1954, and has continued
to explore and pioneer the technique ever since. Extending the
practice, study and teaching of the photogram, Neusüss worked
intensively on the human body as a motif throughout the 1960s
and 1970s. The artist sometimes varies his photograms using
chemical treatments and multiple exposures. In 2000 Neusüss
shifted his attention from animate to inanimate human forms,
working at night in various museums to capture the shadows
cast by sculptures. The artist has also worked outdoors, using
lightning to expose the paper. In exploring such binary structures
as black and white, shadow and light, and movement and
stillness, Neusüss's imagery can be understood collectively as
an examination of history, nature and mythology. Alongside his
photographic practice, he is known as an influential writer on
and teacher of camera-less photography. He lives and works in
Kassel, Germany.

Pierre Cordier
(Belgian, born Brussels, 1933)

In 1958 Cordier briefly studied with influential experimental photographer Otto Steinert. Cordier is self-taught; this was the only formal photography course that he attended. Nevertheless, two years earlier, he had conceived of the chemigram, an image-making technique that combines the physicality of painting (varnish, wax, oil) and the chemistry of photography (photosensitive emulsion, developer, fixer) without the use of a camera. While practising as a commercial photographer, a career he abandoned in 1967, Cordier continued to pioneer the use of the chemigram technique. In 1965 he was appointed as a lecturer at the École Nationale Supérieure des Arts Visuels de la Cambre in Brussels, a position he occupied until 1998. When creating his chemigrams, Cordier often emphasizes the physical reactions on the surface of the photographic paper by repeatedly dipping the paper in developer and then fixer. This process has allowed Cordier to create graphic forms impossible to realize using any other medium. He continues to live and work in Brussels.

Susan Derges
(British, born London, 1955)

Derges studied painting at the Chelsea School of Art and at the Slade School of Fine Art, both in London. She subsequently explored early forms of camera-less photography, and has continued to refine and develop them. From 1981 to 1986 she lived and worked in Japan, carrying out postgraduate research at the University of Tsukuba. During this time she was inspired by Japanese minimalism, a style that has continued to influence her art practice. While Derges's work engages with the subject of alchemy – testing the interrelationship between the elements of fire, water, earth and air – her interest in revealing the hidden forces of nature through her observation of water remains central. Her images reflect a holistic system that encompasses the human psyche and finds its metaphors in the natural world. Derges currently lives and works near Dartmoor, in south-west England.

Garry Fabian Miller
(British, born Bristol, 1957)

Fabian Miller grew up learning the craft of photography from his father, who worked as a commercial photographer. Having established his reputation as a landscape photographer in the late 1970s and early 1980s, Fabian Miller stopped using a camera in 1984, choosing instead to explore the elements of photography through camera-less images produced in his darkroom. While the artist's works are reminiscent of early experimental photographs, they also display a compelling contemporary quality. Simultaneously possessing formal and spiritual characteristics, his imagery skilfully combines the Modernism of Donald Judd, Elsworth Kelly and James Turrell with a fundamental Englishness that can be traced back to Turner, as well as to such post-war abstract painters as Ben Nicholson. Fabian Miller's work is informed by the landscape of Dartmoor, in south-west England – on which his home and studio are situated – and examines in depth the subjects of time, light and colour.

Adam Fuss
(British, born London, 1961)

Fuss spent his formative years between rural Sussex in the south of England and Australia before moving to New York in 1982. After producing a series of pinhole-camera images in 1984, the artist created his first photogram in 1986. Responding to the pervasive technological-consumerist culture, Fuss returned to the most basic forms of photography in an artistic practice that combines both historic and contemporary photographic techniques, skilfully perfected and tailored to his own use. Drawing upon his childhood memories and personal experiences, his works address a broad set of emotion-laden themes, with a strong emphasis on composition, craft and formal elegance. In Fuss's work, light is used as a metaphor to illuminate the processes and stages of human life. Exploring the spiritual themes of life and death, the artist often uses one of a number of compelling motifs – including babies, water, spirals, snakes, flowers, smoke, ladders and birds in flight – that, over the years, he has developed into a personal and symbolic lexicon. He lives and works in both England and New York.

BIBLIOGRAPHY

BOOKS

Martin Barnes, *Illumine: Photographs by Garry Fabian Miller: A Retrospective*, London and New York (Merrell) 2005

Martin Barnes, ed., *Susan Derges: Elemental*, Götingen (Steidl) 2010

Pierre Cordier, *Le Chimigramme/The Chemigram*, Brussels (Éditions Racine) 2007

Garry Fabian Miller, with essay by Edmund de Waal, *Year One*, Edinburgh (Ingleby Gallery) 2007

Garry Fabian Miller and Lavinia Greenlaw, *Thoughts of a Night Sea*, London (Merrell) 2002

Adam Fuss, *My Ghost*, Sante Fe, N. Mex. (Twin Palms) 2002

Gottfried Jäger *et al.*, *Concrete Photography/Konkrete Fotografie*, Bielefeld (Kerberger Verlag) 2005

Martin Kemp, *Susan Derges: Liquid Form 1985–99*, London (Michael Hue-Williams Fine Art) 1999

David Alan Mellor and Garry Fabian Miller, *Tracing Light*, Maidstone (PhotoWorks) 2001

Floris Neusüss and Peter Cardorff, *ULOs Wunderbar*, Düsseldorf (Parerga) 2000

Floris Neusüss and Renate Heyne, *Das Fotogramm in der Kunst des 20. Jahrhunderts: Die andere Seite der Bilder. Fotografie ohne Kamera*, Cologne (DuMont Buchverlag) 1990

Eugenia Parry, *Adam Fuss: Less of a Test Than Earth*, Santa Fe, N. Mex. (Arena Editions) 1999

Lyle Rexer, *Photography's Antiquarian Avant-Garde: The New Wave in Old Processes*, New York (Harry N. Abrams) 2002

Lyle Rexer, *The Edge of Vision: The Rise of Abstraction in Photography*, New York (Aperture Foundation) 2009

Marina Warner *et al.*, *The Colour of Time: Garry Fabian Miller*, London (Black Dog) 2010

EXHIBITION CATALOGUES AND BROCHURES

Adam Fuss, Thomas Kellein, Boston, Museum of Fine Arts, September 2002 – January 2003; Kunsthalle Bielefeld, March–May 2003

Alchemy: Twelve Contemporary Artists Exploring the Essence of Photography, ed. Anna Douglas and Katy Barron, Harewood, London, Kendal and Nottingham, 2006–07

Anteidola: Fotogramme von Floris Neusüss in der Glyptothek, Raimund Wünsche, Munich, Glyptothek, March–June 2003

Azure: Susan Derges, Christopher Bucklow, Edinburgh, Ingleby Gallery, June–July 2006

Brought to Light: Photography and the Invisible, 1840–1900, ed. Corey Keller, San Francisco Museum of Modern Art, October 2008 – January 2009; Vienna, Albertina, March–June 2009

Camera-less Photography: Susan Derges, Garry Fabian Miller, ed. Junichi Seki, Yokohama Museum of Art, October 1994

Elective Affinities: Susan Derges and Garry Fabian Miller, Mark Haworth-Booth, London, Michael Hue-Williams Fine Art, April–May 1996

Experimental Vision: The Evolution of the Photogram Since 1919, Floris Neusüss *et al.*, Denver Art Museum, January–March 1994

Floris Neusüss – Körperbilder: Fotogramme der sechziger Jahre, T.O. Immisch *et al.*, Staatliche Galerie Moritzburg Halle, October–December 2001

Floris Neusüss: Nachtstücke Fotogramme 1957 bis 1997, Klaus Honnef, Bonn, Bad Arolsen and Hamburg, 1997

Garry Fabian Miller: Time Passage, James Hyman, London, James Hyman Gallery, November 2008 – January 2009; Kendal, Abbot Hall Art Gallery, April–June 2009

Kamera Los: Das Fotogramm. Eine künstlerische Position von der Klassik bis zur Gegenwart, Floris Neusüss and Margit Zuckriegl, Museum der Moderne Salzburg, October 2006 – February 2007

Recycling Lucifer's Fall, Nick Hackworth, London, Houldsworth Gallery, October–November 2003

Susan Derges, London, Purdy Hicks, June–July 2006

Susan Derges, Kim Airyung, Seoul, Johyun Gallery, May–June 2008; Busan, Johyun Gallery, June–July 2008

Susan Derges, Christopher Bucklow, London, Purdy Hicks, June 2009

Susan Derges: River Taw, Richard Bright, London, Michael Hue-Williams Fine Art, October–November 1997

Susan Derges: Woman Thinking River, ed. Frish Brandt and James Danzinger, New York, Danzinger Gallery, March–May 1999; San Francisco, Fraenkel Gallery, April–May 1999

Under the Sun: Photographs by Christopher Bucklow, Susan Derges, Garry Fabian Miller, and Adam Fuss, ed. Jeffrey Fraenkel, San Francisco, Fraenkel Gallery, December 1996 – January 1997

WEBSITES

concrete-photography.org
photogram.org
pierrecordier.com
susanderges.com
vam.ac.uk (see, in particular, a film by David Waldman specially commissioned for the *Shadow Catchers* exhibition related to this book)

AUDIO

British Library National Sound Archive interviews:

Susan Derges interviewed by Mark Haworth-Booth, 1996, C459/79/1–2/F4966–F4967 C1

Garry Fabian Miller interviewed by Mark Haworth-Booth, 1996, C459/78/01–03/F4963–F4965 C1

Garry Fabian Miller interviewed by Martin Barnes, 2003, C459/78/04–07/F4963–F4965 C1

Adam Fuss interviewed by Mark Haworth-Booth, 1998, C459/103/F6559–F6562

ACKNOWLEDGEMENTS

My sincere thanks go to the five artists who have helped me in the realization of this book: Floris, Pierre, Susan, Garry and Adam.

I would also like to thank Renate Heyne and Ulf Saupe, working with Floris Neusüss; and Ben Burbridge and Di Poole, at Atlas Gallery, London. For their help with Floris's *Lattice Window* remake, my thanks go to Roger Watson, Rachel Nordstrom, Harvey Edington and Graham Heard of the Fox Talbot Museum, Lacock Abbey and the National Trust; Claudia Amthor-Croft, Maja Grafe and Penny Black at the Goethe Institut, London; and Richard Learoyd, who processed the work and kindly assisted in its creation. Additional thanks go to Flavia Souza at Adam Fuss's studio; Howard Read, Jan Eldrich and staff at Cheim & Read Gallery, New York; Camille Van Vooren at Pierre Cordier's studio; Richard and Florence Ingleby, Andrew Innes, Alice Ladenburg, Daniel Smernicki and David Mackay at Ingleby Gallery, Edinburgh; and Marcus Bury, Kate Stevens, Christian Dillon and Zara Horner at HackelBury Fine Art, London.

I am indebted to Hugh Merrell for his enthusiasm, and to the team at Merrell Publishers, especially Nicola Bailey, Claire Chandler, Mark Ralph and Alenka Oblak.

I would like to thank my colleagues at the Victoria and Albert Museum (V&A), especially those who assisted me in the research stages: Liz Miller, Christopher Breward, Mark Evans, Julius Bryant, Lauren Parker, Lizzie Capon and Glenn Adamson. My thanks also go to the Photographs Section team in the museum's Word and Image Department – Susanna Brown, Ashley Givens, Marta Weiss, and interns Ashley Galloway and Ariane Belisle – who assisted with various stages of this book and acted in support while I was absorbed in its writing. For producing a beautiful design for the related *Shadow Catchers* exhibition, I wish to thank V&A designers Line Lund and Nadine Fleishcher, and the V&A exhibitions team. V&A exhibition project manager Sarah Terkaoui deserves a special mention for her good humour, late hours and input into the book beyond the call of duty. Importantly, I would also like to thank Barclays Wealth for providing generous sponsorship, which enabled the V&A to realize its ambitions for the exhibition.

Much gratitude also goes to Pierre Brahm for support behind the scenes, and to Gottfried Jäger, Susie Needham and Margit Zuckriegl for their help and for discussing topics of shared interest. Christopher Bucklow and Mark Haworth-Booth are really the crucial missing, but not absent, links in this book. Thank you for paving the way, and for your always perceptive insight and shared thoughts.

INDEX

First published 2010 by

Merrell Publishers Limited
81 Southwark Street
London SE1 0HX

merrellpublishers.com

in association with

Victoria and Albert Museum
Cromwell Road
London SW7 2RL

vam.ac.uk

British Library Cataloguing-in-Publication data:
Barnes, Martin, 1971–
Shadow catchers : camera-less photography.
1. Photograms. 2. Photography, Artistic. 3. Photographic chemistry.
I. Title II. Victoria and Albert Museum.
770.9′22-dc22

ISBN 978-1-8589-4538-5

Produced by Merrell Publishers Limited
Designed by Nicola Bailey
Project-managed by Mark Ralph
Indexed by Vicki Robinson
Printed and bound in Singapore

Published on the occasion of the exhibition *Shadow Catchers: Camera-less
Photography*, Victoria and Albert Museum, London, 13 October 2010 –
20 February 2011, sponsored by

**BARCLAYS
WEALTH**

JACKET, FRONT
Adam Fuss, from the series *My Ghost* (detail; see page 173)

JACKET, BACK
Floris Neusüss, *Untitled (Körperfotogramm, Berlin)* (see page 26)

FRONTISPIECE
Susan Derges, *Arch 4 (summer)* (detail; see page 113)

PAGES 6–7
Pierre Cordier, *Chemigram 8/2/61 III* (detail; see page 67)

PAGE 192
Garry Fabian Miller, *Gaze (i)* (detail; see page 146)

NOTE ON CAPTIONS
All dimensions indicate height followed by width followed by depth.